GEORGE WASHINGTON'S VIRGINIA

GEORGE WASHINGTON'S VIRGINIA

John R. Maass

THE
History
PRESS

Published by The History Press
Charleston, SC
www.historypress.net

Copyright © 2017 by John R. Maass
All rights reserved

Front cover: George Washington's home at Mount Vernon, exterior view, showing façade facing the Potomac River. *Library of Congress*.

First published 2017

Manufactured in the United States

ISBN 9781467119788

Library of Congress Control Number: 2016961482

*This book is dedicated to the memory of John Joseph Young Sr., PhD, scholar,
father-in-law and friend.*

In omnibus requiem quaesivi, et nusquam inveni nisi in angulo cum libro

CONTENTS

Foreword, by Thomas A. Reinhart 9
Acknowledgements 11
Introduction 13

1. The Early Years Along the Potomac 17
2. Mary Ball Washington and the Northern Neck 27
3. Fredericksburg: George Washington's Hometown 35
4. The Young Surveyor 44
5. "My Inclinations Are Strongly Bent to Arms":
 The French and Indian War 66
6. "An Elegant Seat and Situation": Mount Vernon and Vicinity 98
7. "The Just Object of Your Affections":
 Martha Dandridge Custis and Tidewater Virginia 123
8. The Burgess and the Revolutionary 134
9. The Revolutionary War: Triumph at Yorktown 170
10. Old Town Alexandria 182
11. "Pursuits of Commerce and the Cultivation of the Soil" 195

Conclusion 211
Bibliography 213
Index 215
About the Author 221

FOREWORD

The Virginia landscape familiar to George Washington has changed considerably over the last 217 years. An increase in Virginia's population from just over 886,000 at the time of Washington's death in 1799 to just over 8 million in 2010 has wrought changes that have left few features the father of our country would recognize with certainty. The growth of his federal city has transformed once-rural northern Virginia into tens of thousands of acres of suburban development. Fewer than five hundred acres of his beloved Mount Vernon survive in a form he would know. The remainder has been divided and subdivided into dozens of neighborhoods with names he would recognize but whose close-packed dwellings would seem alien to him. Even further afield, in the parts of the commonwealth where farming has remained the principal economic pursuit, changes in agricultural practice, brought about first by emancipation and then by industrialization, have produced landscapes that bear only passing similarity to the fields farmed by the labor of enslaved Africans and draft animals. Increased productivity creates larger fields, and decreased reliance on wood for heat means less need to nurture stands of forest, which, ironically, means fewer trees are to be found.

Sprinkled throughout this new Virginia, however, are survivors that Washington knew and would recognize today if he were somehow to reappear: towns, roads, taverns, mills, churches, dwellings and other cultural features that have withstood the tides of change. These important links to our past connect us to the man and his times, but they are few and scattered

throughout the modern landscape. They are sometimes quite well known, but far more often they are obscure, situated off infrequently traveled byways, on side streets or along country lanes. One needs a guide to locate them and a knowledgeable historian to reveal their stories and significance: John Maass provides both in *George Washington's Virginia*.

John has been published in many professional journals and wrote *The French and Indian War in North Carolina: The Spreading Flames of War* (The History Press, 2013) and *The Road to Yorktown: Jefferson, Lafayette and the British Invasion of Virginia* (The History Press, 2015). Even a quick look at his publications reveals not only a facility with the archival record and a keen analytical eye that teases out historical threads but also a sensitive understanding of natural and cultural landscapes and the important influence they exert on any unfolding of human events. This ability to utilize non-archival evidence to present a fuller, more accurate history puts John in a unique position to address the subject of this book.

In this book, John reverses his usual approach. Instead of starting with a serious academic history into which he has woven knowledgeable discussion of the buildings and places that shaped events, creating a narrative that inspires in readers a desire to see and experience those cultural landscapes for themselves, John begins with the cultural features associated with Virginia's greatest son, connecting these to the documents that place them in the broader context of Washington's world. In doing so, John has produced a guide that is infused with serious scholarship. This is a guide for real lovers of history, those who not only want the how, when and why, but also want to see the where for themselves.

George Washington traveled extensively through Virginia and knew many parts of it intimately. With John Maass as your guide, you will come to know the Old Dominion better than before. He will take you to places that would have escaped your notice and whose significance you may never have guessed. The modern world will briefly fade away, and you will see things more closely to how Washington did. I hope you enjoy traveling with John as much as I have over the years.

—THOMAS A. REINHART, Director of Architecture,
George Washington's Mount Vernon

ACKNOWLEDGEMENTS

I am indebted to many people and organizations for helping me research, write and obtain images for this book. I called on friends, colleagues, family members, fellow historians, museum professionals and, in some cases, folks I have never met for assistance. All willingly assisted my efforts to produce the book you are reading now, and to them I offer my thanks.

Several individuals I called on to go beyond the call of duty while I worked on this project, and all fortunately agreed. Thomas A. Reinhart, Director of Architecture at Mount Vernon, read and gave comments on parts of the manuscript but more importantly spent a long summer day driving around the Northern Neck with me looking at old houses, churches and roads. Additionally, Sabrina and Ray Miller allowed me to get an inside look that day at their historic home, Bushfield, and supplied the wonderful aerial photo of the house.

Tim Arnold, old friend and fellow alumnus of Rockbridge High School, reviewed the entire manuscript and offered helpful advice. A new friend, Robert Orrison of the Prince William County Historic Preservation Division, provided images and answered many of my questions about sites in his county. Dr. Robert A. Selig assisted me immeasurably with my questions related to the Washington-Rochambeau Route in Virginia and has done much superb original research in that area. Thanks also to Jim F. Brown of Lexington, who unhesitatingly provided me with images of some of Virginia's distant frontier forts in the Allegheny Mountains, in areas difficult to access.

ACKNOWLEDGEMENTS

I also thank my son Richard C. "Charlie" Maass II, who accompanied me on most of my photographic excursions all over Virginia for this book and took several of the images himself—time well spent. Likewise, my daughter Eileen Mairéad Maass helped me get the last three images for this book—by taking them herself.

Additional thanks and appreciation go to the Carlyle House, Randy Carter, Richard Dennis Harold Clark, Kathryn Horn Coneway, Anne Darron, Scott Douglas, Kristina Doyle, the Fred W. Smith National Library for the Study of George Washington, Friends of Chatham, Nancy Fahy, Abigail Fleming, Jim Gallagher, Carolyn Gamble, Jim Glanville, Chelsea S. Goldstein, Susan Hayward-Costa, Rachel Jirka, Jumping Rocks Photography, Chris Kolakowski, Edgar Lafferty, P. Jeffrey Lambert, Lawrence Latane, Lauren Leake, Edward Lengel, Jennifer Loux, Molly Young Maass, Robert Madison, Bob Maher, Candace Warren Mangum, Marianne Martin, Peggy McPhillips, Amanda McVey, Jon Middaugh, Kerry Mitchell, Jay Morris, James Mullins, Sarah K. Myers, the National Guard Bureau, Rebekah Oakes, Brent O'Neill, Jeffrey P. Oves, William W. Richardson III, Virginia "Ginger" Shaw, Mark Smith, Banks Smither, the Society of the Cincinnati, Dennis Springer, Theresa F. Stavens, Helen Stewart, Carrie G. Sullivan, Mike Taimi, James A. Tobias, the Virginia Division of Historic Resources, the Washington Heritage Museums, Liz Williams, Theresa Clark Williams, the Winchester-Frederick County Historical Society, Helen Wirka and Joseph Ziarko.

INTRODUCTION

George Washington was a man of the American continent, at least as it was geographically defined in the eighteenth century. Born and raised in Virginia, his early frontier surveying career took him to the rugged mountains and swift rivers of what is now West Virginia. During the French and Indian War (1754–63), as a young officer, Washington campaigned beyond Virginia's borders into Maryland, Pennsylvania and Ohio. In search of a British army commission, he ventured to Boston and New York. As a Continental Congress delegate before the Revolutionary War broke out, he traveled to Philadelphia, and when chosen by his illustrious fellow delegates to be the commander of the rebellious colonies' Continental forces in June 1775, Washington again traveled to Boston to take up his new assignment. From there his military duties throughout the war took him to New England and the mid-Atlantic states. He fought major battles in New York, New Jersey and Pennsylvania. During his presidency, Washington visited the Carolinas and Georgia on a 1791 southern tour and made other journeys to the distant northern states during his two administrations as well, including what later became the state of Maine. In search of new land, he went to what is now West Virginia. In an era of foot, hoof, carriage and sail transportation, Washington certainly managed to see much of the new nation, from Lake Champlain to Savannah, Georgia.

In addition to traveling throughout the eastern part of what became the United States, Washington was also identified as representative of *all* the states. He was a delegate to the Continental Congress, an extralegal body called to

promote the unified actions of the thirteen American colonies in rebellion. From 1775 to 1783, he was the Continental Army's commander, the leader of all military forces on the American continent. Four years later, he was chosen to preside over the Constitutional Convention in Philadelphia, a summit of all American states to modify and perfect the terms of their unwieldy wartime confederation. And perhaps most notably, he was the first man elected president of the United States, known later as "the father of his country."

And yet for all of Washington's extensive journeys and his identification as a unifying figure in the nation's early military and political history, he

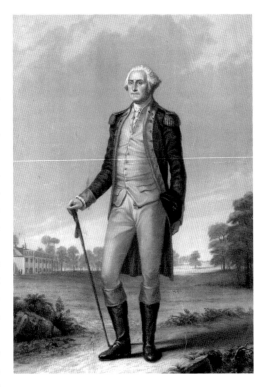

General George Washington. *Library of Congress.*

was first and foremost a Virginian. He was born in the state's tidewater region, where his family had put down roots in the seventeenth century. He was reared near Fredericksburg, took up residence at Mount Vernon along the Potomac River in northern Virginia and died there in 1799. As a youthful surveyor, he worked primarily in northern and western Virginia. His early military career was as a Virginia militia and provincial officer, and he served much of his time in the colony's Shenandoah Valley. He took up a seat in the Virginia House of Burgesses in Williamsburg for over a decade. The majority of his widespread land holdings were in his native state (and what was so at the time), while most of his entrepreneurial endeavors ranged from the swamplands of southeastern Virginia to the upper Potomac River Valley. His letters bear testimony to his desire to retire to his native land. "I can truly say I had rather be at Mount Vernon with a friend or two about me," Washington wrote in 1790, "than to be attended at the Seat of Government by the Officers of State and the Representatives of every Power in Europe." Several years beforehand, after retiring from military service at the end of the Revolution, Washington's relief was evident. "From

the clangor of arms and the bustle of a camp, freed from the cares of public employment, and the responsibility of office, I am now enjoying domestic ease under the shadow of my own Vine, and my own Fig tree; and in a small Villa, with the implements of Husbandry, and Lambkins around me, I expect to glide gently down the stream of life, 'till I am entombed in the dreary mansions of my Fathers," he wrote eloquently to the Marquis de Lafayette in 1784. Virginia was truly his home.

George Washington's Virginia is not a biography of the great general and first president of the United States. Readers looking for such a study have several fine recent works to peruse, including those by Edward Lengel, Joseph Ellis, John Ferling, Stephen Brumwell and Ron Chernow. Rather, this book is an introduction to Washington's multifaceted life within the Old Dominion and an exploration of many of the sites in Virginia with which he was associated and familiar. Given Washington's many years spent in Virginia and his extensive travels throughout the state, it would be impossible to include every place related to him within the scope of this book. I have attempted, however, to provide at least an overview of the major places Washington knew in his time and their histories. I have also included some lesser-known locations—homes, rivers, roads, routes, fords, taverns, forts and so forth—particularly those accessible to visitors today. With an eye toward covering much of Virginia's beautiful landscape, readers will hopefully understand that Virginia sites that were part of Washington's life include more than his Mount Vernon home and the Yorktown battlefield.

This book is structured to present the story of George Washington in Virginia both chronologically and thematically. Initially, readers will learn about young George's early years, including his birthplace and early home in Westmoreland County along the wide Potomac River. Additionally, many sites in and around Fredericksburg figured prominently in Washington's early life and are accessible to visitors today. Readers will also encounter places and stories associated with Washington's mother, Mary Ball Washington; his association with the powerful Fairfax family; his surveying career in the Virginia backcountry; and his courtship and marriage of Martha Dandridge Custis.

Before he was the president, Washington was a soldier, and he gained much of his military experience within Virginia. He traveled widely across northern Virginia, in the Shenandoah Valley and along the colony's southern frontier while leading the provincial forces during the French and Indian War in the 1750s. Many of these sites can be easily found from Alexandria to the headwaters of the Potomac and south to the North

Carolina border. Perhaps most famously, Washington's greatest military success came at Yorktown, in tidewater Virginia, where in October 1781 he led a combined Franco-American army to victory over a besieged British force under Lieutenant General Charles, Lord Cornwallis.

No exploration of Washington's native state would be complete without a detailed look at his home, Mount Vernon, along the banks of the Potomac in Fairfax County. Here Washington brought his new wife, Martha, right after their marriage and built a diversified plantation and entrepreneurial concern. Moreover, readers will encounter many sites related to Washington located nearby the estate, such as his gristmill and distillery, the homes of his friends and family, the church where he worshipped and several nearby towns—some of which have all but disappeared. He died at his beloved farm in December 1799 and is entombed with his wife on its grounds.

With numerous locations associated with Washington, the old river port town of Alexandria is also the subject of a thematic chapter in this work. Along the quaint streets of Old Town are the churches, homes, inns and businesses Washington knew as his hometown, several of which are open to visitors today. Likewise, nearby taverns, roads and plantations of his friends and neighbors can also be found still existing. And in a final chapter, Washington's varied business ventures—and their locations—receive an overview, including his endeavors in the Great Dismal Swamp, the Potomac River Valley and innovations on his own plantation.

So that readers can see the sites described in this book, brief descriptions about their locations and visitor information are included where appropriate, along with the modern roads associated with several historic routes on which Washington traveled during his military service, surveying trips, political involvement and business pursuits.

Finally, many of the sites listed in the chapters that follow are privately owned and not open to public visitation (although they can be seen from roads and paths). Please respect private property and do not trespass; descriptions of places and locations in this book should not be taken as permission to do so.

THE EARLY YEARS ALONG
THE POTOMAC

WASHINGTON'S ANCESTORS IN VIRGINIA

Although today George Washington is primarily associated with his famous Mount Vernon estate on the Potomac River in Fairfax County, the future American president's birthplace, early years and the lives of his colonial forebears were spent in the tidewater county of Westmoreland, over fifty miles downstream. Formed in 1653 and much larger than its present boundaries, Westmoreland County during George Washington's life was a region of flat sandy roads, sluggish tidal creeks and waterside tobacco plantations worked by thousands of slaves. Sparsely populated today, it was anything but remote in the seventeenth and eighteenth centuries when the first Washington put down roots there. In fact, the county was later home to other distinguished Virginians, including future U.S. president James Monroe, two signers of the Declaration of Independence—Richard Henry Lee and Francis Lightfoot Lee—and Confederate general Robert E. Lee.

George Washington was born February 22, 1732, to Augustine and Mary Ball Washington at the family's Popes Creek Plantation, where that small tidal estuary empties into the wide Potomac River. It was in part of the Old Dominion called the Northern Neck, a long peninsula between the Potomac and Rappahannock Rivers that would eventually come to include all of northern Virginia and part of what is now the state of West Virginia. George

The mouth of Popes Creek at the Potomac River, where Washington was born. *Author photo.*

was descended from a long line of Washingtons born along the Potomac River beginning in the previous century, after the first known ancestor of his surname decided to leave England and remain in the distant American colony of Virginia. George and his family called Popes Creek home until he was just over three years old, when they moved about sixty miles upriver to what later became the famous plantation called Mount Vernon.

George's adventurous great-grandfather John Washington was the first of his family to settle in Virginia. Known to later historians and genealogists as John Washington "the Immigrant," he was born about 1631 in the English county of Essex and was the son of a Church of England minister who later ran afoul of the ecclesiastical authorities. In 1656, he entered the lucrative tobacco trade and left England as an officer on a merchant ship bound for far-off Virginia, settled by colonists just fifty years earlier. During this voyage, after unloading the ship's cargo in February 1657, his vessel foundered and sank in the Potomac near the mouth of Mattox Creek in Westmoreland County, where tobacco shippers frequently brought their annual crop for transportation to English ports. With the

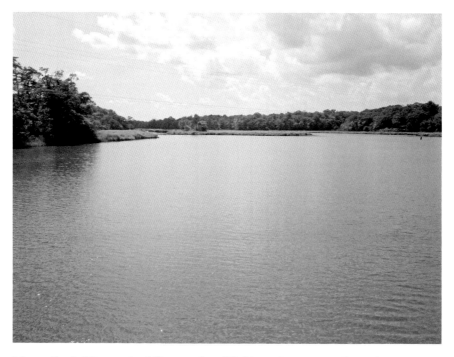

Mattox Creek, Westmoreland County, where Washington's great-grandfather first settled. *Author photo.*

newly loaded cargo ruined and temporarily stranded in the New World, John Washington resigned himself to staying in the tidewater country.

John Washington must have made a favorable impression on his new Westmoreland neighbors because he soon became a friend and business associate of a wealthy plantation owner there, Lieutenant Colonel Nathaniel Pope, whose eldest daughter, Anne, became Washington's wife in 1658.

For a wedding gift, Pope gave the newlyweds 700 acres along Mattox Creek. In 1659, the couple had the first of their five children, Lawrence, grandfather of the future general and president. In 1664, John Washington purchased additional land close by on the east side of Bridges Creek near its mouth on the Potomac. There he and Anne soon established their modest home. John Washington steadily grew into a prominent member of his community. He acquired throughout his life over 8,500 acres, including his purchase on Little Hunting Creek on the Potomac, which would eventually become Mount Vernon. He also served in the Virginia House of Burgesses at Jamestown beginning in 1666, as a local justice of the peace and an officer in the county militia. He owned and operated a grain mill on nearby

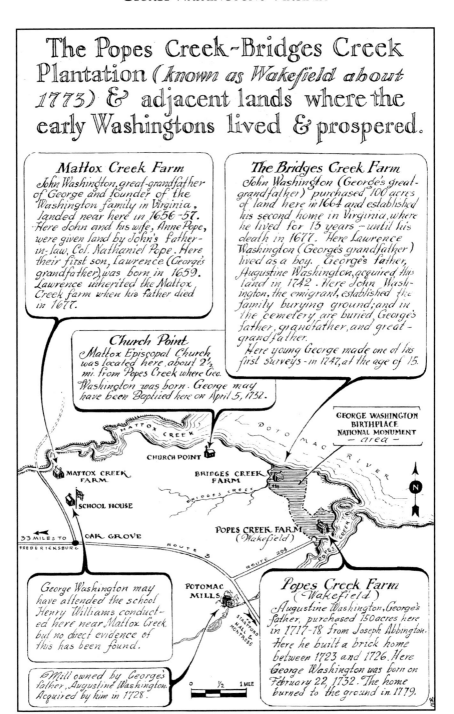

The Popes Creek~Bridges Creek Plantation (known as Wakefield about 1773) & adjacent lands where the early Washingtons lived & prospered.

Mattox Creek Farm

John Washington, great-grandfather of George and founder of the Washington family in Virginia, landed near here in 1656-57. Here John and his wife, Anne Pope, were given land by John's father-in-law, Col. Nathaniel Pope. Here their first son, Lawrence (George's grandfather), was born in 1659. Lawrence inherited the Mattox Creek farm when his father died in 1677.

The Bridges Creek Farm

John Washington (George's great-grandfather) purchased 100 acres of land here in 1664 and established his second home in Virginia, where he lived for 13 years – until his death in 1677. Here Lawrence Washington (George's grandfather) lived as a boy. George's father, Augustine Washington, acquired this land in 1742. Here John Washington, the emigrant, established the family burying ground; and in the cemetery are buried, George's father, grandfather, and great-grandfather.

Here young George made one of his first surveys – in 1747, at the age of 15.

Church Point

Mattox Episcopal Church was located here, about 2½ mi. from Popes Creek where Geo. Washington was born. George may have been Baptized here on April 5, 1732.

GEORGE WASHINGTON BIRTHPLACE NATIONAL MONUMENT – area –

MATTOX CREEK

CHURCH POINT

MATTOX CREEK FARM

SCHOOL HOUSE

33 MILES TO FREDERICKSBURG

OAK GROVE

BRIDGES CREEK FARM

BRIDGES CREEK

POTOMAC RIVER

N

POPES CREEK FARM (Wakefield)

ROUTE 3

ROUTE 204

POPES CREEK

George Washington may have attended the school Henry Williams conducted here near Mattox Creek but no direct evidence of this has been found.

POTOMAC MILLS

STRATFORD HALL & MONTROSS

Popes Creek Farm (Wakefield)

Augustine Washington, George's father, purchased 150 acres here in 1717-18 from Joseph Abbington. Here he built a brick home between 1723 and 1726. Here George Washington was born on February 22, 1732. The home burned to the ground in 1779.

Mill owned by George's father, Augustine Washington. Acquired by him in 1728.

0 ½ 1 MILE

Popes Creek Plantation and environs. *National Park Service.*

20

Rosier's Creek on land he acquired in 1665 (near today's Colonial Beach). Anne Washington died in 1669 and was interred in the family burial ground at Bridges Creek—as was John, who died in 1677. The year before his death he had helped quell Bacon's Rebellion, a dangerous backcountry uprising against royal Governor William Berkeley and the colony's governing elites led by Nathaniel Bacon. During this brief revolt, Bacon's insurgents occupied the Bridges Creek lands for a short period.

John and Anne's eldest son, Lawrence, received a legal education in England and inherited the lands at Mattox Creek, the mill and half interest in the Little Hunting Creek tract upon his father's death. This latter parcel was in (then) Stafford County, "in the Freshes of Pattomomooke River," far away from the brackish water of the lower Potomac. In 1688, Lawrence married Mildred Warner, a daughter of the colony's one-time Speaker of the House of Burgesses, Colonel Augustine Warner Jr. of Warner Hall in Gloucester County. Her mother, Mildred Reade, traced her lineage back to many of England's monarchs, although her grandson George never made much of these lofty connections. Lawrence and Mildred had three children: John, Augustine and Mildred. Starting in 1684, Lawrence served four terms in the House of Burgesses and was a justice of the peace, county coroner, an officer in the militia and high sheriff, but he died young at the Bridges Creek farm in 1698, at the age of thirty-eight.

Lawrence's second son, Augustine, was born in 1694 at Mattox Creek. After his father's death, Augustine (known to friends as Gus) and his family sailed across the Atlantic and took up residence at Whitehaven, England, for several years once his mother remarried. He and his two siblings Jane and John had returned to Virginia by 1704, after their mother's death. He lived with his guardian and cousin John Washington at a plantation along the winding Chotank Creek on the Potomac, east of what would become Fredericksburg. In adulthood, he became a planter, sheriff and justice of the peace in Westmoreland County. He was "six feet in height, of noble appearance, and most manly proportions," a Washington descendant recalled years later. In 1715, he married Jane Butler, a fifteen-year-old orphan, with whom he had four children at the Bridges Creek plantation, which he had inherited. Their surviving sons, Lawrence and Augustine, became George's half brothers.

After Jane Washington's death in 1730 while Augustine was away in England looking after business matters, he married a second time the next year, to Mary Ball of nearby Lancaster County. Mary gave birth to six children, the oldest of whom was George, born in 1732. His other

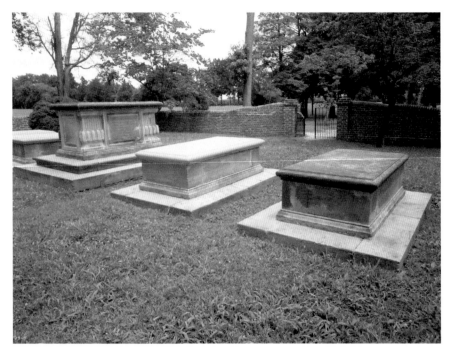

The Washington family burial ground along Bridges Creek. *Author photo.*

full siblings were Samuel, John Augustine, Charles and Elizabeth (Betty). A second daughter, Mildred, died in infancy in 1740. When George was eleven, his father died near Fredericksburg and was buried in the family graveyard at Bridges Creek.

GEORGE WASHINGTON'S BIRTHPLACE

Like most early Virginia planters, the Washingtons were hungry for more land on which they could plant tobacco or sell to others at a profit. Thus, while Augustine was married to his first wife, Jane, he expanded his holdings by purchasing the land on Little Hunting Creek from his sister Mildred for £180 in 1726, along with 150 acres in Mattox Neck on Popes Creek in 1718, to the southeast of the tobacco fields of the Bridges Creek farm. Here he eventually built a new house or expanded an existing one and oversaw the plantation and its many slaves. There has

been no discovery of a drawing, plan or painting of this house, but from family recollections it is thought that the brick house had five dormers, four exterior chimneys and as many as eight rooms. In a 1792 letter while president, George Washington described the house as "the ancient mansion seat," which perhaps implies it was a large structure.

George was born on this Popes Creek property and lived there until he was three years old, at which time the family moved briefly to the Little Hunting Creek lands, then known as Epsewasson after a nearby creek of that name (also called Dogue Creek). Then, in December 1738 or early 1739, the Washingtons moved again, this time to what later became known as Ferry Farm, a tobacco plantation on the Rappahannock River across from Fredericksburg, so that Augustine could better manage his business interests in a profitable iron furnace on lands he and Mary owned nearby.

The Popes Creek property was not part of George's patrimony. Augustine Washington II, George's half brother, inherited the fields, structures and slaves on Popes Creek in 1743 upon the death of their father. The property eventually passed on to his son, William Augustine Washington, who renamed the estate Wakefield. On Christmas Day 1779, the house burned

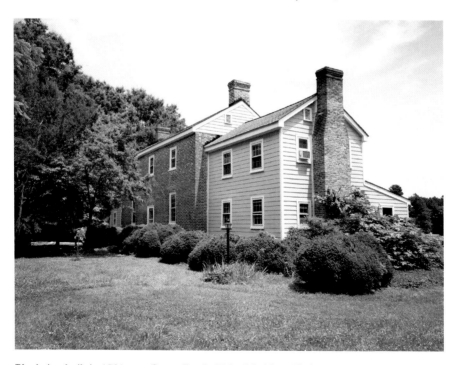

Blenheim, built in 1781 near Popes Creek. *Richard C. Maass II photo.*

to the ground, forcing him and his family to eventually relocate to a new home called Blenheim, built around 1781 a short distance west of Popes Creek, two miles south of the Potomac. Blenheim was a simple brick two-story house of three bays and a central hallway, with interior chimneys at each end. The south addition of this still-existing dwelling may be an older structure moved to the site in the early 1800s. But for one short period, the house has remained in the Washington family since its construction, although William A. Washington's family moved away from Blenheim in 1785 and the Wakefield house was never rebuilt. Subsequently, the area along Popes Creek became known as Burnt House Point.

In 1879 and 1881, the U.S. Congress appropriated funds for a suitable monument to mark the place of Washington's birth and acquired a small parcel of land there from the State of Virginia. In 1923, a group of preservation-minded women formed the Wakefield National Memorial Association to rebuild the house and to maintain the Washington family burial ground located at Bridges Creek, which George Washington called the "Vault of his Ancestors." One of the contributors to this effort was

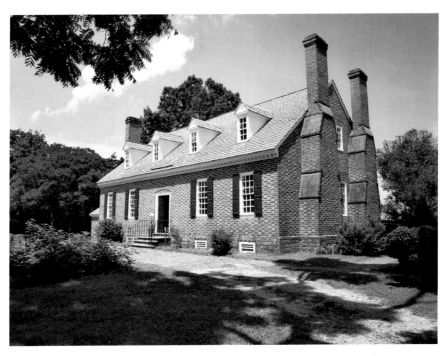

The Memorial House at the George Washington Birthplace National Monument. *Richard C. Maass II photo.*

businessman John D. Rockefeller Jr., who helped purchase almost three hundred acres of the plantation. In 1930, the George Washington Birthplace National Monument was established, including several hundred acres and the graveyard, and officially became a unit of the National Park Service.

In the early 1930s, the Wakefield National Memorial Association oversaw construction of what is called the Memorial House, a conjectural reproduction of a typical tidewater Virginia brick planation house of the early eighteenth century. It is not a replica of the old Washington home at Popes Creek, due to the lack of documentation of the original house's appearance. The site upon which this reconstruction now stands was first thought to be the foundation of the Washington home, but modern research and archaeology have now determined that the original site is actually just south of it. It is now clearly marked on the ground with an outline of oyster shells. Other buildings nearby include those of the dairy, weaving room, barn and kitchen.

The George Washington Birthplace National Monument, a National Park Service site, is located at 1732 Popes Creek Road, near Montross, two miles from Virginia State Route 3 on Virginia State Route 204 and ten miles from Colonial Beach. The site may be contacted at (804) 224-1732 and at www.nps.gov/gewa/index.htm.

WASHINGTON'S WESTMORELAND

Several other nearby sites in Westmoreland County are associated with George Washington and his family. On the south side of Mattox Creek where Route 205 crosses that stream north of today's crossroads of Oak Grove was the original Mattox Creek plantation of John Washington, on the east side of the highway. The location of the mill acquired by Lawrence in 1728 was on Popes Creek, just west of Route 3 at the end of Potomac Mills Road; although the millpond is now overgrown, it is still recognizable. The site of Mattox Church, where the infant George was likely baptized and may have attended school, was part of the Anglican denomination's Washington Parish and situated on the Potomac at Church Point at the mouth of Mattox Creek, a little over two miles from his birthplace. The church was at the end of Church Point Lane (north of Route 3 about two miles west of Popes Creek) on the east side of the stream, but the actual site is now submerged under the river's waters.

Popes Creek plantation fields at the George Washington Birthplace National Monument. *Author photo.*

Round Hill Church in Washington Parish was built by the Washington family in the early 1720s, with Augustine Washington acting as parish treasurer to disperse payments to the builder. By 1837, this small Anglican church was nothing more than "a few broken bricks and a little elevation made by the mouldered ruins," according to an Episcopal minister of the time. No longer standing, this lost church was situated about twelve road miles from the Popes Creek house, at the southeastern corner of Routes 218 (Tetotem Road) and 619 (Stoney Point Road) in today's King George County, near Dahlgren.

The extensive Washington lands along Bridges Creek can be seen north of Route 3, along the east side of Route 721 and from Bridges Creek Road, which runs north from the National Park Service parking lot to the Washington family graveyard, which is accessible to the public. William Augustine Washington's home Blenheim is off of Popes Creek Road. It is a privately owned four-hundred-acre farm owned by Blenheim Organic Gardens of Colonial Beach and has a social media presence.

2

MARY BALL WASHINGTON AND THE NORTHERN NECK

THE MOTHER OF WASHINGTON

Considering how famous George Washington became even in her lifetime, it is surprising that his mother's early years and family history are not well known. Mary Johnson Ball, George Washington's mother, was born in 1708 or 1709 in the Northern Neck county of Lancaster. Married to Augustine Washington in 1731, she was widowed twelve years later and never remarried—quite unusual among the landed gentry society of the colonial tidewater, especially considering that she had five children to raise alone.

Mary has been treated unevenly by historians. Early biographers of Washington praised his mother, noting her strong will, independent nature and abilities to manage her farm. They noted that George signed his letters to her "Y[ou]r most Dutiful & Obed[ien]t Son," and addressed her as "Honourd Madam." She was typically referred to as "the mother of Washington," as if her first baby was predestined for greatness.

Later histories were rather unkind to her, referring to her as cantankerous, ungrateful and difficult. Washington's award-winning biographer Douglas S. Freeman wrote in the early twentieth century that this relationship was "the strangest mystery of Washington's life." James T. Flexner's work a few decades later is particularly harsh in assessing her personality, but is largely conjectural and based on scant proof. Online sources—including the *Papers*

of George Washington's official blog—are also questionable in their conclusions. In truth, little actual evidence from the eighteenth century exists to make accurate judgments about her character or the full relationship she had with her famous son.

Just as the Washington family can be traced to many sites in the Northern Neck, the family of Mary Ball can be linked to churches and homes in this rural region as well. She was the sole child of Colonel Joseph Ball and his second wife, Mary Johnson, a widow of obscure origins at the time of their union and much younger than her spouse. No record of their marriage or of her birth survives. Their home's location—and the probable birthplace of Washington's mother—is now a matter of dispute. The majority of writers going back hundreds of years assert that she was born at a seven-hundred-acre plantation called Forest Quarter in a wooden frame house eventually known as Epping Forest by the nineteenth century. Historian Paula Felder, however, has recently made a strong case based upon Joseph Ball's will that Washington's mother was born at a plantation he was developing at the mouth of Morattico Creek, on the Rappahannock River near the modern

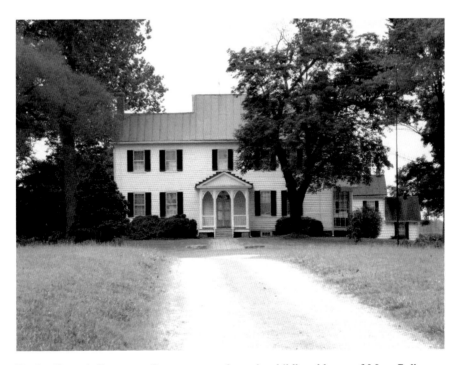

Epping Forest in Lancaster County was perhaps the childhood home of Mary Ball. *Author photo.*

Lancaster County community called Simonson (at the end of modern Route 606, Simonson Road). Given the paucity of surviving records for the period, it is unlikely that this question will be definitively answered.

After her father died when she was three years old, Mary's mother married Richard Hues (sometimes given as Hewes and Howes), and subsequently, the family moved to his plantation called Cherry Point, in nearby Northumberland County along the Potomac River at its mouth on Chesapeake Bay. Hues died shortly thereafter, as did Mary's mother in 1720. Her mother's will was filed by an English-born relative, Colonel George Eskridge, a prominent Northern Neck lawyer, tobacco planter and occasional burgess during a thirty-year period, whose home was at Sandy Point on the Potomac in eastern Westmoreland County. He was also a distant relative of the Washingtons by marriage. Contrary to many modern histories, Erskine was not Mary's legal guardian upon her mother's death.

Mary probably continued to spend most or all of her time at Cherry Point with her half sister Elizabeth Johnson Bonum after her mother died. Through inheritances she had acquired about one thousand acres by the time she was eighteen, including land in Stafford County later found to have valuable iron ore deposits on it. At Sandy Point, she married Augustine Washington in 1731. Some early sources claim the ceremony was at nearby Yeocomico Church, but no church records substantiate it. It is also possible that George Eskridge introduced the couple to each other.

NORTHERN NECK SITES

Those searching for sites related to Mary Ball Washington might start at Epping Forest, her possible birthplace, situated on the south side of Morattico Road (Route 622) in Lancaster County, less than a mile west of Route 3. The current white frame house has been significantly altered from its eighteenth-century appearance with several nineteenth-century additions. This two-story dwelling east of the rural crossroads called Nuttsville is readily visible from the county road but privately owned and not open to visitation. A historical marker supporting Mary Ball's association with Epping Forest is located close by on Route 3 at Lively.

Cherry Point, now called Cowart's Point, is at the end of Cowart Road (Route 625) on the Coan River, opposite (west of) Lewisetta. Colonel Erskine's former lands at Sandy Point are along Skipjack Road (Route 610), about two

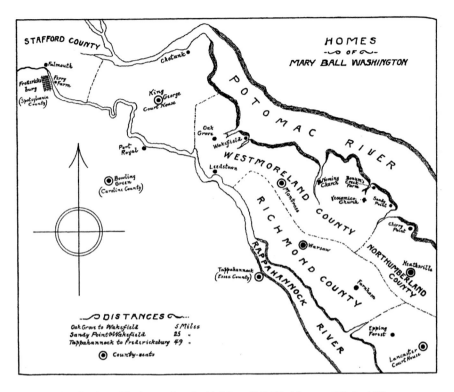

Sites in the Northern Neck associated with Mary Ball Washington. *Wayland,* The Washingtons and Their Homes.

miles east of the hamlet of Westmoreland and north of Lynch Point on the Potomac River. Neither of these two eighteenth-century houses still stand.

One of the religious structures of the Northern Neck related to Washington's mother and accessible to visitors is Yeocomico Church, about three miles west of Sandy Point. The current brick structure dates from 1706 (and was enlarged in 1740); it is the oldest church in Westmoreland County and the fourth oldest in Virginia. The brickwork is a mixture of English and Flemish bond, a transition from Gothic to Georgian styles, and the bricks were fired at the church site. Uniquely, inside the south door of the church is the only known wicket door (a small pedestrian entrance built into a larger gate) in an American colonial church, possibly retained from the original 1655 building, and the Jacobean-style communion table is thought to be the oldest in Virginia. Mary Ball attended church there regularly from 1721 to 1730, and John Augustine Washington (George's brother) served as vestryman here in the years after the Revolution. Virginia troops were stationed at the site in the Revolutionary War and the War of 1812, and

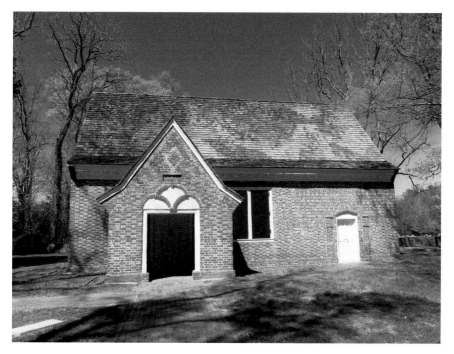

Yeocomico Church in Westmoreland County, the fourth-oldest church in Virginia. *Candace W. Mangum photo.*

later, Confederate soldiers used it during the Civil War. The church is located on Old Yeocomico Road (Route 606), north of Route 202 near the cross roads of Tucker Hill, and is still part of the Episcopal Church's Cople Parish. Interested visitors can contact the church at (804) 472-2593 or visit www.copleparish.com/yeocomico-church.

Near Lancaster, at the corner of White Chapel Road (Route 201) and River Road (Route 354) a mile from the Rappahannock River, is St. Mary's Whitechapel, where an Anglican chapel of ease has stood at the site since the 1650s. President James Monroe's grandfather was the builder of this structure. This parish also has a long association with the Ball family. The current Episcopal church, which dates to the eighteenth century, is a striking rectangular building with a hip roof, and the Flemish bond brickwork shows signs of significant repairs and alterations over the years. Inside, a gallery installed in the south end of the building was paid for privately by the Ball family for their own use in the 1740s. The one-piece baptismal font dates from 1718. The lovely church stands among numerous tall trees near the ancient graveyard at 5940 White Chapel Road, Lancaster. More history of

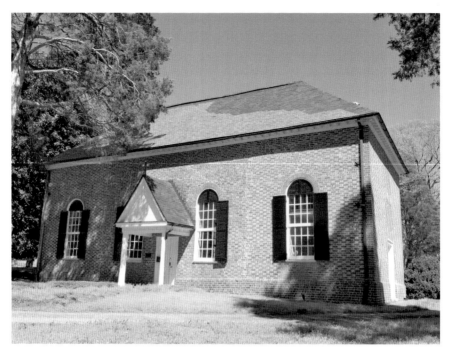

St. Mary's Whitechapel, parish church of the Ball family, close to the Rappahannock River. *Candace W. Mangum photo.*

the church and visitor information is available at www.stmaryswhitechapel. org and an information kiosk at the site.

Another Northern Neck ecclesiastical structure of the period was Nomini Church, originally built in 1704 on the creek of the same name in Westmoreland County, replaced by a brick church at the same spot in the late 1750s. As an adult, George Washington attended services at Nomini Church twice in 1768 and was in the area to visit his brother John Augustine, who lived nearby. During the War of 1812, hostile British forces under the command of Admiral George Cockburn burned the church in July 1814. The present church on site was built in 1852 and may incorporate part of the earlier ruined structure, although perhaps just one wall. Somewhat in disrepair, it still stands on a knoll on the north side of Cople Highway (Route 202), a short distance west of Mount Holly.

Three miles north of Nomini Church is an imposing three-story brick house called Bushfield, located on Clubhouse Loop, just off Bushfield Road (Route 780). This site was the home of George Washington's younger brother John Augustine Washington and his wife, Hannah Bushrod, whose

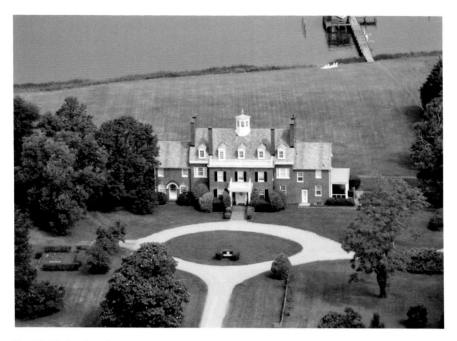

Bushfield, the site of an early home of John A. Washington, located on Nomini Creek. The family graveyard can be seen at lower left. *Sabrina Miller photo.*

family originally owned the surrounding plantation lands. The future president visited this plantation on Nomini Creek several times before the Revolutionary War while he was a burgess. John Augustine's son Bushrod was born here in 1762; he later became a U.S. Supreme Court justice in 1798, before inheriting Mount Vernon from his illustrious uncle. The original house, built in the 1750s, was a rectangular two-story brick home with a center passage and five bays. In the War of 1812, British ships bombarded the house from Nomini Creek in 1814, causing considerable damage. It has since been significantly enlarged and remodeled several times in the colonial revival style of the early 1900s to double its eighteenth-century size and includes a distinctive cupola that can be seen for miles. Still preserved on the grounds is a small graveyard in which John Washington was buried upon his death in 1787, although there is no longer a legible headstone for his grave. His wife, Hannah, is also buried there.

Visible from the road, the house and several acres are now privately owned by Bushfield Manor Events, LLC, but it is occasionally made available for events. The company may be reached at contact@bushfieldmanorevents.com.

The Glebe, a parish house significantly expanded since it was built in the eighteenth century. *Author photo.*

Several miles east of Nomini Church and Bushfield in a modern community called Glebe Harbor off Mount Holly Road (Route 626) is a large brick dwelling house known as the Glebe. This was the home of the rectors of Cople Parish, including Reverend Walter Jones, who married Washington's parents in 1731 (although not at this site). Later, the long-serving parish rector Thomas Smith lived there; he was the chairman of the Westmoreland County Committee of Safety at the outbreak of the Revolutionary War in 1775. He supposedly hosted George Washington at the home in May 1771. Much of the imposing building is from the nineteenth century, but a section to the east of the front entrance likely dates from the early to mid-eighteenth century and includes some fine brickwork. Although privately owned, it is visible from Glebe Harbor Drive (Route 1501) on the north side, after turning off Mount Holly Road.

Additional information on the Washington and Ball families in Virginia's tidewater counties can also be obtained by contacting the Northern Neck of Virginia Historical Society in Montross at www.NNVHS.org or (804) 493-1862 as well as the Mary Ball Washington Museum & Library in Lancaster, www.mbwm.org or (804) 462-7280.

3

FREDERICKSBURG

George Washington's Hometown

For much of his youth, Washington lived in the Rappahannock River town of Fredericksburg, which the Virginia House of Burgesses established in 1728. Situated at the river's rocky fall line, the town became a shipping point and inspection station for tobacco and other agricultural commodities and later an important supply depot during the Revolutionary War.

ALONG THE RAPPAHANNOCK

George Washington and his family moved from their Little Hunting Creek house on the upper Potomac to what they called their "home farm" in Stafford County in December 1738, when he was six years old. From there, George would later write, one had a "clear and distinct" view of "almost every house" in nearby Fredericksburg. Augustine Washington moved the family to the area to be closer to his interests in iron mines and a furnace nearby and perhaps for his five children's access to education. This six-hundred-acre plantation on the river opposite Fredericksburg was subsequently called the Ferry Farm because of a ferry landing there, across from a busy wharf. Young George later came to inherit the home farm and ten slaves in 1743 upon the death of his father (along with three town lots in Fredericksburg). Mary Ball Washington was named in her husband's will as the custodian of George's property until either he came of age (at twenty-

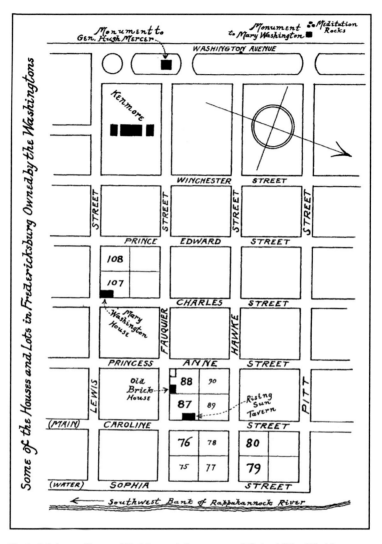

Fredericksburg, George Washington's hometown. *Wayland,* The Washingtons and Their Homes.

one) or she remarried, and while she lived there until 1772, she managed the farm, family and slaves herself. George eventually sold the plantation in 1774, after his mother had moved into town to a home he purchased for her.

The Washingtons' house at the new farm was a one-and-a-half-story dark red clapboard dwelling, fifty-three feet, eight and a half inches by twenty-eight feet, four inches, set on an Aquia stone foundation, as confirmed by recent archaeology. When advertised for sale in 1738, the owner described it

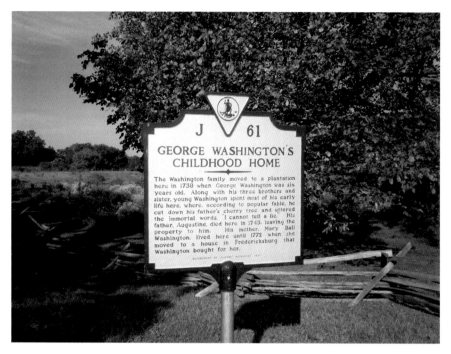

George Washington spent most of his childhood at the Ferry Farm near Fredericksburg. *Author photo.*

as a "very handsome dwelling house, three store houses, [and] several other convenient out houses." It was flanked by two chimneys and had two stone storage cellars under it. The house partially burned in 1740 but was repaired after sustaining limited damage. Although Mary moved the family back to Popes Creek for a time after her husband's death, George spent much time at Ferry Farm under the watchful guidance of his mother. As the years passed by, however, he spent less time at the family farm in order to pursue his education under the direction of his older half brother Lawrence at Little Hunting Creek, renamed Mount Vernon by the time George moved there. Additionally, he lived for periods with his half brother Augustine at Popes Creek.

Long after Mary Washington moved away from the Ferry Farm house, a new one was erected, but Federal troops destroyed it and nearly everything else of value there during the Civil War. The property was within the Union lines during the battle of Fredericksburg in December 1862, and President Abraham Lincoln visited Federal troops camped at the farm site around the same period. Decades later, the George Washington Foundation purchased the Ferry Farm in 1928 but lost the property in the ensuing

years of the Great Depression. After several more unsuccessful attempts by preservationists to save and restore the property in the 1940s and 1950s, the Kenmore Association in Fredericksburg saved 114 acres of Ferry Farm in 1996 from the threat of increasing commercial development. This group then changed its name to George Washington's Fredericksburg Foundation and also purchased the lands of Augustine Washington's ironworks around Accokeek Furnace. This nonprofit organization again changed its name to the George Washington Foundation in 2008 and is now dedicated to enhancing "the public understanding and appreciation of the lives, values, and legacies of George Washington" and his family. Ferry Farm was designated a National Historic Landmark in 2000.

Visitors to Ferry Farm should know that two of the best-known legends associated with George Washington were set at this site—that of young George and the cherry tree invented by Parson Weems and his alleged feat of throwing a silver dollar across the Rappahannock River as told by George's cousin Lewis Willis.

One colorful incident in which Washington was involved along the Rappahannock was decidedly not a fabrication. In the summer of 1751, according to Spotsylvania County court records, while young George was washing in the river, a Fredericksburg servant named Mary McDaniel stole his clothes on the riverbank. She was found guilty of petty larceny after an accomplice turned king's evidence in December of that year, and after pleading for mercy, she was sentenced to be tied to a whipping post where the county sheriff was to publicly "inflict fifteen lashes on her bare back." The records do not tell us how George managed to get out of the river and back home without his clothes.

Washington's Ferry Farm is located east of Fredericksburg on Route 3 in Stafford County, across the Rappahannock River from town at 268 Kings Highway. The site's webpage is www.kenmore.org.

KENMORE

In 1772, Mary Ball Washington moved from the farm at the ferry site into Fredericksburg. Her son George was already established at Mount Vernon, and she wished to be closer to her daughter, Betty Washington Lewis, born in 1733. At age seventeen, Betty married her second cousin, a widower and father of two children, Colonel Fielding Lewis, a son of

An early twentieth-century image of Kenmore, home of Betty and Fielding Lewis in Fredericksburg. *Library of Congress.*

John and Frances Lewis of Warner Hall in Gloucester County. After their 1751 marriage, they came to live in a brick two-story Georgian house of eight rooms built in 1752, although interior work continued for many more years. The fifty-three-by-forty-one-foot dwelling was part of a 1,300-acre plantation just outside the town that came to be called Kenmore in the early 1800s and was worked by as many as eighty slaves. George Washington surveyed the land and assisted in picking out the house site. Fielding lived there until his death in 1781; Betty remained there several more years but eventually moved into a smaller home, as Kenmore's expenses became too great. "I should most certainly have been ruined had I continued there one more year" she wrote to her brother George. In 1797, Fielding's heir and son John sold the land and house weeks after his mother's death at "Western View" along the Rapidan River in Culpeper County, the home of her daughter Betty Lewis Carter. Her grave is in a small cemetery on private land on the west side of Mitchell Ford Road (Route 680), half a mile south of Batna Road near Lignum.

George Washington bought this home in Fredericksburg for his mother in 1772. *Author photo.*

WASHINGTON FREDERICKSBURG SITES

Once relocated to Fredericksburg, Washington's mother did not live with the Lewis family. Instead, she resided in what is now called the Mary Ball Washington House, at 1200 Charles Street. In 1772, George Washington purchased a house for her (built in 1760) at the corner of Charles and Lewis Streets, and there she lived for her last seventeen years, close to Kenmore. Washington visited her at the house often while traveling, and the Marquis de Lafayette was also her guest. In 1890, an organization called Preservation Virginia bought this dwelling and, after a period of restoration, opened it to the public in 1931. After decades of stewardship, Preservation Virginia gave over the ownership and direction of the house in 2013 to the Washington Heritage Museums, which had previously been the Mary Washington Branch of the organization. Open to the public, visitors can see the house, extensive gardens, and the original eighteenth-century kitchen building. More information about touring the home can be found at www.washingtonheritagemuseums.org.

Other sites associated with the Washington family in the historic area of Fredericksburg are open to the public, including the Hugh Mercer Apothecary

Shop at 1020 Caroline Street, also owned by the Washington Heritage Museums. Dr. Mercer was a Scottish-born physician who practiced medicine for fifteen years in the town, and Mary Washington was one of his patients. He also saw extensive military service, having been a surgeon in the forces of "Bonnie" Prince Charles in "The '45" uprising in Scotland and with Pennsylvania forces in America during the French and Indian War. After becoming friends with George Washington during the latter conflict, he moved to Fredericksburg in 1760. In 1774, he bought the Ferry Farm from his friend George after Mary Ball Washington had moved into town. He was a noted Patriot at the beginning of the revolutionary struggle in America, and when the war erupted, he became an officer in Virginia's Continental troops, quickly rising to the rank of brigadier general. At the battle of Princeton, New Jersey, on January 3, 1777, he was unhorsed during combat and surrounded by enemy soldiers who mistook him for General Washington. He was bayoneted several times and left for dead on the field after refusing to surrender; he died nine days later in a field hospital. The museum can be contacted at (540) 373-3362 for visitor information.

A few blocks away is the Rising Sun Tavern, located at 1304 Caroline Street, originally built as the residence of George Washington's youngest brother, Charles, in 1760. It subsequently became a tavern when the Wallace

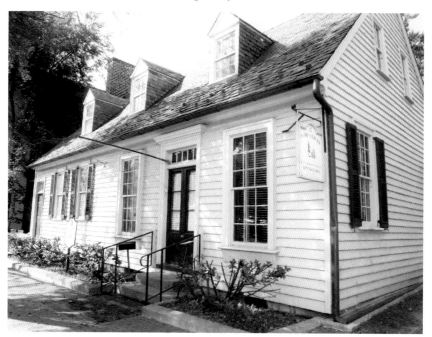

Hugh Mercer's apothecary shop in Fredericksburg. *Author photo.*

family assumed ownership of the structure. A one-and-a-half-story frame building with dormers, much of the interior paneling is original. Restored beginning in 1907, it is now owned by the Washington Heritage Museums. Tour information may be had by calling (540) 371-1494 or visiting the website at www.washingtonheritagemuseums.org.

A block from the Mary Ball Washington house is the St. James House on Charles Street, erected about 1768, one of the few wooden frame homes in Fredericksburg from the 1700s. This was the dwelling of attorney James Mercer, who wrote the will of Mary Washington. He was also a member of the colonial House of Burgesses. The house was restored in the 1960s and given to Preservation Virginia. The Washington Heritage Museums now owns this property, and it is open to visitors occasionally. More information on visitation can be had at www.washingtonheritagemuseums.org.

The Washingtons were also affiliated with St. George's Church in town, at 905 Princess Anne Street. The current Romanesque Revival structure is from 1849, but at the earlier church on this site—a wooden one-story structure completed in 1741—the Washington family attended services. John Dandridge, Martha Washington's father, who died in 1756, is buried in the graveyard, and his tomb is next to the church wall in a corner. Washington's brother Charles and his brother-in-law Fielding Lewis served as vestrymen here during the colonial period.

Washington also frequented Weedon's Ordinary in Fredericksburg in the years before the Revolution. Established in 1728, it eventually came to be owned by George Weedon, a French and Indian War veteran. He was later a Continental Army brigadier general during the Revolutionary War and was involved in the Yorktown campaign of 1781 with Virginia's militia forces. The tavern was destroyed by fire in 1807. An interpretive marker about the tavern is located on the southwest corner of the intersection of Caroline and William Streets, two blocks from the Rappahannock River.

As noted above, one of the primary reasons George's father moved his young family from their Little Hunting Creeks lands along the upper Potomac to Ferry Farm in Stafford was to be closer to his business interests in commercial iron mining and production nearby. Augustine Washington owned about 1,600 acres ten miles north of Ferry Farm along Accokeek Creek, an area rich in iron deposits. Along this small stream, Augustine began developing its industrial promise in partnership with the Principio Company of England beginning in 1726. About ten years later, he became this firm's principal representative in the American colonies as he expanded iron production and transportation. Output declined significantly by the mid-1750s, however, and operations ceased about 1756. George eventually inherited this land upon his mother's death, but there were title issues to it. By 1793, he had given it to

Robert Lewis, his nephew. The president noted at the time that the land contained "the most valuable Pine in that part of the Country; but which, as I have been informed, has been much pillaged by Trespassers."

At the site was a blast furnace (worked by slaves), a mill, a forge, warehouses and other buildings associated with iron production. According to the nearby historical marker, the site today includes the mill's "wheel pit and races, a retaining wall made of slag, an extensive slag dump, and mine pits." It was the second-oldest iron furnace developed in Virginia and at one time the largest single producer of pig iron in all of the colonies. The area is now an archaeological site on private property with no public access. However, the general vicinity of the mine and furnace can be seen

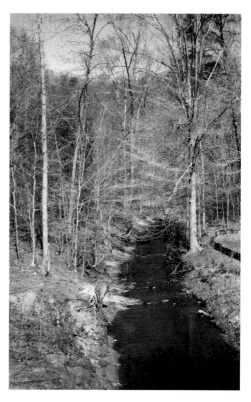

Accokeek Creek in Stafford County, along which Washington's father owned an active iron furnace. *Author photo.*

near modern (and aptly named) Colonial Forge High School, on Courthouse Road (Route 630) 2.7 miles west of the town of Stafford. Just past the school, those interested in finding the approximate location of the furnace complex can turn south on Woodcutters Road, which crosses Accokeek Creek in 0.6 miles, and the creek is clearly visible from the bridge.

Finally, upon the death of his father, Lawrence, young George inherited the Ferry Farm and half ownership with his brother Samuel of a tract of land on Deep Run. This stream flows into the Rappahannock River from the north, about ten miles west of Falmouth, and now forms the border of Stafford and Fauquier Counties. The parcel consisted of 4,360 acres, and Lawrence Washington's will suggested that Mary take up residence there. She never did. George did not develop the property, and eventually, he conveyed it to a nephew in 1796. Much of this rural land can be seen today while driving on US Route 17 about four miles west of the Hartwood post office on the west side of the run in Fauquier County.

4

THE YOUNG SURVEYOR

The sudden death of his father in 1743 and the resulting financial constraints his mother faced prevented George Washington from obtaining the formal education in England common among Virginia's landed gentry, which his older half brothers, Lawrence and Augustine, had already received. After briefly flirting with a nautical career in the British Royal Navy at his brother Lawrence's strong suggestion—but which his mother rejected—young George settled on another occupation deemed respectable for sons of minor gentry of limited means: land surveying. He had learned the basics of surveying as a youth, and part of his father's estate included some basic surveying instruments. With a key introduction to the aristocratic Fairfax family by Lawrence, George began his career in surveying and land acquisition that he pursued vigorously all his life. He eventually surveyed over sixty-five thousand acres from 1747 to 1799.

Lawrence became the chief influence in George's life once the latter began to spend time with his older sibling by the mid-1740s at Mount Vernon, the name Lawrence had given the lands he had inherited along Little Hunting Creek in the newly formed county of Fairfax. Lawrence had served as an officer commanding Virginia troops in the disastrous British expedition against the Spanish fortress at Cartagena (in modern-day Colombia) during the War of the Austrian Succession (1740–48). He named his estate after his commander, Royal Navy vice admiral Edward Vernon, with whom he was impressed. Upon his return to Virginia in 1742, Lawrence received an appointment as adjutant of the Virginia militia,

with the rank of major, from colonial governor William Gooch. George admired his brother's military service and rank, which later influenced his own inclination toward arms as a profession.

With the strong desire for land in Virginia among the colony's elites as well as new immigrants pouring into the sparsely populated backcountry from Pennsylvania and abroad in the 1740s and '50s, the need for measuring, marking and authenticating land transactions was acute. Surveyors spent much of their time in the field, which gave them the opportunity to see rich lands on the frontier for their own future purchase. Moreover, as Washington came to see, involvement in surveying and land speculation facilitated valuable patronage from wealthy planters who needed his services. As the modern editors of George Washington's published papers have noted, "[S]urveying was a respectable occupation for a young Virginian in 1749, roughly on par with law, medicine, the church, or military service, and most of the surveyors were drawn from the Virginia gentry."

THE FAIRFAX CONNECTION

It was his brother Lawrence's connection with the powerful Fairfax family in Northern Virginia that allowed George to begin his surveying career in his teenage years. "[T]o that family I am under many obligations," George wrote appreciatively in 1755. In 1743, Lawrence married Anne Fairfax, the vivacious fifteen-year-old daughter of Colonel William Fairfax and his late wife, Sarah. Colonel Fairfax was the Virginia land agent of his wealthy Oxford-educated first cousin Thomas, sixth Lord Fairfax, Baron of Cameron. Eventually taking up permanent residence in Virginia—a unique step for a British peer—Lord Fairfax owned the vast land grant in Virginia known as the Northern Neck. This tract of over five million acres originally granted in 1649 by King Charles II (at the time he was the Prince of Wales in exile) eventually came down to Fairfax in its entirety from his mother's family, the Culpepers, in 1719, though many disputed the title in England and in Virginia. It consisted of the territory between the Potomac and the Rappahannock Rivers, extending into the mountainous western frontiers to the sources of both rivers. Lord Fairfax derived income from this grant by selling and renting the land he owned. When his Lordship moved his residence to Virginia in 1747, he initially lived at Belvoir plantation, which had been established by William six years earlier close to Mount Vernon.

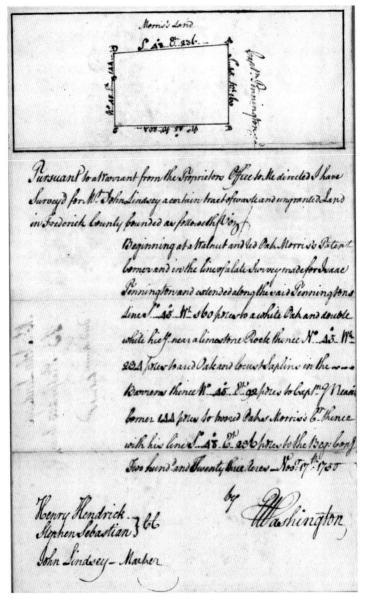

George Washington completed this signed Frederick County survey in 1750. *Library of Congress.*

Several years later, his Lordship moved to the lower (northern) Shenandoah Valley, where he maintained a semi-isolated existence until December 1781, when the old proprietor died at age eighty-eight.

In order to help sell their property on the Virginia frontier, the Fairfax family turned to the young brother of their in-law and neighbor for surveying land. In 1748, George Washington accompanied a survey party led by Lawrence's brother-in-law George William Fairfax, son of Colonel Fairfax and assistant land agent for the Northern Neck. This month-long expedition into the increasingly populated Shenandoah Valley—a region Washington would come to know quite well during his early military service—gave the young surveyor invaluable experience in wilderness travel and assessing land. The following year, the seventeen-year-old Washington received an official appointment as the first surveyor for the newly formed Culpeper County, then a barely settled backcountry region east of the Blue Ridge Mountains. His appointment was probably arranged by William Fairfax, who at the time sat on the royal governor's council, a board of twelve influential men that acted as advisors, a high court and the upper house of the legislature. His first survey was completed two days after he took his oath, for four hundred acres along Flat Run, now in Orange County.

Washington's survey of the land on which Alexandria was founded in 1749. Note riverside locations of warehouses on the right. *Library of Congress.*

The following year, he resigned this position but continued to survey professionally for several more years, primarily for Lord Fairfax in the Shenandoah Valley and westward into what is now the panhandle of West Virginia. Washington surveyed almost two hundred Northern Neck land tracts by November 1752, totaling more than sixty thousand acres. He continued to survey his own lands in Virginia until November 5, 1799 (only six weeks before his death), at which time he was surveying property on Difficult Run, in western Fairfax County. About one hundred of his well-rendered surveys and maps are still known to exist.

A number of tracts surveyed by Washington can easily be found by modern explorers. The Flat Run survey is now in Orange County near the Wilderness Battlefield, where State Route 3 crosses the stream about two and a quarter miles east of Germanna Community College. Washington completed two known surveys of Alexandria, one showing only the land without a plat, the other with town lots and streets included. In addition, there are several surveys Washington made of Mount Vernon and his several farms nearby, particularly along Little Hunting Creek, on the George Washington Memorial Parkway.

BELVOIR AND GREENWAY COURT

When George Washington was not surveying on the Virginia frontier, he resided primarily at Mount Vernon with Lawrence. During that time, Lawrence's health began to decline, and George accompanied him in 1751 on what was intended to be a restorative trip to Barbados. The younger brother returned to Virginia in early 1752, followed by Lawrence in June of that year. The Caribbean journey did little good, as Lawrence succumbed to tuberculosis the following month (as did all his four children over time), a disease he likely contracted while in military service in the 1740s. After the 1754 death of Lawrence's only remaining child, Sarah, and the remarriage of his wife, Anne, George leased the land and slaves at Mount Vernon from her. Upon Anne's death in 1761, the estate became George's property outright, and he called it his home until his own death thirty-eight years later.

Living at Mount Vernon put George Washington in proximity to the Fairfax home, Belvoir, four miles down river, set atop a high bluff on the Potomac's west side on a 2,200-acre plantation. Built about 1741 by William Fairfax, the large brick house was an elegant and imposing dwelling.

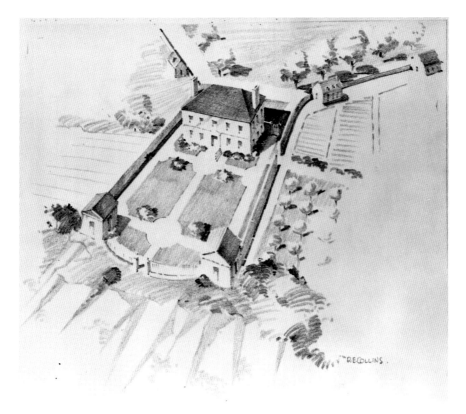

Conjectural view of Belvoir, the Fairfax family's Georgian mansion destroyed by fire in 1783. No contemporary image exists. *Library of Congress.*

Washington wrote that it was "two Stories high, with four convenient Rooms and a large Passage on the lower Floor, five Rooms and a Passage on the second, and a Servants Hall and Cellars below, convenient Offices, Stables, and Coach House adjoining, as also a large and well furnished Garden, stored with a great Variety of valuable Fruits, in good Order." It was "one of the most beautiful seats on the river," and included a large flower garden inspired by one in Stirling, Scotland.

After Colonel Fairfax died in 1757, the estate passed to his son George William, longtime friend of Washington and resident of Belvoir, along with his amiable wife, Sarah "Sally" Cary Fairfax, of a prominent Hampton family. Much speculation has been raised over George Washington's relationship with Sally, but it seems clear that he was in love with her and that she was at least flattered by his attentions. Whether there was more than flirting between the two is not definitively known, but during the

Site of the house at Belvoir along the Potomac River, now within the U.S. Army's Fort Belvoir in Fairfax County. *Richard C. Maass II photo.*

1750s, the unmarried George was a frequent guest at Belvoir. Nevertheless, the Fairfaxes moved back to England in 1773 to handle property matters related to a large inheritance; in the whirlwind of armed revolution in the colonies beginning two years later, Sally and George William remained loyal to Britain and never returned to Virginia. In 1774, George William asked Washington to sell some of his slaves and other property and to rent the house if possible, and that year the furnishings were auctioned. In 1783, Belvoir burned in a fire and was never rebuilt. That year, Washington described the home's ruins to his friend: "The dwelling house & the two brick buildings in front, underwent the ravages of the fire; The walls of which are very much injured: the other Houses are sinking under the depredation of time & inattention, & I believe are now scarcely worth repairing. In a word, the whole are, or very soon will be a heap of ruin." George William Fairfax died in England in 1787, and Sally Fairfax died there in 1811, never having seen Virginia or Washington again.

Today most of the Belvoir estate is within the bounds of Fort Belvoir, an active U.S. Army post. Those seeking to explore the George Washington–

related sites there must contact the fort's visitor center at Tulley Gate, located off US Route 1, for information about how to enter the installation. The visitor center may be reached at (703) 806-4892. If access to the post is properly obtained, tourists can see the ruins of the once grand mansion by traveling from Tulley Gate to the end of Belvoir Drive, heading toward the officer's club. Before reaching the club, turn right on Fairfax Drive, then left on Forney Loop to the trailhead next to a small playground. The ruins are a short, level walk toward the Potomac River, and the grave site of William Fairfax and his second wife, Deborah, are nearby.

In addition to Belvoir, George Washington also came to frequent another Fairfax family estate during his travels in northern Virginia. Bryan Fairfax, George William's younger half brother, was a close friend of George Washington beginning in the latter's surveying career, and the two often traveled together on expeditions. Bryan's father had obtained a tract of approximately 5,500 acres along the east side of Difficult Run in northern Fairfax County, which he named Towlston Grange and left to his son (along with over one dozen slaves there). Bryan lived at the plantation from 1768 to 1790 in a small frame house erected in 1767 with stone chimneys on each gable end. Soon after moving to his new home, he invited Washington to visit him there for "three or four days or more—I can't say my hounds are good enough to justify an invitation to hunt," he lamented. His first marriage was to Elizabeth Cary, the sister of Sarah Cary Fairfax.

Both George and Martha Washington later served as godparents to Bryan and Elizabeth's son Ferdinando at his baptism in 1790 at this home. Bryan Fairfax later became an ordained Episcopal minister and was rector of Christ Church in Alexandria from 1790 to 1792. For years, he refused to assume the title of Lord Fairfax, to which he was entitled. Washington later bought 275 acres on Difficult Run from Bryan Fairfax where the bridge of the main road to Leesburg (modern Route 7) crossed it just east of Colvin Run Mill, now a Fairfax County park. He bought the land as a stopping point for his teams and wagons traveling between Mount Vernon and his Shenandoah Valley property northeast of Winchester along Bullskin Run.

Another nearby Fairfax family connection is Ash Grove, overlooking the Old Courthouse Spring Branch in today's Tysons Corner area. The original dwelling was built by Bryan Fairfax for his son Thomas around 1790 on land originally part of Towlston Grange. The house sat on the former site of a log hunting lodge called the White House, dating back to the 1750s. The property was eventually sold out of the family just prior to the Civil

Bryan and Elizabeth Fairfax lived for years at Towlson Grange in Fairfax County, close to modern Tysons Corner. *Author photo.*

War. The 1790 house burned to the ground in 1960 and was reconstructed using documentation from the Historic American Buildings Survey, family recollections and early photographs.

Both of these houses can be found today among the sprawl of northern Virginia. The original Fairfax house at Towlston Grange, privately owned, can be seen at 1213 Towlston Road, after turning north off of Route 7 (Leesburg Pike) almost three miles west of Route 123 (Chain Bridge Road) in Tysons Corner. It is on the right side of the street, just past Hidden Creek Drive (on the left). Ash Grove is situated at the intersection of the Dulles Toll Road and Route 7, and can be reached from Ash Grove Lane, off of Leesburg Pike after turning west onto Westwood Center Drive. It has been owned by the Fairfax County Park Authority since 1997. It consists of twelve acres, the reconstructed dwelling house and two eighteenth-century outbuildings.

As a frontier surveyor for Lord Fairfax, Washington frequently visited his employer's rustic residence, Greenway Court, about twelve miles south of Winchester and named for a Culpeper estate in England. Fairfax lived

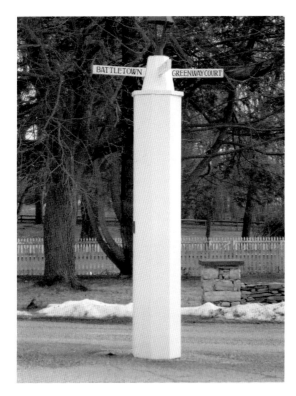

Left: A reconstruction of the white sign post directing travelers to Lord Fairfax's home, Greenway Court. *Author photo.*

Below: The Fairfax land office at Greenway Court near Winchester, still standing today. *Library of Congress.*

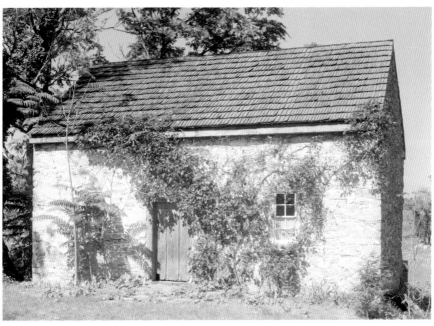

The tomb of the esteemed Lord Fairfax is located today at Christ Episcopal Church in Winchester. He died in 1781, the only English lord to take up permanent residence in the United States. *Author photo.*

at Greenway Court to better oversee his western lands and defend his ownership against rival claimants. He apparently intended to build a grand manor house on his own lands but never did so. Rather, he lived in what was essentially a large hunting lodge (intended originally as a steward's residence) raised around 1752, a one-and-a-half-story timber dwelling with brick chimneys at each end. The sloping roof in the front of the house provided for a long verandah, and within it were four dormer windows. The house burned in the early nineteenth century, and no known authentic depiction

of the dwelling or its ruins has been found. At the site, Lord Fairfax operated his land office, a limestone building measuring twenty-eight feet by eighteen feet built about 1762 that survives to this day, having been initially restored in 1930.

In the eighteenth century, Greenway Court was a well-known landmark in the backcountry and appears on most period maps, not only because Lord Fairfax resided there but also from the series of tall white finger posts he erected to guide travelers to the house from the main road nearby—hence the name of the nearby hamlet of White Post. Lord Fairfax died at his lodge on December 8, 1781. Although he remained loyal to the British Crown, Virginia patriots did not harass him during the Revolutionary War, most likely due to his advanced age and his prudent low political profile during the years of conflict. His tomb is now on the grounds of Christ Episcopal Church, 140 West Boscawen Street in downtown Winchester.

The site of Greenway Court and the extant eighteenth-century land office is located on private property in modern Clarke County and is not visible from the county road. Those wishing to see the general area of the Fairfax estate and lands may drive south from White Post (which is on US Route 340) on White Post Road (Route 658). The old lodge stood on the west (right) side of the road about one half mile south of Carters Line Road (Route 627).

ON THE FRONTIER

Washington spent much of his later teen years traveling between the large riverside estates on the Potomac—Mount Vernon and Belvoir—and the wilderness of northwestern Virginia, surveying land for Lord Fairfax. During the course of his backcountry employment, he traveled to many frontier towns, taverns, ferries and fords

The northern Shenandoah Valley, area of Washington's French and Indian War service. *New York Public Library.*

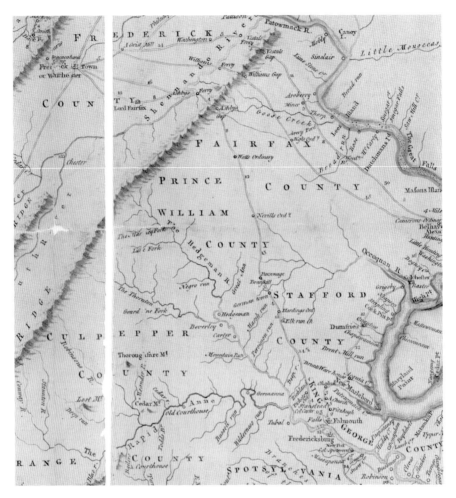

Late eighteenth-century northern Virginia. *Library of Congress.*

over narrow muddy roads that were often little more than woodland paths. Surprisingly, even among the suburban sprawl of modern northern Virginia and the ever-expanding highway systems there, traces of the colonial world and landscape of Washington's era can still be found today. One example of a surveying trip he took to the Shenandoah Valley will illustrate some of Washington's travels and the modern accessibility of related sites and roads that remain in existence.

In the spring of 1748, the sixteen-year-old Washington joined a surveying party to the frontier, his first encounter with the Virginia backcountry beyond the Blue Ridge Mountains. He accompanied George

William Fairfax and others to survey Lord Fairfax's properties along the South Branch of the Potomac River, now in West Virginia, in order to sell tracts and confirm land titles. On March 11, 1748, Washington and young Fairfax began their horseback journey to the west, intending to meet up with the expedition's chief surveyor on their way. Washington began his diary that day by beginning an account of what he called "A Journal of my Journey over the Mountains."

Washington recorded on the trip's first day that he "began my Journey in Company with George Fairfax Esqr.," and that they "travell'd this day 40 Miles to Mr. George Neavels in Prince William County." Most likely the pair rode south from Belvoir, crossed the Occoquan River by ferry near its mouth at Colchester (a town opposite modern Woodbridge, now disappeared) and headed west.

Their route took them by a site related to many fables surrounding Washington written in the early nineteenth century, Bel Air Plantation. Now thought to be the oldest home in Prince William County, this one-and-a-half-story brick house on a raised stone basement was built above Neabsco Creek in 1740 by Charles Ewell, owner of some ironworks on the nearby Occoquan River. In 1795, Ewell's granddaughter Frances married Mason Locke Weems, a parson, Washington's earliest biographer and fabricator of the famous "cherry tree fable." Weems lived at Bel Air for a time and is buried there, but the exact spot of the grave is now unknown. The well-preserved house is privately owned, located in Woodbridge on General Washington Drive next to St. Margaret's Episcopal Church, but can only partially be seen from the street.

Fairfax and Washington rode along what is now Minnieville Road to today's Independent Hill, on Route 234, then proceeded on the south fork of the Dumfries Road to Prince William County Court House. At that time the court building was located on Cedar Run, where present-day Aden Road (Route 646) crosses the run six miles east of Nokesville. Built in 1743, this was the county's courthouse until 1759, when the court moved to Dumfries upon the creation of Fauquier County to the west. The building is no longer standing but was situated in the northwest corner of Marine Corps Base Quantico, south of Aden Road, not accessible to the public.

From here, Washington and Fairfax continued west a dozen more miles to the ordinary and watermill operated by George Neavil on the upper reaches of Cedar Run. This tavern was at the important crossroads of the Carolina Road (running north–south) and the Dumfries Road (Routes 234 and 646), leading west from that port town on Quantico Creek. Today this hamlet

Bel Air, the oldest extant dwelling in Prince William County and once home to Parson Weems. *Library of Congress.*

in Fauquier County is called Auburn, at the junction of Routes 602 and 670. The foundation of an eighteenth-century mill still stands there next to Cedar Run, and the ordinary was located nearby. It is shown on several early Virginia maps as well, and a Civil War skirmish was fought here in 1863.

Prince William County's chief surveyor James Genn met Washington and Fairfax at the ordinary the next morning, and the party set out early along

Watt's Ordinary along Washington's route to the Blue Ridge gaps, now in Fauquier County near Delaplane. *Author photo.*

the Dumfries Road (modern Route 605, then US Route 17) northwest to the distant Blue Ridge Mountains. En route, the group passed—and most probably were refreshed at—Watt's Ordinary, a small tavern standing on the west side of the road about three-fifths of a mile east of modern Delaplane, and clearly visible from the highway on a small knoll. This is a circa 1760 structure then owned by Thomas Ashby on the site of an earlier 1750s tavern (and was later called Ashby's Tavern). Also on the site are a mid-eighteenth-century stone dairy and a meat house. The tavern was at the intersection of the road from Neavil's and the old colonial road (now Route 55) leading directly west to the Shenandoah Valley and Front Royal.

On the same day (March 12), the surveyors "travel'd over the Blue Ridge to Capt. Ashbys on Shannondoa River," noted Washington, a distance of over thirty miles. They crossed the mountains at what is still known as Ashby's Gap, where modern US Routes 17 and 50 traverse the Blue Ridge around one mile west of Paris. Coming down the west slope of the mountain, Washington and the others arrived at Ashby's Ferry on the Shenandoah River. He noted in his journal that one day "we went through the most beautiful grove of sugar trees [maples] and spent the best part of the day admiring the trees and richness of the land."

On the fifteenth, Washington recorded the difficulties of a newcomer to the frontier in a passage about learning the basics of wilderness living. That day, the men endured heavy rain until early afternoon and

> *worked hard till Night & then returnd to Penningtons* [near present-day Berryville] *we got our Suppers & was Lighted in to a Room & I not being so good a Woodsman as the rest of my Company striped my self very orderly & went in to the Bed as they call'd it when to my Surprize I found it to be nothing but a Little Straw—Matted together without Sheets or any thing else but only one Thread Bear blanket with double its Weight of Vermin such as Lice Fleas &c. I was glad to get up (as soon as the Light was carried from us) & put on my Cloths & Lay as my Companions. Had we not have been very tired, I am sure we should not have slep'd much that night. I made a Promise not to Sleep so from that time forward chusing rather to sleep in the open Air before a fire as will Appear hereafter.*

After spending time around the frontier town of Winchester in Frederick County, a few days later, the party reached the natural warm springs called Bath, later Berkeley Springs, now in Morgan County, West Virginia. (Washington would later come to own two lots in the town and

Ashby's Gap in the Blue Ridge Mountains, through which Washington frequently traveled into the Shenandoah Valley. *Author photo.*

once accompanied his brother Lawrence there for healing.) The men spent several weeks in the mountains, and on April 12, Washington, Fairfax and several others began their return journey. From the Winchester area they rode east along a trail that is now Route 7, crossed the Shenandoah River by ferry and passed through Williams Gap in the Blue Ridge, later called Snicker's Gap, at modern Bluemont (just off Route 7). Due to the rugged, disorienting wilderness of the area Washington noted that the party "after Riding about 20 Miles...lost ourselves & got up as High as Ashbys Bent [Gap]." They did, however, "get over Wms. Gap that Night and [progressed] as low as Wm. Wests [ordinary] in Fairfax County 18 Miles from the Top of the Ridge." Here Washington referred to West's Ordinary, on the Little River at modern Aldie in Loudoun County, which they reached by riding along a forest trail from the mountains along what is now the Snickersville Turnpike, Route 734. The tavern was a long one-story building with a low-slung roof, and although it is no longer extant, it appears to have been standing as late as 1925.

Soon the party was back on the banks of the Potomac. On the next day, April 13, Washington wrote that "Mr. Fairfax got safe home and I myself safe to my Brothers," at Mount Vernon, "which concludes my Journal."

BULLSKIN RUN AND CHARLES TOWN: THE "MOUNTAIN QUARTER"

As a busy surveyor for Lord Fairfax, during the course of his duties, Washington had many opportunities to explore lands he considered acquiring for himself through grants, bounties and purchases. He was also able to scout land tracts on the distant frontier during his French and Indian War military service in the 1750s. Eventually, he acquired over sixty thousand acres, including Mount Vernon; several town lots in Alexandria, Winchester, Bath and Fredericksburg; thousands of acres along the Ohio River and its tributaries; and even land along the Mohawk River in Upstate New York.

Much of Washington's property was in northern Virginia and the valleys of the Shenandoah and Potomac Rivers. One such tract can be easily found today along quiet backroads five miles southwest of Charles Town, West Virginia, then part of Frederick County, Virginia. In October 1750, Washington obtained the first of several grants from Lord Fairfax for land along Bullskin Run. This is an easterly flowing stream that empties into the

Shenandoah River about fourteen river miles upstream from Harpers Ferry. His half brother Lawrence had previously acquired several thousand acres in this area, too, having been impressed by the area's fertility, drainage and suitability for settlements. By March 1751, George was in possession of 1,861 contiguous acres on Bullskin Run by way of four separate grants and purchases, which he often referred to as his "mountain quarter." On this farm of flat bottomland and low hills Washington grew tobacco, oats, corn and wheat with slave labor and kept hogs and cattle there as well. Much of this land he leased to small farmers, whom he required to erect houses and barns on their plots. During his French and Indian War campaigning, his brother John Augustine Washington managed George's farm on Bullskin Run, and he also had a resident overseer there along with a blacksmith. Washington frequently visited his Bullskin property and stayed at his house there called Rock Hall, on the south side of the creek. This dwelling was a two-story stone house built as early as 1755 and later enlarged by Washington. It was mostly destroyed by a kitchen fire in 1906.

The Washington lands along Bullskin Run can be best viewed by driving along West Virginia Route 13 (Summit Point Road), on the north side of the stream between the village of Summit Point and the hamlet called Wheatland, on US Route 340 south of Charles Town. Rock Hall was south of the run, approximately one mile east of Summit Point.

Washington's experiences in the lower (northern) Shenandoah Valley as a surveyor and later as a soldier not only impressed him enough to buy land there, but it also influenced his brothers and their families to do so as well. Particularly in modern Jefferson and Berkeley Counties in West Virginia's eastern panhandle south of the Potomac River, members of the Washington family moved there to take up lands, all not far from Charles Town.

One of the easiest Washington family farms to find today is Harewood, although it is privately owned and not a public site. Nonetheless, the impressive two-story fieldstone Georgian house can be viewed on the south side of West Virginia Route 51, about three miles west of Charles Town. The main house is one room deep and sixty-five feet across, with a southern kitchen wing connected to the dwelling by a hyphen. (The north wing was added in the 1950s, and the porches are not original.) The house was built in 1770 for George's younger brother Samuel Washington, formerly of Chotank Creek in King George County, Virginia. The house was likely constructed by John Ariss of Westmoreland County, who also built Kenmore in Fredericksburg for Washington's sister Betty and her husband, Fielding Lewis. Although always something of a financial drain on his family, by the

time of his death in September 1781, Samuel had accumulated 3,800 acres of plantation lands, worked by dozens of slaves.

In the waning years of the 1700s, a happy celebration took place in the parlor of this house. After Samuel Washington's death, Harewood came into the possession of his son George Steptoe Washington, who had married Lucy Ann Payne of Hanover County, Virginia. Lucy's widowed sister Dolley married James Madison at Harewood in 1794. Later, the future king of France, Louis Philippe I, lived for a brief period with his brothers at Harewood while in exile following the French Revolution. The 264-acre property has remained in the Washington family to this day.

John Ariss also built Fairfield in 1768 in nearby Berryville for Samuel and George Washington's cousin Warner Washington. Located in Virginia several miles south of Charles Town on the south side of US 340 (Lord Fairfax Highway) on Long Marsh Run, the private home is difficult to see except in wintertime. This dwelling, like Harewood, is also of fieldstone construction in the Georgian style and two and a half stories with five bays. Warner lived here with his wife, Hannah Fairfax Washington, daughter of William Fairfax of Belvoir, and the couple was visited there by George Washington on several occasions. Warner died in 1791, and after Hannah's death in 1804, the family sold the property a few years later to William Page and his wife, Anne Lee Page, the sister of Henry ("Light Horse Harry") Lee III, of Revolutionary War fame. Of note, Ariss asked in his final will to be buried at Fairfield upon his death.

George Washington's youngest brother, Charles, also moved to the lower Shenandoah Valley from Fredericksburg and was the founder and namesake of Charles Town. His home was called Happy Retreat, a Federal/Greek Revival style home now on twelve acres on the town's south end near Evitts Run. Charles and his family moved there in 1780 and founded the town six years later. The dwelling was significantly enlarged in the 1830s by a subsequent owner. The property is now in the care of the Friends of Happy Retreat, a nonprofit founded in 2006 to preserve the house and surrounding grounds located at Mordington Avenue and the south end of Blakeley Place. More information about visiting the Washington home is available at www.happyretreat.org.

The descendants of the Washingtons later built and occupied many other fine homes in the Charles Town area, some of which have survived. One additional house to be noted here is Cedar Lawn, just south of Samuel Washington's Harewood. It was built in 1825 by John Thornton Augustine Washington, a grandson of Samuel. The house is a two-story

Samuel Washington's limestone home, called Harewood, just west of Charles Town, West Virginia. James and Dolley Madison were married here in 1794. *Author photo.*

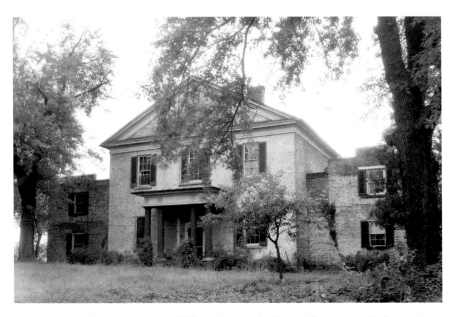

An early twentieth-century image of Happy Retreat in Charles Town, once the home of George Washington's youngest brother, Charles, and his family. *Library of Congress.*

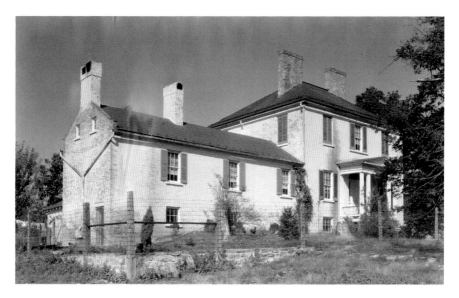

Cedar Lawn was built by a descendant of George Washington near Charles Town in 1825 and still stands today. *Library of Congress.*

Federal-style home with a hip roof and two central chimneys, along with a Greek Revival front porch facing east. The hilly plantation land north of the house was the site of a Civil War skirmish in August 1864 between Confederate troops under Lieutenant General Jubal A. Early and Union forces led by Major General Philip Sheridan. The imposing home is situated on the west side of Route 51/1 (Earle Road), 1.4 miles south of Route 51 (Middleway Pike), in Jefferson County. Although privately owned, the house is close to the road and can be clearly seen.

"My Inclinations Are Strongly Bent to Arms"

The French and Indian War

The Young Colonel and the Ohio Country

When George Washington returned to Virginia from his trip with Lawrence to Barbados in 1752, Britain and its North American colonies were steadily becoming embroiled in an international crisis with France over land. The territory in question was called the Ohio Country, an area of rich soil west of the Appalachian Mountains along the Ohio River, where fortunes could be made in land speculation and trade with the Indians. A number of prominent Virginians (including Lawrence Washington) had organized the Ohio Company of Virginia in 1748 and sought to claim half a million acres in the region for its investors. The area had yet to be populated by British colonists, and due to its mountainous terrain and lack of roads, it was difficult to reach.

These obstacles, however, were not the greatest barrier Anglo-Americans faced in the settlement of the Ohio Country. A huge swath of territory between the Appalachians and the Mississippi River was claimed by France and occupied by Indians. French forces had pushed west from the city of Quebec and were feverishly building a string of frontier forts from Lake Ontario, down the Ohio River and on to the Mississippi River and New Orleans. In the early

FRENCH AND INDIAN WAR

MAP OF THE SCENE OF OPERATIONS.

The northern theater of the French and Indian War, with Forts Cumberland, Necessity and Duquesne shown at lower left. *Lossing,* Harper's Encyclopedia of United States History.

1750s, when French military forces began constructing forts at and around the Forks of the Ohio—where the Monongahela and Youghiogheny Rivers converge to form the Ohio River at the site of modern Pittsburgh—Virginians became alarmed, and began preparing for conflict.

In November 1752, Washington received an appointment from Virginia's Lieutenant Governor Robert Dinwiddie as militia adjutant of the colony's southern district, encompassing a huge area from the James River to the North Carolina border. The post (soon switched to the more convenient northern district) came with a £100 annual salary and the rank of major, a remarkable

favor from Dinwiddie considering the young man's complete lack of military experience and his age. Perhaps he wanted to appoint an active young man who was familiar with the colony's frontier, where friction with the French was likely to start. The royal governor also gave Washington the task of delivering a message to French forces in late 1753, demanding they withdraw from the disputed Ohio River Valley. Washington made a grueling winter journey from Williamsburg almost to the shores of Lake Ontario but was unsuccessful in getting the intractable French officers there to heed Virginia's confrontational warning.

George Washington in his French and Indian War officer's uniform. *Library of Congress.*

In April 1754, French troops seized the forks, dispersed a small Virginia force there and built Fort Duquesne. Virginia had earlier raised a regiment of provincial soldiers and placed Washington—who had recently been promoted to the rank of lieutenant colonel—in command of it. After substantial difficulties raising, arming, equipping and paying the troops at Winchester, Washington brought several hundred of them to the frontier in western Pennsylvania and built a hasty log stockade he dubbed Fort Necessity. After a bloody day-long battle with the French and their Indian allies in a steady rain, the young colonel was forced to surrender the post on—of all days—July 4.

Despite the setback, Washington won praise from the House of Burgesses and his neighbors for his efforts and endurance. Still, Dinwiddie decided to reorganize Washington's Virginia Regiment into several independent companies to be led by captains and disperse them along the frontier, with no commanding officer in overall charge of them. Washington took this as a slight to his honor and resigned his commission in October 1754 rather than be demoted. The next year, the British decided to launch a campaign against

Fort Duquesne with a force consisting of British regulars, Indian scouts and colonial troops—including men from the Virginia Regiment. Washington volunteered to serve as an aide to the campaign's commander, General Edward Braddock, who landed his redcoats and began his campaign from Alexandria in early 1755. The young Virginian's goal was "to attain a small degree of knowledge in the Military Art," in his own words, by setting out with the expedition. Washington joined Braddock's forces in April.

General Braddock made his headquarters for several weeks in April at the home of John Carlyle, on Fairfax Street in what is now Old Town Alexandria. Prior to the campaign, in the home's dining room was held what Carlyle called the "Grandest Congress" of five colonial governors with the general in order to plan military operations against the French in 1755. Here young Colonel Washington "had the honour to be introduced to the Governors," he wrote to William Fairfax, "and of being well received by them all." Braddock remained a guest of John Carlyle's for three weeks but seems to have worn out his welcome. Carlyle found the British officer "too fond of his passions, women and wine."

The Scottish-born Carlyle was one of the port town's founding trustees, a successful merchant and a member of the Ohio Company. He was also

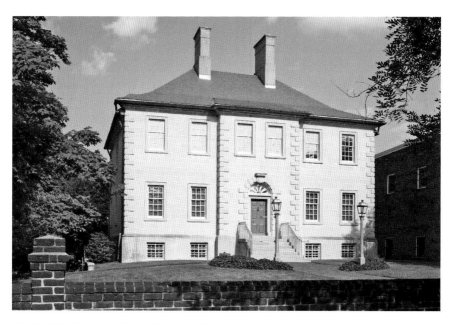

The Carlyle House in Alexandria, one of the city's oldest surviving eighteenth-century structures. *Carlyle House Historic Park, Alexandria.*

the husband of Sarah Fairfax, daughter of William Fairfax of Belvoir, and thus well connected. More importantly to Braddock and Washington, he was commissioned by Dinwiddie as commissary of the Virginia troops for the campaign. Although Major Carlyle hoped to earn £500 per year in this position, he would soon come to call it "the most troublesome one I've had."

Carlyle's large Georgian-era Palladian house was built starting in 1751 and is now one of the oldest buildings in Alexandria. Made of stone and situated along the town's original waterfront on one acre, it signified Carlyle's wealth, status and business pursuits. John and Sarah moved into the house in the summer of 1753, and nine slaves lived at the house by the time Carlyle died in 1780, his wife, Sarah, having died nineteen years earlier. The property remained in the family until 1827. Of note, recent research has suggested that in the late fall of 1757, George Washington recuperated from a debilitating illness during the war at the Carlyle home, worn out from his burdensome duties on the Virginia frontier.

Today, the house has been fully restored to its striking colonial splendor, and it has been a property of the Northern Virginia Regional Park Authority since 1970. Public guided tours of the house and grounds are given year round at 121 North Fairfax Street in Old Town, and many public events are

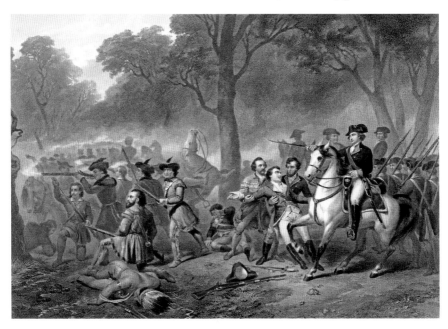

Nineteenth-century dramatic depiction of Braddock's 1755 defeat, with Washington riding a white horse in action (*on right*). *Library of Congress.*

held there. More information can be had at www.novaparks.com/parks/carlyle-house-historic-park or by calling (703) 549-2997.

General Braddock and most of his troops marched west from Alexandria toward Virginia's frontier beginning on April 27, 1755. Washington accompanied the general on his route across northern Virginia and on toward Fort Duquesne. After a strenuous march over countless mountains, creeks and bogs, the advance element of the column met with disaster and near annihilation at the hands of the French and Indians only a few miles from their objective on July 9. Most of Braddock's soldiers were killed or wounded, and the general was mortally injured as well. Despite the defeat, Washington won high praise from Virginians for his coolness under fire and "Heroick virtue," and he considered himself lucky to have avoided being wounded. "I escaped unhurt, although death was leveling my companions on every side of me," Washington wrote his mother soon after the survivors reached safety. After helping to regroup colonial forces at Fort Cumberland (today's Cumberland, Maryland), Washington returned to Mount Vernon on July 26.

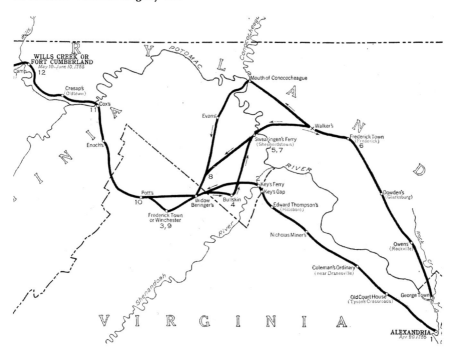

General Braddock's army and Washington moved from Alexandria to Fort Cumberland before meeting with disaster near modern Pittsburgh in 1755. George Washington Bicentennial, *Vol. 1.*

When they set out, most of Braddock's army, including the Virginia Regiment, marched west from Alexandria toward the Shenandoah Valley by a route that can still be traced today and easily driven by those wishing to follow Washington's and the army's progress across northern Virginia. It was also the route taken by Washington to and from Alexandria on numerous occasions after the campaign, when he assumed command of Virginia forces in the valley through 1758. The path is approximated by Route 7, but much of it deviates off that modern road (Leesburg Pike).

The army left Alexandria from its encampment (west of current Washington Street, north of Oronoco Street) by way of modern Braddock Road. The column then turned northwest on to what is now King Street (Route 7) at Quaker Lane but did not march on today's West Braddock Road from this point, despite the street's name. The army's first campsite after leaving the encampment was the site of the original Fairfax County Court House from 1743 to 1754, situated on Freedom Hill (now a county park) near the junction of today's Chain Bridge Road (Route 123) and Old Courthouse Road, at Tysons Corner.

The following day, the men marched to Coleman's Ordinary, a prominent tavern on the east bank of quick-flowing Sugarland Run. The approximate site of the tavern is on high wooded ground near the creek at the end of Sugarland Road (Route 604), a third of a mile west of the Fairfax County Parkway and half a mile south of Route 7. Nothing remains of the tavern, and the original road is now hard to discern within the bounds of Sugarland Run Stream Valley Park.

From Coleman's, the soldiers and George Washington proceeded on what was often called the Vestal's Gap Road (which ran roughly parallel to and just south of today's Route 7). Some of the best preserved remnants of this eighteenth-century road can be clearly seen within Claude Moore Park, accessible by driving less than a mile south of Route 7 on Cascades Parkway and entering the park on the left on Old Vestals Gap Road. Open since 1990, Claude Moore Park is a Loudoun County facility with a visitor center, trails and picnic sites as well as the Loudoun Heritage Farm Museum. The original road is located close to the park's entrance. More details are at www.loudoun.gov.

Braddock's route then went by way of Minor's Ordinary (called Leesburg from 1758) to Thompson's plantation, now at Wheatland on State Route 9 (Charles Town Pike), after the troops turned off modern Route 7 at Paeonian Springs. After passing through a narrow gap at what is now Hillsboro and Short Hill Mountain, the troops crossed the Blue

Braddock's route to Winchester crossed Sugarland Run here at Coleman's Ordinary, a Fairfax County tavern well known to Washington from his frontier travels. *Author photo.*

Ridge Mountains at Keyes's (also called Vestal's) Gap into modern West Virginia, still on Route 9. The route then crossed the Shenandoah River by a ferry at a site at the end of West Virginia Route 32/1, just downstream from Route 9. Within West Virginia, Washington rode west along the road (West Virginia Route 51) near his Bullskin Run lands. Braddock and his column of redcoats and Virginians continued to march west by way of what is today Cumberland, Maryland, and then into Pennsylvania, cutting a rough forest road as they went to their eventual defeat.

The British disaster in the Ohio Country left Virginia's frontier vulnerable to Indian attacks and reprisals, particularly among the isolated farms in the Shenandoah Valley and the headwaters of the Potomac River.

A rare remnant of the Vestal's Gap Road at Claude Moore Park in northern Virginia, used by Washington and Braddock to reach the Shenandoah Valley and Winchester. *Author photo.*

"His Majesty's poor Subjects on the Frontiers…are left to the Mercy of an inhuman Enemy," warned Governor Dinwiddie a month after Braddock's defeat, "A Dismal Situat'n indeed!" The unexpected withdrawal of the

remaining British redcoats to Philadelphia in late July meant that colonial officials had to decide how to defend the backcountry with their own limited resources and few soldiers. Accordingly, Dinwiddie reestablished the Virginia Regiment in August 1755, with Washington back in command, holding the rank of colonel once again. His headquarters were in Winchester, a town of about sixty houses that one prewar traveler called "rather badly built." He served actively in the war until December 1758.

WAR COMES TO THE VIRGINIA BACKCOUNTRY

Once he returned to Winchester, Washington established his command post in a small log structure that stands today at West Cork and Braddock Streets. Colonel Washington used the office from the fall of 1755 until December 1756. The office now houses a small museum related to Washington's service in the war. The museum is an excellent starting point to explore Washington's French and Indian War experiences, and it is open to the public from April through October, operated by the Winchester-Frederick County Historical Society, www.winchesterhistory.org/society_museums.htm.

George Washington's frontier military headquarters during the French and Indian War has been preserved in Winchester on Cork Street. *Author photo.*

During his frontier service, young Colonel Washington spent about four years in Winchester, and many sites in that town can be identified today, although few from the 1750s are still in existence. These include the locations of the Red Lion Tavern, the town's military hospital and a jailhouse. A guide to these sites and others may be obtained from the Winchester-Frederick County Historical Society and the Washington Headquarters Museum.

While commanding Virginia's defenses, Washington oversaw construction of Fort Loudoun at Winchester, started in 1756. This defensive work—designed by the colonel—was the largest in Virginia during the war and completed in 1758. The fort served not only as a base for his troops in the northern Shenandoah Valley but also as a supply depot for the colony's forces on the entire frontier. This square fort with four corner bastions was made of log walls, filled with soil and stones and sat on a slight rise. Barracks for 450 soldiers were inside the walls. The young colonel wrote that "the Gate of the Fort Fronts the main Street in Winchester, & is distant ab[ou]t 150 or 200 Yards from the Town, and ab[ou]t 40 Feet higher with a gradual assent all the way on the Sides." Washington was eventually able to mount fourteen cannons at the fort by 1757.

The site of the fort is located at the intersection of today's Clarke and Loudoun Streets. Today, all but the fort's well has disappeared. Tours of the fort's location can be arranged by contacting the French and Indian War Foundation at fiwf.dsg@comcast.net.

Fort Loudoun was the largest of a string of forts built and garrisoned—though inadequately due to the colony's persistent recruiting woes—by Virginia's military forces along the lengthy frontier. An act passed in 1756 by the colony's House of Burgesses declared "that a chain of forts shall be erected, to begin at Henry Enochs [settlement], on Great-Cape-Capon [Caccapon]...and to extend to the South-Fork of Mayo-River, in the country of Halifax." These small forts ranged from near the Potomac River to the colony's border with North Carolina. After Braddock's defeat, Indian raids on the frontier increased markedly, often directed at settler farms and those traveling between forts. Colonial officials and military officers hoped the series of strongholds would allow militia, rangers and Virginia Regiment detachments to thwart the deadly attacks "of a crafty savage enemy." Of the numerous forts constructed according to the 1756 statute—almost all of which were wooden stockades near key trails, roads, rivers or settlements—several of the locations are still known today and can be discovered in Virginia's rural western counties, as well as West Virginia.

The site of Fort Loudoun on a hill immediately north of downtown Winchester is commemorated by several historical markers today. *Author photo.*

In the fall of 1756, Washington made an inspection tour of the colony's southern forts, riding south from Winchester on what he called a "jaunt" along what is today for the most part US Route 11, the "Great Wagon Road" from Philadelphia. Starting out in late September on horseback, his route took him south to Augusta Court House (now Staunton). Along the way he passed one of the numerous "house forts" in the valley, homes of settlers used as defensive posts in times of Indian raids. Now called Steele's Fort, the structure was made of an early log section from 1750 and a later limestone rock addition erected in 1754 on Moore's Creek in what is now northern Rockbridge County. The private home can be viewed today from Steele's Fort Loop by turning west off US 11 two miles south of Steele's Tavern onto Steele's Fort Road.

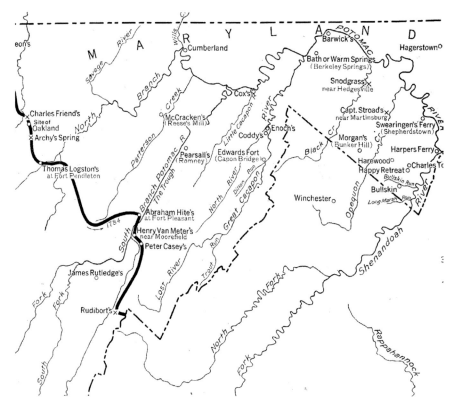

Washington's French and Indian War service with Virginia forces took him to many of the rivers and forts shown on this 1932 map. George Washington Bicentennial, *Vol. 1.*

On his journey south from Winchester, Washington also passed two Shenandoah Valley Presbyterian churches used as places for settlers to gather for defense against Indian incursions. Both of these stone churches are still standing today and can be visited along US Route 11. Nine miles north of Staunton is Augusta Stone Church, built in 1749, the oldest Presbyterian church in continuous use in Virginia. This early building is now the nave of the current church. In 1755, a log stockade was erected around the church to bolster its defenses after Braddock's defeat, but the church was never attacked during the war. The church is located just off Route 11 at 28 Old Stone Church Lane in Fort Defiance, Augusta County.

Farther south is the Timber Ridge Presbyterian Church in Rockbridge County, a rectangular limestone church originally built in 1756. Although it was significantly modified around 1900, much of its colonial character remains. The rear building and vestibule are later additions. The sturdy

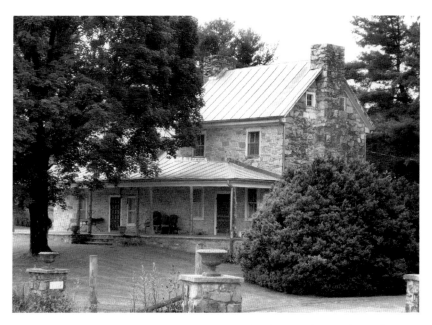

An eighteenth-century house called Steele's Fort in Rockbridge County, four miles north of Fairfield. *Author photo.*

Augusta Stone Church near Staunton was used as a place of refuge during Indian raids in the Shenandoah Valley, but it was never directly attacked. *Author photo.*

The original section of Timber Ridge Presbyterian Church in Rockbridge County, erected in 1756 along the Great Wagon Road. *Author photo.*

structure was also intended to be a place of strength and safety on the frontier during the war years. Sam Houston, later president of the Republic of Texas, a military leader and a U.S. senator, was born near the church in 1793. It is the second-oldest Presbyterian house of worship in the Shenandoah Valley, located on US 11 seven miles north of Lexington.

It is likely that during this portion of the journey Washington made a visit to the Natural Bridge, a geological curiosity located in the southern end of Rockbridge County, about thirteen miles south of Campbell's Ford (later called Lexington) on the North (now Maury) River. Although there is no documentary evidence of Washington carving his initials in the rock wall of the 215-foot-high arch, and his own writings do not record a visit there, recollections of his close associates in the 1790s support the story that he did, in fact, view the huge rock arch. Claims that he surveyed the Natural Bridge and its surrounding land are almost certainly false, as he did no surveying work during the French and Indian War and the site of the bridge was not part of the Fairfax land grant, in which he completed so much of his work.

Continuing south, Washington conferred with militia leaders at Robert Looney's Ferry, where the Great Wagon Road crossed the James River. The

The Natural Bridge was likely visited by George Washington in 1756 on his inspection tour of Virginia's frontier forts. It is now part of a new Virginia State Park. *Library of Congress.*

ferry was at Cherry Tree Bottom, the site of today's Buchanan, named after Colonel John Buchanan, who lived on the northwest side of the river during the war and met there with Washington. The crossing was by the mouth of Looney Creek at the James, near the junction of today's Routes 772 and

625 (*not* where US Route 11 crossed the river north of town) in Botetourt County, but there is no public access to the site. Near the ferry landing, local military forces later built Fort Fauquier (also called Looney's Fort) in 1758, named after Francis Fauquier, lieutenant governor of Virginia from 1758 until his death in 1768. Apparently, the log fort stood on the west side of Looney Creek near the James, but nothing remains of it today.

Not far from Looney's Ferry was a defensive work called Fort William (also known as Preston's fort and at various times the "Catawba fort"). The fort was built in 1755 by Captain William Preston and was located about fifteen miles west of Looney's Ferry, at the head of the Catawba Creek, an area populated by numerous settlements and a common path of Indian raiding parties. Washington wrote that three days before he arrived at Looney's Ferry, at "Fort William some of the militia…was attacked by the Indians which occasioned all that Settlement to break up totally, even to the ferry at Luneys." Colonel Buchanan was unable to get any additional militia to go to the site of the attack and catch up with the Indian raiders. Washington inspected this post during his 1756 journey. Fort William was near modern Haymakertown, on Route 666 six miles northwest of today's Daleville in Botetourt County, but it has long since disappeared.

Colonel Buchanan agreed to accompany Washington from Looney's Ferry to Vause's Fort (also called Vass's Fort and Fort Lyttelton) on the Roanoke River, rebuilt by Captain Peter Hog and his soldiers of the Virginia Regiment after an Indian attack that summer destroyed it. Hog made a new earthen fort but at a different location than the first one. The original fort was the house of Ephraim Vause surrounded by a stockade, which was attacked on June 25, 1756, by a party of twenty-five French Canadians and one hundred Shawnee, Miami and Ottawa Indians—all led by French captain Picoté de Belestre. With just a dozen soldiers under Captain John Smith to defend it, the fort's small garrison surrendered after an eight-hour fight and was razed by the enemy, who took 150 captives with them to the Ohio country by a long trek. Nine of the fort's defenders were killed or wounded, and Captain Smith was taken to Quebec, where he was eventually exchanged. Belestre was severely wounded in the fighting, and the enemy party did not continue eastward toward more settlements. The next day, parties under Buchanan and Captain William Preston (of Tinker Creek) totaling forty-seven men arrived at the ruined fort, but they were too late to offer any help to the survivors.

Upon seeing the new but still unfinished fort and its strategic location, Washington called it "a pass of very great importance, being a very great

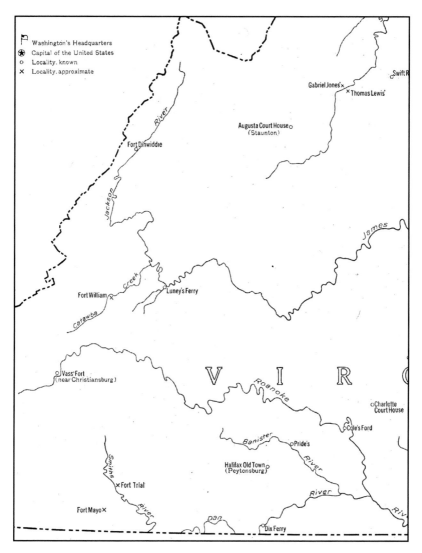

The southern forts on the Virginia frontier in the 1750s. Note Fort Dinwiddie at upper left and Fort Trial at lower left. George Washington Bicentennial, *Vol. 1.*

inroad of the enemy, and secure, if it was strongly garrisoned." The site of Hog's second fort is along Spring Branch on the western edge of Shawsville, at 3728 Oldtown Road. A Virginia Department of Historic Resources marker is at the site.

Washington left Fort Vause with a servant and guide for Halifax County far to the south, where several forts had recently been constructed. Riding

on the primary road from the mountains to the colony's southern piedmont and the Carolinas, he doubtlessly stopped to inspect Blackwater Fort and review its small garrison, which was a defensive post on modern US Route 220 in today's Franklin County, a few miles north of Rocky Mount. Also known as Terry's Fort for its commander, it was situated close to the twisting Blackwater River, although no trace of it can be found today.

Fort Mayo, also called Captain Samuel Harris's fort to honor its commander, was, according to Washington, "within five miles of the Carolina line…the southernmost fort in Halifax." It was located on the North Fork of the Mayo River and built in 1756, a small enclosure with a twenty-foot-high stockade surrounding a log blockhouse. The exact location of Fort Mayo is uncertain. The site was long said to be near Stella in Patrick County, but modern research suggests the fort was located in present-day Henry County on the North Fork of the Mayo River near Spencer, on Old Well Road (Route 630) south of present-day US 58.

Colonel Washington also journeyed to Fort Trial (also referred to as John Hickey's fort) in today's Henry County. It was situated on the slow-moving Smith River on high ground near its confluence with Reed Creek, entering from the north. A square fort made of logs buried deep in the ground to create walls about sixteen feet high, it might have had bastions at the corners as Washington had recommended and seems to have had an inner wall and an outer wall, filled with rocks between them. Washington considered it to be "a very out-of-the-way-place" and seems to have doubted its usefulness as a result. The approximate location of Fort Trial was near the intersection of US 220 and Route 57, about one mile south of Bassett Forks and twelve miles from the North Carolina border.

On his return north to Winchester from Halifax County, Washington visited several military posts along the Jackson River deep in the Allegheny Mountains. One of these might have been Fort Young, situated near the river in today's Covington. This fort was erected earlier in 1756 and was a wooden stockade on the west side of the river. According to one study, the fort was sixty feet square with walls fourteen feet high and included blockhouses, ramparts and two bastions. This fort had disappeared by the middle of the nineteenth century according to a historical marker placed on South Durant Street in Covington. Its likely site was off of West Liberty Street, around one thousand feet from the river.

Just to the north of there was Fort Breckenridge, also on the Jackson River, where Falling Spring Creek empties into the river ten miles north of Fort Young. This stockade was sometimes called Fort Mann, and it was

Approximate location of Fort Trial on the Smith River near modern Bassett Forks. Washington inspected this small post near the North Carolina border in 1756. *Jeffrey P. Oves photo.*

one of the forts built in 1756 on Washington's orders to create the string of western defensive posts. The fifty-man garrison consisted of militia soldiers led by Captain Robert Breckenridge, a captain in the Augusta militia who met Washington during his inspection tour. During Pontiac's War (1763–64), Shawnee warriors led by Chief Cornstalk attacked this post but were defeated. Although today nothing remains of the fort, its site can be seen west of Route 640 in the small town of Falling Spring north of Covington and by walking on the nearby Jackson River Scenic Trail at the mouth of Falling Spring Creek.

After the inspection of Forts Young and Breckenridge, Washington, Colonel Buchanan and their militia escort continued riding north along the quick-flowing Jackson River to Fort Dinwiddie, in a mountainous region then part of Augusta County. Built in late 1754 or early 1755 by the Irish-born Major Andrew Lewis, it was previously visited by Washington in late September 1755, "to see the situation of our frontiers, how the rangers were posted, and how troops might be disposed of for the defence of the country." The fort was intended to have bastions, officers' quarters and soldiers' barracks and to have the surrounding woods cleared around the site within musket shot to guard "against surprizes." Its walls were about fifteen feet high, and it was constructed above the river's bottomland for "protecting the Inhabitants of Green-Briar, Jackson's River, and those within, from the Incursions of the French and Indians." Beginning in September 1755, this

remote outpost was commanded by Captain Peter Hog of the Virginia Regiment until July 1757, when he was replaced by Lieutenant Thomas Bullitt, and it had a garrison of approximately fifty soldiers and a surgeon. In 1757, a roving Indian band killed several members of the Byrd family within site of the fort, and two of the children were led away as captives.

The location of this fort is about one mile north of State Route 39 where that road crosses the Jackson River, five miles west of Warm Springs in Bath County. The site is on private property, south of Hidden Valley Recreation Area in the George Washington National Forest, which when visited can still give tourists some sense of the fort's isolated eighteenth-century setting. Nothing today remains of the post, which fell into disuse by the late 1780s, although an old cemetery is nearby. Hidden Valley Recreation Area is at 1531 Hidden Valley Road, west of Warm Springs, and has access to the Jackson River.

Several other frontier forts were located nearby, one of which was Fort Lewis on the Cowpasture River. The site and the surrounding bottomland belonged to Colonel Charles Lewis, who fortified his home as early as 1750. A larger fort was built there about 1756 as a stockade for area militia troops. The site of the long-gone fort is now at the Fort Lewis Lodge at 603 Old

The mountains of today's Bath County near the site of Fort Dinwiddie on the Jackson River, near Warm Springs. *Jim F. Brown photo.*

Plantation Way near Millboro, off Route 678, sixteen miles northeast of Warm Springs.

South of Fort Lewis and also on the winding Cowpasture River was Fort Dickinson (also commonly called Dickinson's plantation and not to be confused with another of Dickinson's forts, also known as Fort Young at Covington to the south). It was intended to have a garrison of forty men, "for the defense of a once numerous and fertile settlement" wrote Washington. He also reported that here in September 1756, "Indians ran down, caught several children playing under the [fort] walls, and had got to the fort gate before they were discovered." By the end of the year, this post seems to have been in disrepair. In 1757, the fort was again attacked while most of its defenders were absent; several women and children were captured by the Indians and led away. A frustrated Washington wrote that the inattentive people living near the fort were "indolent and careless, and always unguarded, are liable to be surprized." Fort Dickinson was about twelve miles east from Fort Dinwiddie, about a day's march for soldiers operating in the mountainous terrain. The probable site is now on private property in Bath County and must have been in the wide river bottom just north of the junction of today's State Route 42 and a private lane called Boone's Trail Road, three miles south of Millboro Springs. This broad valley of fertile fields can be viewed today from several spots along Route 42.

Washington finally reached Winchester in October to end his "tedious and troublesome tour" and faced the same challenges he had before his long journey south: how to protect the "melancholy" frontier inhabitants of Virginia with few soldiers and scant resources in a huge swath of mountainous terrain. During his command from 1755 to 1758, Washington had to confront supply problems, deserters, a lack of recruits, troublesome fellow regimental officers (including a card cheat) and dangerous Indian foes. The colonel was unimpressed by the forts' garrisons he observed on his tour: "I found them very weak for want of men; but more so by indolence and irregularity." Attacks by Indians coming from the Allegheny Mountains and beyond struck Virginia settlements all along the "cold and barren" frontier, killing hundreds of farmers and their families and prompting many of the rest to flee. "The cunning and vigilance of Indians in the woods," he reported in April 1756, "are no more to be conceived, than they are to be equaled by our people." The inhabitants "are so affected with approaching ruin, that the whole backcountry is in a general motion towards the Southern colonies—and I expect that scarce a family will inhabit Frederick, Hamp[s]hire or Augusta [Counties], in a little time," Washington reported to Governor Dinwiddie later that year.

The Cowpasture River near Dickinson's plantation and stockade, near modern Millboro Springs. It was attacked at least twice in the French and Indian War. *Author photo.*

In order to combat the Native American threat in the northern Shenandoah Valley and on the Potomac, the colony constructed defensive stockades for its soldiers, especially on the South Fork of the Potomac, Patterson Creek, the Great Cacapon River and the Little Cacapon River, in modern West Virginia. Other forts were located closer to Winchester. Additionally, numerous settlers used fortified houses to protect their families in times of Indian attacks. The sites of several forts can be located today in the mountains west and north of Winchester, and a few "house forts" are still standing today in the lower Valley.

One of these outposts was "Colvin's Fort" on the headwaters of Opequon Creek, built in approximately 1750 as a spring house, initially. The small stone and log structure was about five miles southwest of Fort Loudoun in Winchester. Recent archaeological investigations do not point to its use as a fort, but it was likely a place of safety for local settlers in times of danger. The building—now uninhabitable—is located in a modern neighborhood at 104 Stonebrook Road, just west of Jones Road (Route 621) off the Middle Road (Route 628).

This 1750s structure south of Winchester was called Colvin's Fort, possibly used by local settlers as a defensive post during times of hostilities. *Richard C. Maass II photo.*

Near Colvin's was a stockade enclosing a one-room limestone house belonging to Robert Glass, an Irish immigrant. Later called Long Meadows, the original house has been incorporated into a larger nineteenth-century dwelling, now privately owned. It can be seen today along Opequon Creek at 1946 Jones Road, just north of Colvin's Fort. Several miles to the south is the Hupp House, a small two-and-a-half-story rubble limestone structure on Route 11 (North Massanutten Street) on the north side of today's Strasburg. This home was also likely used as a defensive post during the hostilities of the French and Indian War. Apparently built in the early 1750s in a Germanic style, it is situated over a strong spring by Town Run close to the road. As of this writing, it is in need of restoration. A smaller stone building is next to the house and might have been a distillery.

Northwest of Winchester was Pearis's Fort—a 1755 stockade around the house of Frederick County militia captain Robert Pearis—on a newly

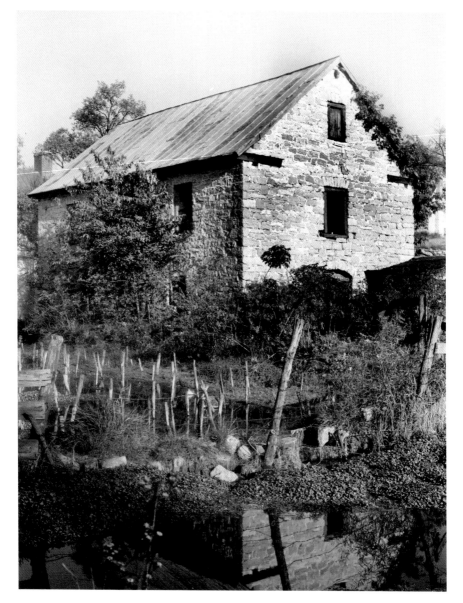

The Hupp House in Strasburg offered Shenandoah Valley residents a place of collective safety during the French and Indian War. *Library of Congress.*

cut road to Hogue Creek around seven miles from town. On this farm, the Virginia Regiment's cattle were sometimes kept to graze in 1755, and commissary supplies were stored there as well. On one occasion in May 1756, Washington recorded that a sergeant and fourteen men deserted from

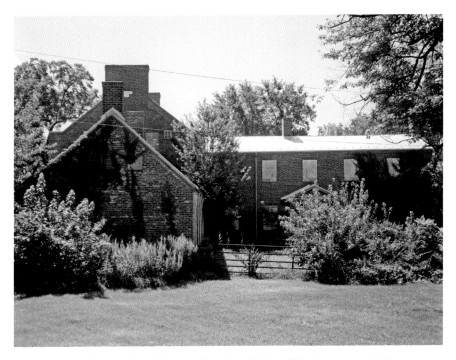

The location of Pearis's Fort during the French and Indian War is now occupied by a nineteenth-century poorhouse several miles west of Winchester. *Author photo.*

Pearis's Fort in one night. The location is often given by local historians as just off Indian Hollow Road at Burnt Church Road, but the site was most likely at the old poorhouse (still extant) on Poorhouse Road (Route 654), below a long ridgeline. To view the site and environs of this stockade, visitors can drive on US 50 (Northwestern Pike) two miles west of Route 37 and turn north on Poorhouse Road, driving one and a half miles. Now privately owned, the large poorhouse building is readily visible from the road on the east side, just above what is now called Parish Run, formerly known as Pearis Run.

Several miles farther west on Northwestern Pike, in the modern town of Gore, is the dwelling of militia captain Jeremiah Smith, a house fort that also served as a supply cache for the Virginia Regiment. It was on the old road from Winchester to Fort Edwards and beyond to Fort Cumberland, Maryland. From the house in the bottomland of Back Creek, often referred to as "Fort Smith," in 1756, the captain led a party of twenty militiamen to the Lost River and defeated a French-led party of fifty Indians in present-day Hardy County, West Virginia. The skirmish was fought near the junction of

Twenty Brave Men, a National Guard Heritage painting by Jackson Walker, depicts Captain Jeremiah Smith's party in battle with the French and Indians on Lost River, now in West Virginia. *Courtesy of the Army National Guard Bureau.*

Routes 259 and 14 (the location of Lost River Post Office). Fort Smith still stands on the side of Back Creek, at the end of Route 750 on the east edge of the town, now a two-story building with a double porch the length of the house and a central chimney.

Continuing farther west on modern Route 50 into West Virginia, Fort Edwards on the flat bottomlands of the Great Cacapon River was nineteen miles west of Winchester, situated in a wide valley on Joseph Edwards's land. In 1750, George Washington surveyed this tract in Hampshire County. This post was a substantial stockade of logs surrounding the Edwards's dwelling, a two-story log blockhouse with in-wall bastions often defended by detachments of Washington's Virginia Regiment. It had been a post since at least 1754, according to Washington's records. In April 1756, a detachment of fifty to one hundred Virginia Regiment troops from nearby Enoch's Fort were scouting for the enemy about a mile from Fort Edwards when they were

ambushed by Indians in what Washington called "a very unlucky affair." The enemy force included "many French among them, and…the chief part of the whole were mounted on horseback." Seventeen of these soldiers were killed, including their commander, Captain John Fenton Mercer. Reports circulated that two of these soldiers "were found tied to Trees & their Bodies most horribly mangled, it is supposed that they were tied while living & put to the most cruel Death." Captain Mercer was a cousin of Virginia statesman George Mason IV, and Mercer's father was a prominent member of the Ohio Company. In the wake of this defeat, Washington called upon the militia of Fairfax, Prince William and Culpeper Counties for support, but wrote Dinwiddie, "[H]ow they are to be supplied with ammunition and provisions, I am quite at a loss to know."

A partially reconstructed stockade is now at the site of Fort Edwards along with outdoor interpretive signs and a visitor center open seasonally on weekends. The site of the fort is at 350 Cold Stream Road in Capon Bridge, less than a half mile north of Route 50, west of the river. Visitors may contact the Fort Edwards Foundation at www.fortedwards.org.

About seven miles north of Fort Edwards was another prominent Virginia Regiment outpost, Enoch's Fort, at the confluence of the Great

The re-created stockade at Fort Edwards on the Great Capon River, a post garrisoned by Virginia Regiment forces during the French and Indian War. *Author photo.*

Cacapon and North Rivers, called Forks of Cacapon today. Washington had surveyed this broad, flat tract surrounded by wooded hills for Henry Enoch in April 1750 and was quite familiar with it. An old trail crossed the Cacapon just downstream (north) from the confluence and was followed and improved by General Braddock's army as it marched to disaster near Fort Duquesne in 1755. The stockade (also known as Fort Capon) was built on Washington's orders in 1756, although it does not appear to have been completed that year. In 1756, militia soldiers from Louisa County helped defend the post, the site of which is on private land about twenty-five miles northwest of Winchester. Washington reported in early April of that year that south of Enoch's, local rangers "fell in with a small body of Indians whom [they] engaged, and, after a contest of half an hour, put them to flight. Monsieur [Alexandre] Douville, commander of the party, was killed and scalped." He also noted in this same letter that the roving enemy had "committed several murders not far from Winchester, and even are so daring as to attack our forts in open day."

The fort was on the west side of the swift North River at a mill Enoch operated near the ford. Enoch's land can best be seen at the junction of Bloomery Pike (Route 127) and Gaston Road, looking to the north, or from the public boat launch on the east side of the Route 127 bridge over the Cacapon River.

Fort Ashby (also called Ashby's Fort) was also constructed during Washington's command in October 1755 to protect the mountainous backcountry far to the west of Winchester. Situated along the east bank of Patterson's Creek about four miles upstream from the North Branch of the Potomac River, it was named for Captain John Ashby, who commanded the fort for much of the war and led a ranger company stationed there. In a notable incident, the fort was approached in April 1756 by hundreds of hostile Indians, but Ashby refused to surrender and the warriors decided not to make an assault. Militiamen from Stafford, King George and Spotsylvania Counties helped garrison the fort in May of that year as well, although desertions among these troops was problematic. In August of that year, Washington reported an event north of the fort in which "Lieutenant Rutherford of the Rangers, escorting an express [of dispatches] to me at Fort Cumberland" (on the north side of the Potomac twelve miles away) was defeated by an Indian party. Washington lamented "the dastardly behaviour of the militia, who ran off without one half of them having discharged their pieces, although they were apprised of the ambuscade by one of the flanking parties, before the Indians fired upon them; and ran back to Ashby's Fort, contrary to orders, persuasions, and threats."

The bottomland at the Forks of Capon owned by Henry Enoch, site of Enoch's Fort. The stockade was located in the distance beyond the far tree line, to the left. *Author photo.*

Evidence suggests that engineers built the fort with four horizontally laid log bastions and stockade walls. Washington had directed that the fort should be "a Quadrangular Fort of Ninety feet, with Bastions," and include barracks and a magazine. It was to serve as a "cover to the Rangers, and as a Receptacle now and then for Provisions." Part of the fort survives and was refurbished by the Civilian Conservation Corps in the 1930s. Today, it can be visited on Dans Run Road in Fort Ashby, West Virginia, off Cemetery Road. More information is available at frenchandindianwarfoundation.org.

Colonel Washington also became familiar with Fort Pearsall, in modern Romney, West Virginia, on the South Branch of the Potomac River. This post was forty road miles west of Winchester through difficult mountainous terrain on the trail from Winchester to Fort Cumberland. It was likely built in the aftermath of Braddock's defeat in 1755 on the site of an earlier defensive position. Constructed on the river's east bank, it was a log stockade that came to support a garrison of the Virginia Regiment by 1756 and its supplies, along with militia from Fairfax County. Washington visited the fort in October 1755 to inspect the region's defenses, initially held by local

militiamen. Although the precise site of the fort is not yet known, it was likely near the river where the road to Patterson's Creek (now US Route 50) crossed it. Early period maps show the location east of the river as well.

ATTACK AT PAINTER RUN

Although there were numerous garrisons in military posts and militia at house forts on the Virginia frontier and backcountry during the war years of 1754–63 (and beyond), these defenses were of only limited value to isolated settlements and farms suddenly attacked in surprise Indian raids. To get a sense of the geography of these quick, violent episodes during the conflict, visitors to the Shenandoah Valley can find the site of an Indian attack on an early farmstead a few miles from modern Edinburg, in Shenandoah County, about thirty-five miles south of Winchester. Along Painter Run in 1758, about fifty Indian warriors and four French soldiers attacked the farm of the George Painter family, which was located near a spring uphill from the stream. Several other neighboring families took refuge in Painter's large log house after word came of the enemy nearby. Painter was killed in the attack, the others surrendered and the Indians set fire to the house and outbuildings. Some of the Painter children escaped capture by hiding, but the other settlers were led off into captivity west through the mountains to the Ohio Country. After being held by Indians for about three years, Mrs. Painter and three of her children were able to return home once the war ended, but her youngest daughter spent eighteen years as an Indian captive, and two other daughters were never seen again.

While only the old stone spring building close to the road survives from the eighteenth century, visitors to the area can see the farm site (also called Indian Fort Stock Farm and privately owned) and surrounding fields along Painter Run by turning off US Route 11 south of Edinburg onto South Middle Road (Route 614) and proceeding two and a half miles to a red-roofed white house and farm buildings on both sides of the road. The rock-walled Painter family cemetery, where George is buried, is on a hilltop on private land near the barn, and the run is on the west side of the road.

George Washington's military service during the French and Indian War continued in late 1758, in the rugged wilderness of western Pennsylvania. In that year, the British made another effort to capture Fort Duquesne with regular troops and colonial provincial forces. This campaign, led by British brigadier general

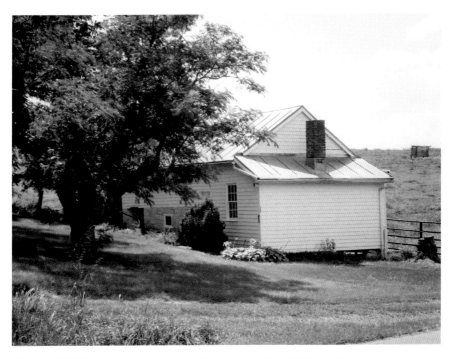

Site of a 1758 Indian attack at Painter's Farm near today's Edinburg, Virginia. The stone foundation of this outbuilding is likely from the mid-eighteenth century. *Author photo.*

John Forbes, included Virginia troops commanded by George Washington. Moving through the Pennsylvania frontier, Forbes's army slowly approached the French at the Forks of the Ohio, all the while building a new road and several forts. As Forbes's command got close to Fort Duquesne, in late November, the French set fire to the post and fled. Forbes occupied the site, and the British soon constructed a massive stone fortress they called Fort Pitt—modern Pittsburgh. With the fighting over in Pennsylvania and the frontier largely quiet for the moment, Washington returned to Mount Vernon in December. This marked the end of his frontier campaigning against the French and Indians. Once back at Mount Vernon, Washington turned his thoughts from defeating the French to making his home plantation a success.

6

"AN ELEGANT SEAT AND SITUATION"

Mount Vernon and Vicinity

No other location is associated with George Washington as closely as is Mount Vernon, his plantation home south of Alexandria. With its sweeping views of the wide Potomac River, distinctive red-shingled roof and park-like landscape, Mount Vernon may be the most famous residence in America, with the possible exception of the White House. It was, as one of the general's staff officers called it in 1781, "an elegant seat and situation, great appearance of opulence and real exhibitions of hospitality & princely entertainment." Likewise, a visitor in 1787 called the estate "the most charming seat I have ever seen in America." Washington came to know the place in 1735 when still a young boy, owned it by the early 1760s and continued to call it home until his death in December 1799. Fortunately, beginning in the decade before the Civil War, the extraordinary efforts of a group of American women, the Mount Vernon Ladies' Association, saved the threatened estate, and the nonprofit association still owns and preserves the property. Visitors today can visit Washington's home and farm, stepping back in time to experience life on a southern plantation, and learn more about America's first president.

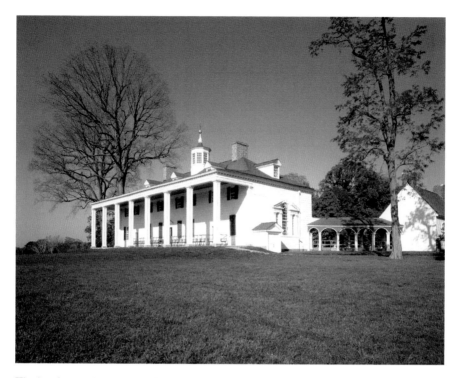

The iconic mansion house at George Washington's Mount Vernon, now owned and maintained by the Mount Vernon Ladies' Association. *Library of Congress.*

ON THE BANKS OF LITTLE HUNTING CREEK

George Washington's great-grandfather John Washington acquired the land along Little Hunting Creek and the Potomac River in 1674 (with a partner, Colonel Nicholas Spencer). This region was in a remote section of Westmoreland County, far to the north of the Washington farms on Popes Creek. There appear to have been a house or other structure on the tract as early as 1690, though inland from the river. In September 1690, the tract was divided between John Washington and Colonel Spencer's widow, with Washington retaining the lands west of Little Hunting Creek.

During the early eighteenth century, the Little Hunting Creek tract passed down to George's father, Augustine, who moved to the site with his family in 1735. They occupied a newly built house that forms the core of the dwelling we see today. When the family moved to Ferry Farm on the Rappahannock River in 1738, George's half brother Lawrence remained on the Little Hunting Creek lands, eventually inheriting them from his father in April 1743. Upon

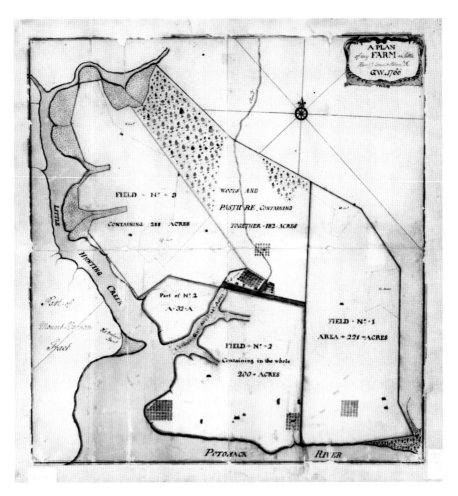

Washington's 1766 survey of River Farm, northeast of Little Hunting Creek, on the left. Washington's fishing spot on the river, Sheridan's Point, is at the bottom right corner of the plan. *Library of Congress.*

the end of his military service against the Spanish under Admiral Vernon in the War of the Austrian Succession (1740–48), Lawrence returned to the plantation and renamed it after his commander. Lawrence died there in the summer of 1752, at which time his wife, Anne, inherited a life interest in the estate. George took up residence at Mount Vernon in 1752 and leased it (and its resident slaves) from his sister-in-law beginning in December 1754, for an annual rent of fifteen thousand pounds of tobacco. After Ann died in 1761, twenty-nine-year-old George inherited the estate and called it home until his death thirty-eight years later. "I can truly say I had rather be at Mount

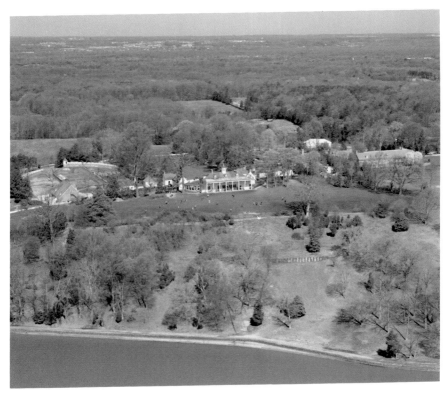

Aerial view of Mount Vernon taken in the 1960s. *Library of Congress.*

Vernon, with a friend or two about me, than to be attended, at the Seat of Government, by the Officers of State, and the Representatives of every Power in Europe," Washington wrote in 1790.

The original dwelling was a one-story frame house, and in 1758, George expanded with major renovations that added a second story. While he was campaigning in Pennsylvania during the French and Indian War, his neighbor and friend at Belvoir, George William Fairfax, supervised the extensive remodeling.

On the eve of the Revolutionary War, Washington was again making changes to his mansion house, this time with his third cousin Lund overseeing the work throughout the war years. Born at Chotank, Lund began his tenure at Mount Vernon in 1765 and remained there for twenty years. He eventually married Elizabeth Foote, a cousin of his from Prince William County, and together they established themselves on a 465-acre farm called Hayfield in 1785, once part of Mount Vernon. The two-story

Mount Vernon's distinctive cupola, added to the roof in 1778. *Library of Congress.*

brick house there no longer stands, but the plantation was located along what is now Old Telegraph Road and Hayfield Road (Route 635) in Fairfax County, less than a mile from the western side of Huntley Meadows Park.

Beginning in 1775, Washington added a wing to each end of the Mount Vernon house, two outbuildings connected to the house by semicircular

covered walks and a distinctive two-story piazza on the home's river side. Once completed, the dwelling was 11,028 square feet—much larger than the typical Tidewater Virginia home. He also added the striking cupola in 1778 to help cool the house, topped in 1787 by a dove of peace weathervane custom made in Philadelphia; the original device can still be seen today in the extensive Donald W. Reynolds Museum on the estate grounds. "I like the house," Bryan Fairfax wrote to Washington during the Revolutionary War, "it is uncommon for there has always appeared too great a sameness in our buildings."

Today, numerous Washington-related items fill the house, including furniture, portraits, scenic paintings, musical instruments, clocks, books and pottery. Close by, a small village of outbuildings can be found near the house, including a detached kitchen, a storehouse, clerk's quarters, a smokehouse, a washhouse, a stable and coach house, a spinning room, a blacksmith shop and a greenhouse. Extensive gardens are also part of the estate, growing flowers, vegetables, nuts, fruits and herbs. One of Washington's many visitors in 1796 was quite impressed with the estate—it was one "of surpassing beauty," he concluded. Many times during his long and arduous service to the United States as commander of the Continental Army in the Revolutionary War, Washington pined to return to Mount Vernon. From his home in 1785 after the war, Washington wrote with pleasure that he was "in the enjoyment of ease & tranquility...now seated under my own Vine & my own Fig-tree in the occupations of rural life."

Sadly, not all was happiness at the plantation. It was here on June 19, 1773, that Martha Washington's seventeen-year-old daughter Martha Parke "Patsy" Custis died of an epileptic seizure, a condition from which she had been suffering for years. Washington lamented the death of this "sweet innocent girl," who that afternoon suddenly "was seized with one of her usual fits, and expired in it, in less than two minutes without uttering a word, a groan, or scarce a sigh." Martha was reduced to "the lowest ebb of misery" at the sudden event, reported her husband the next day.

George Washington also died at Mount Vernon, on December 14, 1799. He had been out on his farms riding in wet weather, and in order to be punctual for dinner, he did not change into dry clothes upon his return to the house. He developed a sore throat the next morning that soon led to breathing problems. Despite the efforts of three doctors who attended him (and bled him four times), he died shortly after 10:00 p.m. on the fourteenth in his bedchamber. Initially, his remains were placed in the family burial vault just down the hill from the house overlooking the river. In 1831, a new brick tomb, built according to Washington's wishes,

The second burial vault at Mount Vernon, where the remains of George and Martha Washington now repose. *Library of Congress.*

was finished a few hundred yards away, where the bodies of George and Martha (who died in 1802) lie together.

FIVE FARMS

Washington's estate was much more than the imposing mansion overlooking the wide Potomac. Mount Vernon consisted of five farms totaling close to eight thousand acres by 1799. The land around the house and outbuildings was called Mansion Farm and was developed as a park-like setting for the elegant Washington home. The fields to the south at the mouth of Dogue Creek was called Union Farm and included the site of Posey's Ferry, linking Virginia to Maryland from a landing at the end of today's Ferry Landing Road (now Route 623). This ferry was operated by John Posey, whose tract was called "Rover's Delight" and was added to Mount

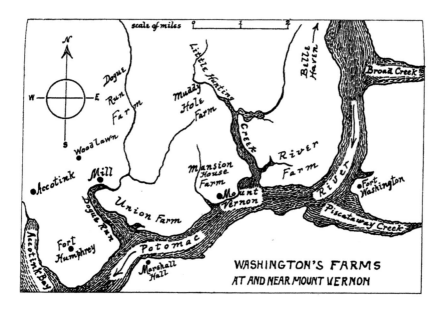

A map of Washington's five farms of Mount Vernon. Fort Humphrey is now called Fort Belvoir. Note the locations of Woodlawn Plantation and the gristmill on Dogue Run. *Wayland*, The Washingtons and their Homes.

Vernon in payment of debts Posey owed to Washington in 1769. The ferry traversed the Potomac River from Posey's property to a plantation called Marshall Hall, the landing of which was at the end of today's Maryland Route 227, near the Accokeek Foundation's National Colonial Farm.

Upstream, Washington's best farmland was given the name Dogue Run Farm, and directly north of the mansion at the headwaters of Little Hunting Creek was Muddy Hole Farm. The last major parcel Washington acquired (in 1760) was on the east bank of Little Hunting Creek. It was eventually named River Farm, though Washington referred to it as "my own neck." This large tract, known originally as Clifton Neck, was situated on the Potomac River as well. It included Sheridan Point on the river, where Washington was known to fish and picnic, including one instance in 1770, in which Washington "dined upon the Point" in the late summer. Each farm was managed by an overseer, worked by slaves and closely supervised by Washington when he was in residence at Mount Vernon. Some sections were leased to long-term renters as well.

As was the case with all large eighteenth-century Virginia plantations, those toiling in the fields were enslaved. George Washington kept as many as 300 slaves of African descent at his five farms by the late 1790s. Many of the unfree

servants were dower slaves, that is, they were the inherited property of Martha Washington and her children from the estate of her first husband, Daniel Parke Custis. As such, Washington was not free to manumit them as he did with his own 123 slaves in his will—the only slave-owning president to do so. By the end of his life, he came to oppose the cruel institution. "I wish my soul that the legislature of [Virginia] could see a policy of gradual abolition of slavery," he wrote in frustration to a kinsman in 1797. Some Mount Vernon slaves lived near the mansion in the greenhouse building (reconstructed in 1951), while others lived in cabins closer to the fields they worked. Today, visitors to Mount Vernon can see a memorial (erected in 1983) to the estate's bondservants at the slave burial ground located near Washington's tomb, below the mansion. No original markers remain, but investigations have revealed approximately fifty to seventy-five graves present at the site.

The legacy of Mount Vernon's reliance on slavery for labor can still be seen nearby at the community of Gum Spring. It was founded by West Ford, a former slave at Mount Vernon who moved to Gum Spring, about two and a half miles north of Washington's home, after he was freed in 1806. According to research conducted by Mount Vernon staff members, there is no documentary evidence to show that George Washington ever met West Ford, nor did Ford live at Mount Vernon during George's lifetime. Nevertheless, Ford was given land at the Gum Spring area by Bushrod Washington (in his will), then the owner of Mount Vernon. The area gradually became a community for former slaves and continues to be an African American center today. Gum Spring is centered around the intersection of Fordson Road and Sherwood Hall Lane, just east of US Route 1. The Gum Spring Museum is located at 8100 Fordson Road, and can be contacted at (703) 375-9825.

After Washington's death, the farms and buildings of Mount Vernon began to deteriorate. The work to restore Mount Vernon from its state of decline began in the late antebellum period. The Mount Vernon Ladies Association came into being in 1853 in reaction to the dilapidated state of the Washington home. The association's founder, Ann Pamela Cunningham of South Carolina, resolved to begin an effort to restore it after hearing of its woeful condition from her mother, who observed the house from the Potomac River while boating. In 1858, the organization bought the house and two hundred acres for $200,000 from George Washington's great-grandnephew John Augustine Washington III, who had owned the estate since 1829. The ladies began allowing the public to visit the house in 1860 and have worked tirelessly and successfully to restore the house, buildings, gardens and farm ever since.

The tidal waters of Little Hunting Creek in Fairfax County, along which the Washingtons owned land starting in the seventeenth century. *Kathryn Horn Coneway photo.*

Today's visitors can see most of the Union Farm along Mount Vernon Memorial Highway, between US Route 1 and the modern visitor center. Most of Dogue Run Farm is west of Route 1, found along Pole Road and Lawrence Street, and includes a small section of Huntley Meadows Park. Muddy Hole Farm is bisected by modern Route 1 and Route 235/Mount Vernon Highway, east of Little Hunting Creek. Mount Vernon Heights Park, Riverside Elementary School, Mount Vernon Community Park and the George Washington Recreation Center are all within the old boundaries of this farm. The River Farm is most easily toured by driving north on the George Washington Memorial Parkway along the Potomac toward Alexandria and across Little Hunting Creek. Fort Hunt Road, which can be accessed off the George Washington Memorial Parkway at several cross streets, runs north–south through the middle of what was the River Farm, but modern neighborhoods and shopping areas make it difficult to imagine what the rural landscape was like during Washington's life. Fort Hunt Park, a National Park Service unit just off the parkway, was also part of the River Farm, and just across the parkway from it is Sheridan Point, accessible off the bike path one mile north of Riverside Park.

For those wishing to see Little Hunting Creek, it is accessible by driving or walking 1.3 miles north of the roundabout at Mount Vernon, then turning left off the parkway onto Stratford Lane, across from Riverside Park. From here, the tidal creek is visible on several streets along the left (particularly Thomas Stockton Parkway, off Camden Street) but there is no public access to the creek within these neighborhoods.

Today, Washington's home and farms receive over one million visitors per year, supported by an endowment of about $140 million. Over forty

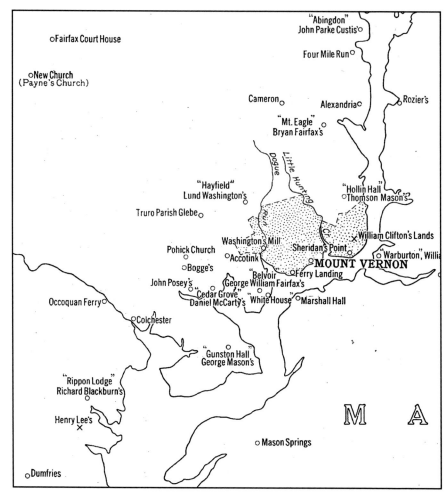

The area around Mount Vernon includes many sites that can still be seen today, including Abingdon, Pohick Church, Hayfield, Colchester, Rippon Lodge and Gunston Hall. George Washington Bicentennial, *Vol. 1.*

thousand individuals donate funds to support Mount Vernon every year. In 2013, Mount Vernon became the home of the Fred W. Smith National Library for the Study of George Washington, "a resource for scholars, students, and all those interested in George Washington, colonial America, and the Revolutionary and founding eras." The additions of the Ford Orientation Center and the Reynolds Museum in 2006 make George Washington's Mount Vernon one of the nation's premier historic sites. For details on visiting Mount Vernon, its museums and grounds, along with daily activities and special events there, visit www.mountvernon.org or call (703) 780-2000. Open all year, it is located at the southern end of the George Washington Memorial Parkway, nine miles from Old Town Alexandria.

Although Mount Vernon was a huge estate in a rural area, the Washingtons were part of a larger community in the surrounding area. The port town of Alexandria was only ten miles to the north, and George and Martha Washington often visited for their social, spiritual, political and commercial needs. A number of other sites close to Mount Vernon associated with the general and president can still be found today, and many are open to the public. A sample of these will be the subject of the remainder of this chapter.

TWO FAIRFAX CHURCHES

George Washington, the descendant of an English Anglican minister, remained attached to that church for his entire life. Although the exact nature of his religious beliefs is difficult to determine accurately (though many writers have tried), he did remain a member of the Anglican faith, and as his military and presidential duties permitted, he was a fairly regular churchgoer. Washington was also a leader within his denomination, and he was at times a vestryman and church warden in northern Virginia. One of the ecclesiastical structures with which he was most associated still stands only eight miles away from his home and remains an active Episcopal congregation today.

Pohick Church, now in its third location, was frequented by the Washingtons from the time of its completion in 1774. The building replaced an earlier wooden frame church two miles to the south (where Cranford United Methodist Church is now located at 9912 Old Colchester Road),

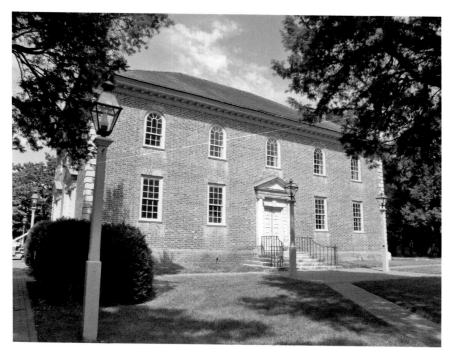

The Washingtons, Masons and Fairfaxes attended the Georgian-style Pohick Church near today's Fort Belvoir from its completion in 1774. *Author photo.*

which Washington also attended. It was part of Fairfax County's Truro Parish, established in 1732, and it stands along the old road from Alexandria to Colchester, a port on the Occoquon River. Washington began serving as a local vestryman (one of the parish's managing committee members) in 1762, before the church moved to its present site and was later the church's warden beginning in 1763. The current structure is a rectangular two-story building of Flemish bond brick and glazed headers, with stonework (called quoins) around the doors and corners. The interior was refurbished in the early nineteenth century, and little original woodwork remains. Nevertheless, it is a striking reconstruction. Washington's neighbors George William Fairfax and George Mason were also vestrymen of this parish. Pohick Church can be visited today on US Route 1, twelve miles south of I-495, at 9301 Richmond Highway, Lorton. Guided tours are given of the church and more information can be had by calling (703) 339-6572 or visiting www.pohick.org/index.html.

Washington was also a warden of the Falls Church, originally a wooden structure erected in 1734 at a colonial crossroads in central Fairfax

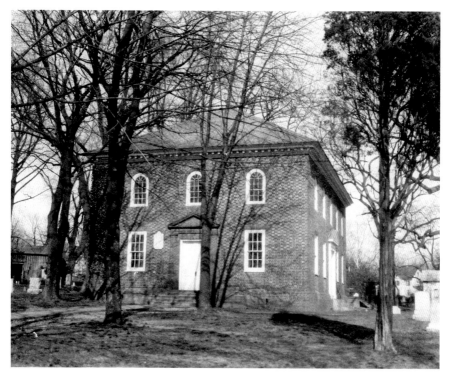

Falls Church in central Fairfax County was built just before the American Revolution. George Washington served several years as a church warden here. *Library of Congress.*

County. In this role beginning in 1763, he oversaw the completion of a new brick church at the site, which was completed in 1769. It is a rectangular brick building with double rows of windows, surrounded by a number of old gravestones. After 1765, Fairfax was divided into two parishes—Truro and Fairfax—so Washington no longer served a role in the Falls Church leadership. During the Civil War, Union troops used the building as a stable, causing major damage to the interior woodwork. The parish made a claim against the federal government in 1908 for war-related damages, but the petition was rejected. Today, the restored church and its graveyard can be seen at 115 East Fairfax Street, in the town of Falls Church, just off Broad Street (Route 7). The contact number for the church office is (703) 241-0003, and its history can be read at www. thefallschurch.org.

LOST TOWN: COLCHESTER

Not far from Mount Vernon was an important early river port that has all but vanished today. Located two miles south of Pohick Church on the main colonial highway to Fredericksburg, Colchester was a commercial town on the north bank of the Occoquan River. Washington came to know the hamlet well during his travels, and his account books show numerous occasions when he crossed the river there by ferry and dined at the tavern. Colchester appears on most period maps of Virginia and was a significant tobacco shipping and inspection point. In the 1750s, the Virginia Assembly described it as "very convenient for trade and navigation." In 1796, George Mason's son Thomas built a wooden bridge over the Occoquan at Colchester, and the town on the south shore came to be called Woodbridge. By the nineteenth century, however, Colchester had declined and all but disappeared, partially due to the rising prominence of the nearby town of Occoquan, growing river sedimentation and a widespread fire in 1815. The town's eighteenth-century tavern, now privately owned, is still

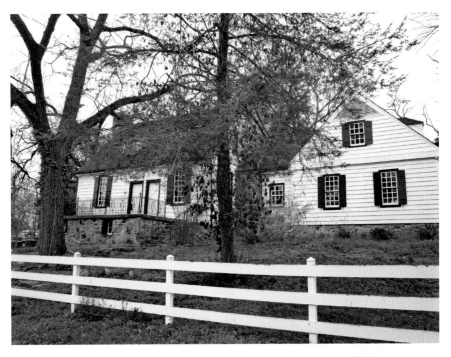

This eighteenth-century tavern is one of the few period buildings now at Colchester, once a thriving port town on the Occoquan River in Fairfax County. *Author photo.*

standing and situated at 10712 Old Colchester Road about one thousand feet from the river, clearly visible from the street. It is recognizable from its two stone chimneys at the gable ends and two single-door entrances facing the road. At some point, a stable for eight horses and a meat house were close by as well. Today, the town is located half a mile east of US Route 1 on Furnace Road (Route 611) and Old Colchester Road in the Lorton area and is also visible from the Route 1 bridge over the Occoquan. The Fairfax County Park Authority's Cultural Resources Management and Protection Services is currently involved in archaeological work at the town site, "rich in unique natural and cultural resources." See www.fairfaxcounty.gov/parks for details about the county's efforts to learn more about Colchester's colonial past.

FRIENDS AND NEIGHBORS

Several homes and plantations of Washington's friends and family are also located near Mount Vernon and can be seen today.

Located on the west side of Fort Belvoir is the site of Mount Air, home of the McCarty family as early as 1727 from a Lord Fairfax land grant. Daniel McCarty had been a neighbor of the Washingtons in Westmoreland County until his death in 1724. His son Denis McCarty moved to northern Virginia and served as a county sheriff, a vestryman of Truro Parish and a member of the Virginia House of Burgesses. Denis also served with Virginia forces in the French and Indian War. He married Sarah Ball, a first cousin of Washington's mother, in 1724. Their son was Daniel McCarty, George's contemporary, with whom he socialized and hunted foxes in the woods and fields beside Accotink Creek. His son Daniel Jr. married the daughter of George Mason, Sally. They lived at Cedar Grove, a plantation on the west shore of Accotink Bay at its confluence with Pohick Bay, now part of Fort Belvoir and the Accotink Bay Wildlife Refuge. There was a tobacco inspection station here in the eighteenth century. The McCarty dwelling at Mount Air burned in 1992; the house site and ruins with several interpretive markers are on Fisher Woods Drive, just off Accotink Road and Telegraph Road, east of its junction with the Fairfax County Parkway near Fort Belvoir.

South of Mount Vernon is Rippon Lodge, which Washington visited often, located just off the King's Highway in Prince William County, which he

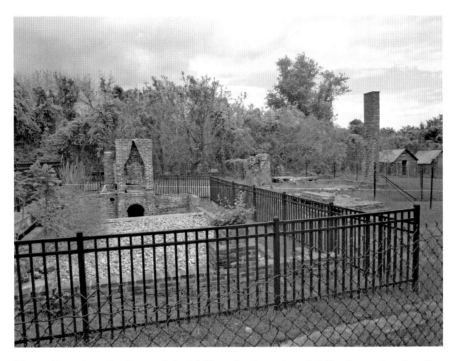

Mount Air, a plantation home of the McCarty family on Accotink Creek, now in ruins after a 1992 fire. *Author photo.*

used on his many journeys to Fredericksburg and Williamsburg. The white-framed house was constructed about 1747 by Richard Blackburn on high ground near Neabsco Creek. He and his son Thomas were tobacco planters whose land (at one time totaling twenty-one thousand acres) and home were north of Dumfries. Thomas Blackburn was later a militia colonel in the Revolutionary War and had been an original member of the Independent Company of Cadets of Prince William County, formed in 1774 as hostilities with Great Britain became more evident. The following year, Washington accepted the command of this unit prior to serving in the Continental Congress at Philadelphia. Colonel Blackburn was also involved with Washington in the Potowmack Company, a venture to build canals around the falls of the Potomac River to open the Chesapeake to commerce with western Virginia. His son Thomas was born at Rippon Lodge, served as an officer of the Second Virginia Regiment in the Continental Army and was wounded at the battle of Germantown, Pennsylvania, in 1777. His daughter Julia Anne married Bushrod Washington, the general's nephew and later an associate justice of the U.S. Supreme Court. Today, the restored house and

The home of the Blackburn family, Rippon Lodge is now open to the public near Woodbridge. It was built circa 1747 near Neabsco Creek. *Prince William County Historic Preservation Division photo.*

forty acres are owned by Prince William County and open to the public at 15520 Blackburn Road in Woodbridge, just south of Rippon Boulevard, off US Route 1. More information may be obtained by calling (703) 499-9812 or visiting www.pwcgov.org.

One of George Washington's most illustrious neighbors was the planter and statesman George Mason IV (1725–1792), whose family had extensive landholdings in Fairfax and Prince William Counties. Born on Mason Neck near Pohick Creek and orphaned at age nine after his father drowned crossing the Potomac, he moved to live with his uncle and guardian, attorney John Mercer, at the now vanished port of Marlborough in Stafford County. There he received his thorough education with the benefit of Mercer's extensive library of about 1,800 volumes.

As an adult, Mason came to live at his Fairfax County plantation in Mason Neck, south (downstream) of Belvoir and Mount Vernon, which he called Gunston Hall. Mason is not as well known as other founders, in that he did not serve in public office at the national level and only occasionally as a Virginia politician. He preferred "the happiness of independence and a private station

to the troubles and vexations of public business." After the death of his first wife in 1773, he "retired from public Business from a thorough Conviction that it was not in my Power to do any Good, and very much disgusted with Measures, which appeared to me inconsistent with common Policy and Justice." He frequently cited ill health and his numerous children as the reason for shunning public life. Nonetheless, he was widely respected by his peers and is known as the "Father of the Bill of Rights" (adopted in 1791) due to his previous authorship of the Virginia Declaration of Rights in 1776. Mason was "a man of the first order of wisdom among those who acted on the theatre of the revolution," wrote Thomas Jefferson. He was later a delegate to the Constitutional Convention in Philadelphia in 1787 but refused to sign it due to his fears for individual liberties. His opposition to the new plan of government led to his break with Washington after decades of friendship and common interests. Mason also came to look unfavorably upon slavery—"such a trade is diabolical in itself, and disgraceful to mankind," he wrote—but did not free his slaves. He died in 1792 at his plantation.

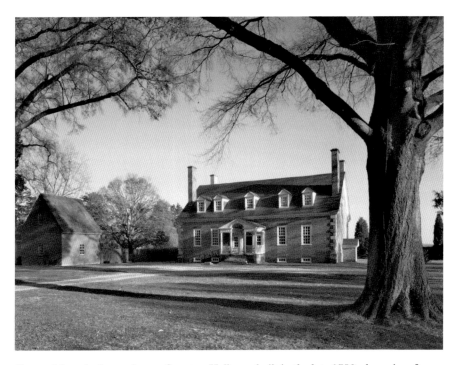

George Mason's elegant home, Gunston Hall, was built in the late 1750s downriver from Mount Vernon and Belvoir. The house and grounds are open to the public today. *Library of Congress.*

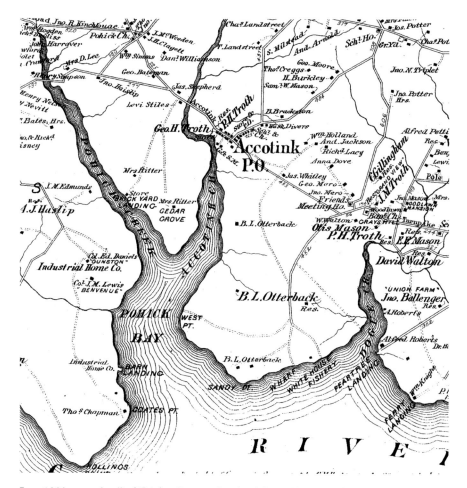

Late 1800s map detail of Fairfax County, showing Mason Neck and Gunston Hall (*left*), Cedar Grove by Pohick Bay, Belvoir Neck (*center, by* "Otterback") and the old ferry landing on the Mount Vernon estate (*lower right*), formerly called Posey's. *Fairfax County Public Library.*

Mason completed the construction of his home at Gunston Hall in 1759, "one of the finest homes in colonial America," according to his biographer Jeff Broadwater. Well preserved along with its grounds and open to the public today, the impressive house is a one-and-a-half-story Georgian dwelling of Flemish bond brick with few subsequent alterations. The house has a center hall plan designed by Mason with two rooms on each side and elaborate interior decorations. Its rural setting overlooks the Potomac River and Gunston Cove and retains its striking eighteenth-century character.

Gunston Hall is located on Gunston Road (Route 242) about four miles east of US Route 1, in the Mason Neck area of southern Fairfax County. Visitors

can contact the plantation museum at www.gunstonhall.org or (703) 550-9220 for details on tours, programs and special events throughout the year.

Closer to Mount Vernon was the small hilltop plantation and home of George Mason's third son, Thomson Mason, and his wife, Sarah McCarty Chichester. Called Hollin Hall and built around 1788, this property was west of Washington's River Farm, overlooking Paul Spring Branch, a tributary of Little Hunting Creek. George Mason deeded the land totaling 676 acres to his son in the early 1780s. Fire ruined the house in 1824, but one original outbuilding remains off Sherwood Hall Lane (privately owned and not visible from the street). However, some of the plantation is now part of the Mount Vernon Unitarian Church, located off Fort Hunt Road at 1909 Windmill Lane, about four miles south of Alexandria. The home's mostly forgotten history is today commemorated by the names of several landmarks nearby, including Hollin Meadows Elementary School, Hollin Hall Shopping Center and Mason Hill Drive.

About three miles west of Mount Vernon, Woodlawn is situated on a high hill within sight of the Potomac River. George and Martha Washington gave this two-thousand-acre plantation to her granddaughter Eleanor ("Nelly") Parke Custis as a wedding gift in 1799 upon her marriage to Lawrence Lewis, the son of Washington's sister Betty and her husband, Fielding Lewis of Kenmore. The tract included Washington's profitable gristmill and distillery, now re-created on Mount Vernon Memorial Highway near US Route 1. Born in 1779, Nelly grew up at Mount Vernon after the death of her father, Jacky Custis, in 1781. She also lived with the Washingtons in New York during part of George's presidency. After serving as an officer in the 1794 Whiskey Rebellion, Lawrence Lewis became Washington's personal secretary in 1797. He met Nelly while he lived at Mount Vernon, where they were married.

The Lewises built the two-story brick plantation home at Woodlawn from 1800 to 1805, where they lived for twenty-five years, and here they had four children who grew to adulthood. At the time, Mount Vernon and the Potomac River were visible from the home's hilltop site. The house was designed by noted architect William Thornton, the designer of the U.S. Capitol building and the Octagon House in Washington. The distinctive home and grounds are today owned by the National Trust for Historic Preservation and can be toured from April through December. Further information is available by calling (703) 780-4000 and at www. woodlawnpopeleighey.org/tours. The site is located at 9000 Richmond Highway (US Route 1), just north of Fort Belvoir.

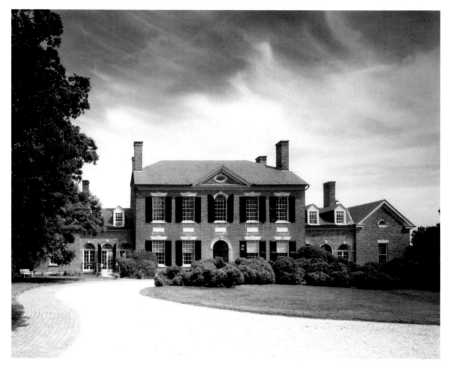

Woodlawn plantation, early nineteenth-century home of Martha Washington's granddaughter Eleanor "Nelly" Parke Custis and her husband, Lawrence Lewis, George Washington's nephew. *Library of Congress.*

Due to modern development over the years, a number of homes and sites Washington knew in the Mount Vernon area are no longer standing. The ruins of one of them, however, can still be seen in an unlikely spot—within the grounds of Ronald Reagan National Airport, across the Potomac from Washington, D.C.

Martha Washington's son Jacky, whose financial interests Washington was responsible for overseeing until the boy reached his majority, was a well-meaning but unfocused youth, a source of persistent frustration to his stepfather for years. "His mind [is] a good deal relaxed from study," Washington complained to Jacky's Annapolis schoolmaster in 1770, "more than ever turned to dogs, horses, and guns." Jacky tended to ignore his studies, was impetuous and married far too young in his mother's estimation. He also failed to heed the advice of his elders and did not always think through his decisions. One example of this was his purchase of Abingdon plantation in 1778, which Washington called "pleasantly situated, and capable of great improvement." Near Alexandria along the Potomac north of Four Mile Run,

Jacky bought the nine-hundred-acre tract and house (built in 1746) from Gerard Alexander at disadvantageous terms, apparently without seeking the advice of George Washington. Custis agreed to pay compound interest to the seller, which was not only unusual in tidewater Virginia but also potentially ruinous. "No Virginia estate (except a few under the best management) can stand simple interest," Washington admonished the young man after the sale, "how then can they bear compound interest?" In his defense, Custis wrote that "nothing could have induced Me to have given such Terms, but the unconquerable Desire I had, to live in the Neighbourhood of Mt. Vernon, and in the County of Fairfax."

Sadly, just three years after moving to Abingdon with his wife, Eleanor Calvert of Maryland, Jackie died soon after the Yorktown campaign ended in 1781 at age twenty-eight while serving as a volunteer aide on General Washington's staff. Eleanor remarried Dr. David Stuart two years later but gave up the plantation due to the crushing debt in 1792. She died in 1811. The brick plantation house burned in 1930 and was at the time the oldest home

The ruins of Abingdon Plantation, once owned by John Parke Custis, now on the grounds of Reagan National Airport on the Potomac River. *Eileen M. Maass photo.*

in Arlington County. The ruins of the house are still accessible along with interpretive signs located near the airport's METRO station, between parking garages A and B, on level 2.

Another home well known to George Washington was Mount Eagle, perched on a high hill overlooking Alexandria from the southeast. This was the second home of his friend Bryan Fairfax, who lived previously at Towlston Grange. Fairfax had become an Episcopal minister in 1789 and bought the property soon thereafter. It was at Mount Eagle that Washington ate his last meal away from Mount Vernon, on December 7, 1799. The year before, while in England, Bryan Fairfax certified his title as eighth Lord Fairfax. He died in 1802 at his home, though his burial location remains unknown.

The large white frame house was built in 1790 overlooking Hunting Creek and known for its striking views. During the Civil War, Union army forces built Fort Lyon on the hilltop as part of the defenses of the city of Washington, but the house survived largely unscathed from the war years. After passing through several owners and an attempt to make the estate a golf club, the house and surrounding acreage was sold to developers who burned the house down in 1968 and paved over its foundations. The site is where the current Montebello condominiums are now situated on the west side of US Route 1 just south of Huntington Avenue. Access to the site is restricted to residents, but the hilltop can best be seen from Mount Eagle Park on Biscayne Drive, immediately to the west near the Huntington METRO station.

Fortunately, those seeking out Washington-related sites can see a home that was not destroyed or declined into ruins close to Mount Vernon and with public access. As noted above, the Clifton Neck area of 1,800 acres became part of Washington's Mount Vernon estate and renamed River Farm in 1760. William Clifton, the owner since 1737, had built a brick home on the land by 1757, and that structure—greatly enlarged over the years—is now the headquarters of the American Horticultural Society. Tobias Lear of New Hampshire, executive secretary to Washington from 1786 until 1799, lived at the house for many years and was present at Washington's death. He was also a tutor to Martha's grandchildren, managed Washington's extensive correspondence, and married Frances "Fanny" Bassett Washington, Martha's niece, at Mount Vernon in 1795.

On the sloping riverside property is the largest Osage orange tree in America, which may have been a gift to Washington's descendants from Thomas Jefferson in the early 1800s. Later, the farm became known as

The much-altered 1750s house at River Farm, part of Mount Vernon after 1760. The house on the west bank of the Potomac was later called Wellington and is now owned by the American Horticultural Society. *Author photo.*

Wellington, after being sold out of the Washington family after the Civil War. The American Horticultural Society purchased twenty-seven acres of these grounds in the 1970s. Once again called River Farm, it is open during the week to visitors and on Saturdays from April to September. It is situated just off the George Washington Memorial Parkway at 7931 East Boulevard Drive, five miles north of Mount Vernon. More information is available at www.ahs.org.

7

"THE JUST OBJECT OF YOUR AFFECTIONS"

Martha Dandridge Custis and Tidewater Virginia

Through his service as a delegate in Virginia's House of Burgesses, his military duties in the Virginia Regiment in the 1750s and his marriage to Martha Dandridge Custis, George Washington came to know well another section of tidewater Virginia besides the Northern Neck. This chapter will detail the homes, lands and roads familiar to Washington as he courted the widow Custis, including those of her substantial inheritance and that of her two children. Many of the roads and places he knew from the 1750s to the 1770s in this region can still be traced and visited today and are filled with the scenes of Washington's life before the Revolutionary War.

THE WIDOW CUSTIS

During the latter part of his arduous service as commander of the Virginia Regiment during the French and Indian War, Washington made a trip to Williamsburg in late March 1758 to discuss military matters with the colony's lieutenant governor, Robert Dinwiddie. While en route to Virginia's capital, Washington crossed the Pamunkey River by ferry and paid a visit to Poplar Grove, the plantation of the Chamberlayne family at the mouth of Matton Creek on the Pamunkey. The house here was a two-story brick structure

Martha Dandridge Custis, about the time of her marriage to George Washington in 1759. *Library of Congress.*

built about 1725 and the seat of Colonel Richard Chamberlayne. While visiting the family, he met a young widow, Martha Dandridge Custis, whose own home was a mile to the east. This was likely the first time Washington

met her, though he would have at least heard of her late husband Daniel Parke Custis, a wealthy planter and county militia officer. Washington dined and spent the night at Poplar Grove and proceeded on his official business to Williamsburg the following day.

Apparently, the squire of Mount Vernon was smitten by the widow Custis during their brief encounter. During his stay in Williamsburg, he made a horseback ride of thirty-five miles to visit her at her home along the Pamunkey River, called White House, followed by a second visit the next week. Soon thereafter, he returned to Mount Vernon prior to resuming his frontier military command at Winchester.

The young woman who captivated Washington was twenty-six years old. Martha Custis had a "good humored free manner that was extremely pleasing and flattering," an acquaintance wrote years later, and a European army officer later noticed that "she has something very charming about her." Abigail Adams concluded that Martha was "one of those unassuming characters which create Love and Esteem." Martha wrote that she had energy and a determination "to be cheerful and happy in whatever situation I may find myself," adding that she had "learned that the greater part of our misery or unhappiness is determined not by our circumstance but by our disposition." No doubt this attitude came in handy during the difficulties of the Revolutionary War years, much of which she spent with her husband in the field.

Martha was the eldest of the eight children of English immigrant John Dandridge and his wife, Frances Jones, of King William County. She was born in 1731 at the family's Chestnut Grove plantation in New Kent County, a modest five-bay, two-story frame house of six rooms on a bend of the Pamunkey River several miles east of the county courthouse. The pine-paneled Georgian dwelling built in 1730 was later described as having "three rooms and a passage-way on each floor, and all the necessary out-houses, with a good orchard." Here she lived until May 1750, when at Chestnut Grove she married the immensely wealthy Daniel Parke Custis of York County, twenty years her senior. He was the son of the cantankerous John Custis IV, who initially opposed the match due to her lower family status but soon found her to be "beautifull & sweet temper'd."

Once married, the couple resided at White House on the Pamunkey River northwest of New Kent Court House. The Custis residence was a seventeenth-century house, and 100 slaves lived and worked on the large estate. Martha bore four children, of whom two survived infancy: John Parke "Jacky" Custis, born in 1754, and Martha Parke "Patsy" Custis, born in 1756. However, tragedy struck a few years later when Daniel Parke Custis

died at White House in July 1757 at age forty-five, probably of a fever. The young widow and her children inherited her husband's massive estate, including nearly 283 slaves, 17,500 acres of land, houses in Williamsburg and Jamestown and other financial assets. It is thus not surprising that Colonel Washington was interested in Martha Custis, given her enormous wealth, although the estate was embroiled in legal challenges for years.

After Washington visited the recent widow in March 1758, he corresponded with her at least several times, and some sort of understanding must have been reached between them regarding their future together. "I profess myself a Votary to Love," he wrote from the frontier in September 1758 to Sally Fairfax at Belvoir, though whether he was referring to Martha or Sally remains a disputed question. Once he returned to Virginia in late 1758 after serving in the Forbes campaign against Fort Duquesne in western Pennsylvania that fall, Washington married Martha in New Kent County on January 6, 1759. Washington's fellow Virginia Regiment officer Captain Robert Stewart congratulated him soon thereafter on the "happy union with the Lady that all agree has long been the just object of your affections."

After a brief stay at Williamsburg and White House, the family left to live

Nineteenth-century print of George Washington and family at Mount Vernon, including Martha and her two children, John Parke Custis and Martha Parke Custis. *Library of Congress.*

at Mount Vernon in early April 1759. Washington was apparently anxious about how Martha would like Mount Vernon, which she had never before seen. In advance of their arrival, Washington wrote to his chief servant that he must "have the House very well cleand, & were you to make Fires in the Rooms below it w[oul]d Air them—You must get two of the best Bedsteads put up—one in the Hall Room, and the other in the little dining Room that use to be, & have Beds made on them against we come—you must also get out the Chairs and Tables, & have them very well rub[be]d & Cleand—the Stair case ought also to be polishd in order to make it look well." Washington also directed him to "get some Egg's and Chickens, and prepare in the best manner you can for our coming."

Washington became the legal guardian of Martha's two children once they married and was responsible for managing all their financial affairs and property. He wrote many years later that he "considered marriage as the most interesting event of one's life, the foundation of happiness or misery." Shortly after their arrival at Mount Vernon, he wrote "I am now, I believe, fixed at this seat, with an agreeable partner for life." It is clear from the course of their nearly forty-year union that happiness and not misery were the results.

THE WORLD OF MARTHA CUSTIS

Few of the homes related to Martha Washington can be visited today. Chestnut Grove, her childhood home, was on a bend of the Pamunkey River three miles northeast of New Kent Court House. It was on Cook's Mill Road (Route 623) heading east from the courthouse village, where Chestnut Grove Road is seen on the left. The house burned down in 1926, and the site is not open to the public or visible from the road. Poplar Grove, where Martha first met Washington, is four miles north of Talleysville in New Kent County, near the mouth of Matton Creek along the Pamunkey River and north of Route 608 (Old River Road). It, too, is privately owned and not open to the public.

Also in New Kent County is the site of the White House, the Custis property where George married Martha. No longer standing, it was situated along the river at the end of White House Road (Route 614), opposite the Pamunkey Indian reservation, seven miles northwest of New Kent Court House. The site is now privately owned but can be seen clearly from the end of the public road along with views of the river. The house burned down in May 1862 during

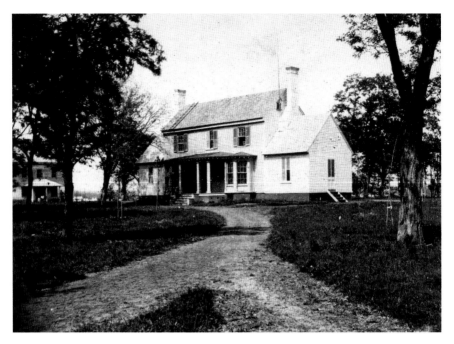

Pre–Civil War image of White House plantation in New Kent County, where George and Martha Washington were likely married. The house was destroyed in 1862. *Library of Congress.*

occupation by Union troops of Major General George B. McClellan's Army of the Potomac during the Peninsula campaign in the Civil War.

Several other important locations related to George and Martha Washington were in New Kent County and across the tidal Pamunkey River in King William County, some of which can be found today. One of the most striking is St. Peter's Church in New Kent County about three miles south of White House plantation, on what was the original colonial road from the county courthouse. Begun around 1701 and completed in the summer of 1703, this stately brick church is the third oldest in Virginia and was Martha's parish church until she moved to Mount Vernon in 1759. It replaced an earlier Anglican church of the late seventeenth century about three miles west. Her father previously served as this church's warden and vestryman. The rector of the church, Reverend David Mossom, performed the wedding nuptials of Martha and George Washington, although whether or not the ceremony took place at St. Peter's Church, as a number of books and traditions have asserted (including the state historical marker nearby on State Route 249), is not certain. In the wooded, park-like churchyard are several colonial-era graves, and the church itself is distinguished by a high tower added in 1740.

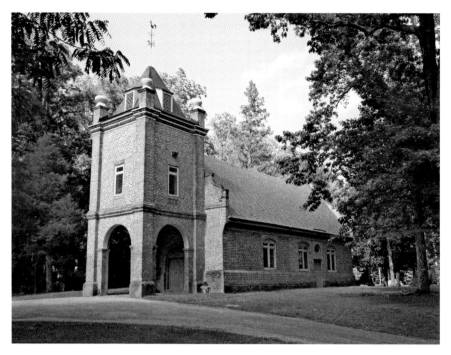

Martha Washington's home parish church, St. Peter's in New Kent County, still has an active congregation today. It is an early eighteenth-century structure. *Author photo.*

After the Revolution, the church fell into disrepair and was occupied by Union troops during the 1862 Peninsula Campaign. After the Civil War, Confederate general Robert E. Lee (who married Martha's great-granddaughter in 1831) called it "beautifully situated on the road from New Kent courthouse to Richmond in a grove of native oaks." As an 1871 newspaper reported, however, "the church itself was broken and battered, and rendered wholly unfit for use." It was reopened in 1872 after some repairs were completed by local parishioners. Active restoration work began in 1922, and by 1960, the State of Virginia deemed it "The First Church of the First First-Lady." With an active congregation today, the picturesque renovated church can be visited north of Talleysville at 8400 St. Peter's Lane (Route 642), New Kent, and can be contacted at (804) 932-4846 or by visiting www.stpetersnewkent.org.

Another church in the vicinity—attended by the Washingtons on occasion while visiting with friends—was Warreneye Church, which was also called the upper church in Blisland Parish near Eltham plantation. At least two early eighteenth-century marked graves can be found there, surrounded by

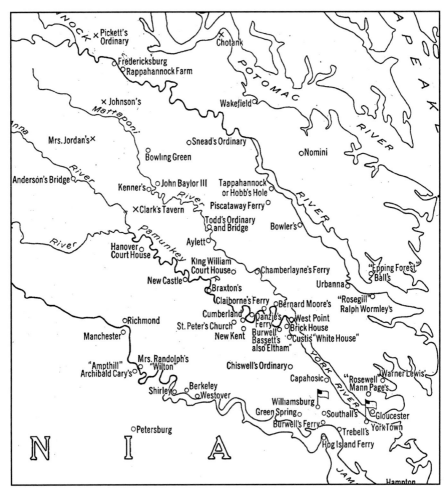

Tidewater Virginia, from Fredericksburg to Yorktown, includes many sites from Washington's "Burgess Route" and the Yorktown campaign. *George Washington Bicentennial, Vol. 1.*

a white fence. The church was erected in 1703, and the site of the now-lost structure is within the 138 acres of the Wahrani Nature Trails in New Kent, at the far eastern point of the park on a hill near the Pamunkey. The trail head is on the east side of Route 33 about 3.8 miles from exit 220 off I-64, just past Route 30.

The Warreneye Church was located near the home of one of George Washington's closest friends and his brother-in-law, Colonel Burwell Bassett. Two years younger than Washington, he was married to Martha Washington's sister Anna Maria Dandridge, a member of the House of

Burgesses and later an active supporter of the Patriot cause in the American Revolution. Bassett handled much of Washington's financial affairs while the general commanded the Continental Army during the war. Washington was a frequent guest at the Bassett home, called Eltham, on the south bank of the Pamunkey River two miles from West Point. No longer standing, it was a huge early Georgian brick house of two and a half stories and five bays, with wings at each side. One contemporary wrote that "the house presented an imposing front, one hundred and fifty feet from wing to wing; the entire building, with peaked roof and gable front, rising above them like the keep of a castle." It burned down in the 1870s, and the site is privately owned today. The small village of Eltham is in New Kent County just across the Pamunkey River from West Point on Route 33; the plantation house was by the river northwest of the town.

Also in the vicinity of West Point were several plantations in New Kent County inherited by Martha's son, John Parke Custis, from his father's large estate. The Custis plantations in New Kent, totaling 6,264 acres, included Rockahock (along the Pamunkey River); Brick House (one and a half miles southeast of the town of Eltham, along Brickhouse Lane to Brickhouse Point); Old Quarter (north of St. Peter's Church); and Harlow's, which consisted of over 2,000 acres near Cumberland and a landing on the Pamunkey two miles from New Kent Court House on Cumberland Road. Daniel Park Custis's estate also included plantations on the Eastern Shore of Virginia totaling 4,650 acres, including Smith Island and Mockhorn Island and Arlington in Northampton County near Cheriton. In 1778, Jacky Custis advertised them for sale, as they were too far away to manage them effectively.

Claiborne's plantation of nearly three thousand acres (much of it marshland) in King William County was included in Martha's dower property for her lifetime according to her first husband's will. This land would eventually revert to Jacky Custis upon Martha's death. Claiborne's, the site of a well-known ferry on the Pamunkey River at the time, was on the north side of that tidal estuary in a bend of the river near modern Route 634 off Route 30 (King William Road), at Sweet Hall. Claiborne's Ferry connected King William County to New Kent County at a landing now at the end of Route 624 (Old Sweet Hall Ferry Crossing), five miles northwest of New Kent Court House and west of West Point.

Washington later negotiated the purchase of two additional plantations for his stepson in 1773. One was in King and Queen County north of the Mattaponi River, the former lands of the late Speaker of the House of Burgesses John Robinson called Pleasant Hill, described in a sale notice

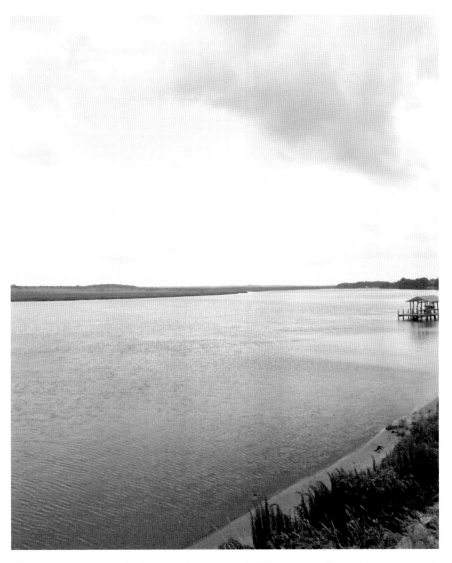

The Pamunkey River at Claiborne's Ferry in King William County. Several ferries operated here starting in the mid-1600s at this river crossing, used by colonial travelers to reach Williamsburg. *Author photo.*

as a "beautiful seat and plantation." These 1,300 acres were located on the river near the modern hamlet called Little Plymouth, at State Route 14 (The Trail) and Route 614 (Clifton Lane), which leads to the river east of Plymouth Swamp. Robinson was buried here upon his death in 1766, after which the largest financial scandal in Virginia's colonial period

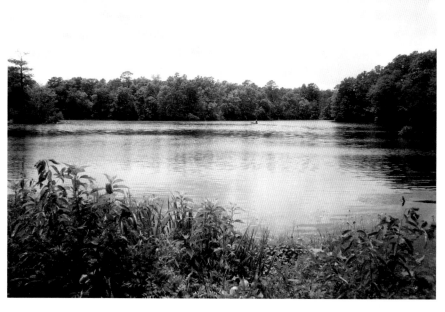

The Custis Mill pond, part of Romancoke plantation owned at one time by Martha Washington's son, John Parke Custis, along with several other estates nearby. *Author photo.*

emerged when the Speaker's illegal loans of public money to his political favorites was revealed by auditors.

The other plantation sat between the Pamunkey and Mattaponi Rivers in King William County and was called Romancoke. It included 1,700 acres, a water gristmill on Bull Creek "very lately rebuilt, on a fine and constant stream," several peach orchards and "a large genteel two story brick house, with four rooms and a large passage on a floor, and all convenient out-houses in good order, and a large falling garden inclosed with a good brick wall." Romancoke, a dower property of Martha's, was located west of the current town of West Point, along Route 30, with the house located close to the Pamunkey River near the modern Ephesus Church. Much of the land was directly across the river from Eltham and full of marshes. The mill was farther west, on what is now Custis Mill Pond Road (Route 625), north of Route 30, and is now owned by a private fishing club but visible from the road. Through the Custis family inheritance, Romancoke later came to be owned by Robert E. Lee Jr. after the Civil War, and he held this tract until his death in 1914.

The Burgess and the Revolutionary

A ccording to a modern writer, George Washington visited Virginia's second capital, Williamsburg, over fifty times during his lifetime. As a young officer in the Virginia provincial forces, he traveled to Williamsburg from Mount Vernon and the Shenandoah frontier several times during the French and Indian War to meet with Governor Dinwiddie and other Virginia leaders. Beginning in 1758, Washington served as a member of the colony's House of Burgesses, the first democratically elected legislative body in Britain's North American colonies, which met at the capitol building, rebuilt in 1754 after a fire destroyed the previous one.

Williamsburg: Taverns and Politics

Washington was first elected to the House of Burgesses (also called the Assembly) in 1758 from Frederick County, in the northern Shenandoah Valley, where eligible voters there would have known him well from his military service. He represented this county until 1761, at which time he was elected to the legislature from Fairfax County, home of Mount Vernon. For fifteen consecutive years he served in the House, until 1775, at which time he was named Continental Army commander while he attended the Second Continental Congress in Philadelphia.

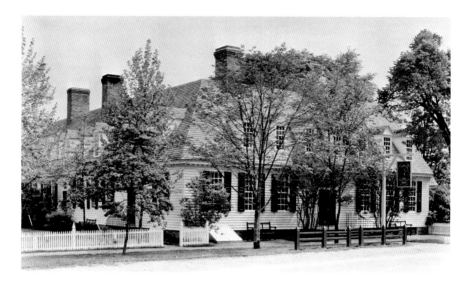

The reconstructed Raleigh Tavern at Colonial Williamsburg, frequented by Washington and numerous other Founding Fathers in the decade prior to the American Revolution. *Library of Congress.*

While in Williamsburg, Washington frequented many public taverns to lodge, take his meals and gather with fellow burgesses and public officials during the course of his responsibilities. One of these was Christiana Campbell's Tavern, at 101 South Waller Street, just east of the capitol building. Washington also dined at Wetherburn's Tavern on Duke of Gloucester Street (the main street in town), an original building dating back to before the 1750s. Across the street at the Raleigh Tavern, one of the largest in Virginia in the colonial period, Washington took refreshment and meals, and it was here he engaged in the important political debates of the 1770s, when two royal governors disbanded the House of Burgesses for opposing the policies of the British Crown. Delegates—including Washington—met in the Apollo Room to debate the issues of the growing crisis and agree on a course of opposition. The current white frame building is a reconstruction of the original, which burned in 1859.

Also open to visitors in Williamsburg are several other buildings Washington and his contemporaries—Thomas Jefferson, George Mason, Patrick Henry and others—knew well. The colonial capitol building, on the east end of Duke of Gloucester Street, was where Washington and his fellow burgesses met for their legislative sessions. This was a two-story brick structure of two sections connected by an arcade. In the west building housed the colony's General Court, and in the east section was the chamber of the House of Burgesses. The original building was completed in 1705. After a 1747 fire, the capitol

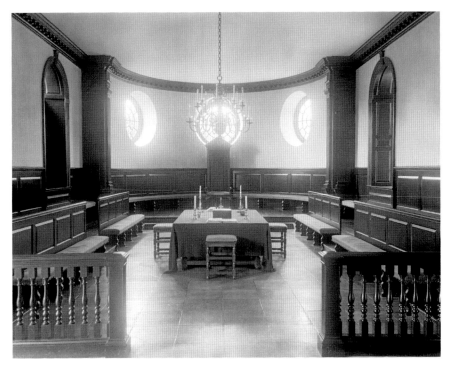

The chamber used by the Virginia House of Burgesses in the colonial capitol building. Washington served here as a representative of Frederick and Fairfax Counties. *Library of Congress.*

was rebuilt by the end of 1751. The south ends were squared in this new iteration of the capitol, rather than the semicircular apses seen in today's reconstruction, completed in 1934 by the Colonial Williamsburg Foundation. Although Washington gave few speeches or addresses while a delegate in the colonial House, he served on several committees and was a regular attendee at the Assembly's sessions, particularly during the growing imperial crisis with Great Britain in the 1760s and early 1770s.

Farther west and two blocks north of Duke of Gloucester Street is the Governor's Palace, reconstructed by 1934 by the Colonial Williamsburg Foundation. Built as the colonial governor's official residence in 1722, it was described two years later as a "magnificent Structure built at the publick Expense, finished and beautified with Gates, Fine Gardens, Offices, Walks, a fine Canal, Orchards, etc." Lieutenant Governor Robert Dinwiddie lived here beginning in 1752 through Washington's frontier war service, as did Governor Norborne Berkeley, baron de Botetourt; Governor Francis Fauquier, who served during the Stamp Act Crisis of 1765; and

The Virginia Governor's Palace in Colonial Williamsburg, rebuilt in the 1930s. *Library of Congress.*

Lord Dunmore, the last colonial governor of Virginia, who incurred the wrath of Patriots for his high-handed actions on the eve of the rebellion. Numerous dinners, balls, receptions and other festivities were held inside the palace and attended by Virginians in colonial times. Both Patrick Henry and Thomas Jefferson lived there during their terms as governor in the war years. The palace was destroyed by fire in 1781.

Washington was also an acquaintance of George Wythe, a well-known attorney originally from Hampton, a law professor at the College of William and Mary, a Continental Congressman in 1775, a signer of the Declaration of Independence and, in 1777, the speaker of the Virginia House of Delegates. "No man ever left behind him a character more venerated," Thomas Jefferson recalled of his law tutor. Washington was once a guest at Wythe's home, a house still standing on the Palace Green. A brick two-story Georgian dwelling of eight rooms, the house was obtained by the Colonial Williamsburg Foundation in the 1930s and restored for public visitation soon thereafter.

All of these Williamsburg sites and many more are part of Colonial Williamsburg and can be visited almost year-round. Some sites require admission fees. For extensive information about touring Colonial Williamsburg, see www.colonialwilliamsburg.com or call (888) 965-

The home of George Wythe in Williamsburg. Wythe was an eminent attorney and a fellow Virginia Patriot with Washington. *P. Jeffrey Lambert photo.*

7254, which includes planning for events, lodging, dining, tour packages, museums and living history demonstrations.

Just south of the Governor's Palace in Williamsburg is Bruton Parish Church, dating from 1715. George and Martha Washington and many other notables attended services in this Anglican ecclesiastical structure, now over three hundred years old. In the brick cruciform church with its tall steeple, men and women initially sat apart, with all parishioners seated in wooden box pews to keep out cold winter drafts. Overhanging galleries were added later, including one for College of William and Mary students. Governor Fauquier is buried under the stone floor of the church, which was used as a hospital during the Revolutionary War siege at Yorktown in 1781 and after the Civil War battle of Williamsburg in May 1862. The first two infant children of Daniel Parke Custis and Martha Custis are buried in the churchyard on its north side, near the church wall. Initial restoration of the church began in 1903, followed by an extensive renovation aided by Colonial Williamsburg in the 1930s. Bruton Parish Church remains an active Episcopal parish, is open daily for visitors and has services every day.

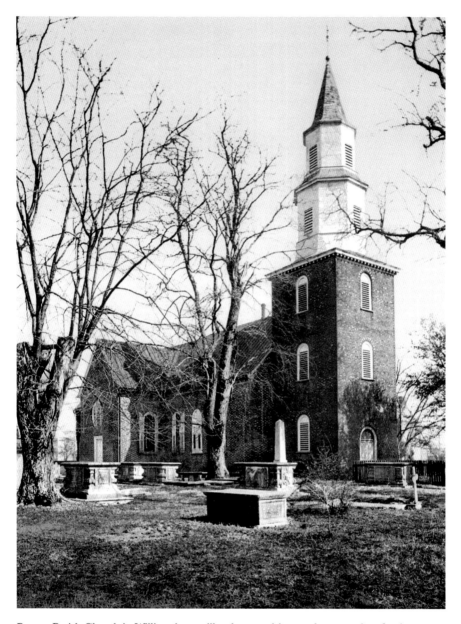

Bruton Parish Church in Williamsburg still welcomes visitors today centuries after it was built in the early 1700s. *Library of Congress.*

Many recitals and instrumental performances are held inside every year, including a Candlelight Concert series. More information may be had at www.brutonparish.org/visiting_bruton or by calling (757) 229-2891.

THE TRAVELS OF A VIRGINIA BURGESS

In the course of serving as a burgess in the colonial assembly, Washington had to travel from Mount Vernon to Williamsburg and back many times. Writers and biographers of the first president referred to this as "Washington's Burgess Route" beginning in the early twentieth century. It should be noted, however, that Washington took several different paths to Williamsburg, not just one, depending on road conditions, weather, flooding of rivers and streams and whom he wished to visit while traveling. These vagaries did not prevent the Virginia House of Delegates from coming up with its own designation for the "Burgess Route" in a 1940 act designating several roads in the state as authentic modern incarnations of Washington's colonial trail that citizens could follow in their cars. Little research underpinned the term, much like that of the state's 1980 designation of the Washington Rochambeau "Route to Victory" at Yorktown.

Perhaps a more accurate concept would be Washington's Burgess *routes*, in order to encompass the many roads, paths, fords, ferries, taverns, churches and homes he used, passed, visited and stayed in from the late 1750s until the eve of the Revolution in 1775. Many of these sites are known and still exist and can be seen by the curious explorer today throughout northern and eastern Virginia.

Often when Washington set out for Williamsburg, he rode south for Fredericksburg on what was then called the Potomac Path or King's Highway, so he could visit with family during his journey. On many occasions, he crossed the Occoquan River at Colchester by the ferry owned by George Mason or at what is now the town of Occoquan on Ox Road (Route 123), almost two miles upstream on the southern bank. From 1755 on, entrepreneur John Ballendine operated an iron furnace, a forge, two sawmills and a bolting mill and did business over the years with Mount Vernon's owner. In 1760, Washington considered suing Ballendine for shorting him some iron he purchased but was dissuaded from doing so by his lawyer.

The town originally started with the construction of a tobacco warehouse in 1734 at the falls of this stream, and the first courthouse of Prince William County was located nearby. Later, Occoquan emerged as a flour-producing center in the 1780s. Visitors to the town today can still see Rockledge Mansion, built of stone in about 1758 with a six-bay façade only one room deep. It is at 440 Mill Street on the northwest end of the village, at a site that overlooked the falls.

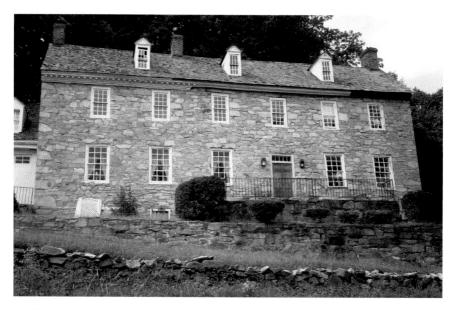

Rockledge, the striking home of prominent Prince William County entrepreneur John Ballendine in Occoquon. *Author photo.*

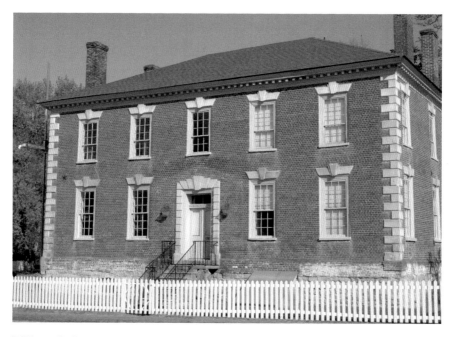

Williams Ordinary on the King's Highway in Dumfries, well known to Washington as he traveled to and from Williamsburg. *Prince William County Historic Preservation Division.*

From the Occoquan River, he rode south on the King's Highway. Washington made numerous stops over the years at Dumfries, in Prince William County. This town, founded in 1749 by Scottish merchants, was a thriving port rivaling Alexandria farther north situated on Quantico Creek about four miles inland from the Potomac River. Here was located Williams Ordinary, a two-story brick tavern with four interior chimneys built in the 1780s and located on the King's Highway—as it is today. The façade is unusual in that it was built with all of the bricks' headers facing outward. It is the last remaining Georgian-style building in Dumfries and can be seen along with the surrounding grounds at 17674 Main Street on the right side of the southbound lanes of US Route 1. Dumfries was also the third site of the Prince William County courthouse from 1760 to 1822, but it is no longer standing. Situated on the west side of Duke Street between Fairfax and Main Streets about five hundred feet north of Quantico Creek, it was a brick Georgian-style building with a hip roof. While this public structure was being constructed, the court met temporarily at the large home of Major Fouchee Tebbs—a fellow burgess with Washington—which was a two-story brick house of five bays on a steep slope on Main Street, destroyed in the 1930s. By the 1790s, the creek had become silted from runoff, and the port eventually declined in commercial importance.

Just north of Dumfries was the birthplace and home of Henry Lee III, later a cavalryman in the Continental Army, father of Robert E. Lee and post–Revolutionary War governor of Virginia. Called Leesylvania, the plantation was located on the Potomac River at Freestone Point, on a neck of land between Neabsco Creek and Powell's Creek. Washington visited the home at least once, in October 1768, with his stepson Jacky. The house no longer stands, but its site and much of Lee's tobacco lands are now part of Leesylvania State Park, where visitors can hike a trail to where the house once stood and explore over five hundred acres on several trails. It is located on Neabsco Road east of US Route 1 in Prince William County.

Several miles south of Dumfries was Peyton's Ordinary, where Washington stopped many times en route to Fredericksburg and Williamsburg. The tavern was owned by Yelverton Peyton and stood along the main road to Falmouth. Although a state historical marker is located on modern US Route 1 about two and a half miles north of Stafford Court House, the tavern was actually a mile north of Aquia Church. The tavern building no longer stands, but it was about two-tenths of a mile northwest of where Route 1 crosses Aquia Creek on the discontinued original roadway south of the creek. Close by was a small settlement called Aquia, on the creek of the same name in Stafford County.

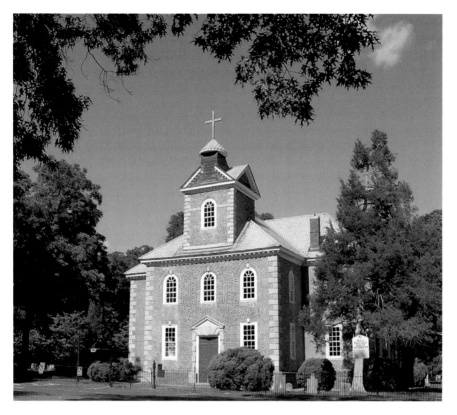

Set high above the old colonial road between Falmouth and Dumfries, Aquia Church was erected in the 1750s and is still in use today. Nearby was a town of the same name. *Dennis Springer photo.*

This, too, was an important place for shipping tobacco for the area's planters. It was also the source of sandstone used in the construction of Mount Vernon and Christ Church in Alexandria—and later the base of the Washington Monument. Thomas Tyler's ordinary was located there, where Washington is known to have dined.

Aquia Church is a wonderful remnant of the eighteenth century and Washington's days traveling in the area, perched on a high hill overlooking the old colonial road (now Route 1 at Route 610 and the Garrisonville Road exit off I-95), just south of Aquia and Peyton's Ordinary. This Anglican church was erected in 1757 on the site of two earlier wooden structures. The current church, which was known to Washington, was built in the form of a Greek cross, rare in Virginia, as is the unusual tower on the front (west) side of the building. Much of the interior is original, including

the three-tiered pulpit. Visitors can see the church at 2938 Jefferson Davis Highway, Stafford. For more information, call (540) 659-4007 or visit www. aquiachurch.com.

About twelve miles south of Peyton's Ordinary is Falmouth, on the north side of the Rappahannock River opposite Fredericksburg. The town is at the intersection of US Route 1 and US Route 17 and contains numerous structures of historic importance, mostly from the nineteenth century. The town was formed in 1727 and became a thriving river port and mercantile center at the fall line.

When Washington planned to visit his mother at Ferry Farm, he would ride southeast of Falmouth on the north side of the Rappahannock along River Road (today's Route 607) about three miles to her plantation. On his way (beginning in 1771), he passed the large brick Georgian manor house called Chatham, built over three years on a steep bluff overlooking Fredericksburg. Washington was a guest here, hosted by its owner, William Fitzhugh, and his wife, Ann Bolling Randolph Fitzhugh. Fitzhugh was a fellow burgess (1772–75) and—like Washington—an avid lover of horses and racing. An active Patriot during the Revolutionary War, after that conflict, he sold Chatham due to his poor financial situation and moved his family to Alexandria in 1796.

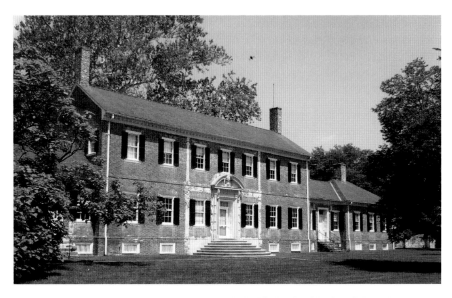

Once the imposing home of Washington's friends the Fitzhughs, Chatham Manor is now part of the Fredericksburg and Spotsylvania National Military Park. It was also the Union army's headquarters during the 1862 battle of Fredericksburg. *Friends of Chatham photo.*

Chatham Manor, since 1975 a unit of the National Park Service's Fredericksburg and Spotsylvania National Military Park, is easily accessible to the public off Kings Highway by taking the Williams Street bridge from Fredericksburg across the river and turning left (north) onto Chatham Heights Road. The house was the center of a 1,280-acre plantation that also included slave quarters, horse barns, outbuildings and a racetrack. There were extensive gardens surrounding the house and terraces leading down to the river's plain. Chatham also figured prominently as the Union army's headquarters in the Civil War battle of Fredericksburg in December 1862. Today's visitors can contact the Chatham Manor staff by calling (540) 693-3200.

SOUTH FROM FREDERICKSBURG

From Fredericksburg, Washington's usual route to Williamsburg was along what is now approximated by Route 2 south to Bowling Green, in Caroline County, about twenty miles away. Originally called New Hope, several taverns were located there, including Francis Coleman's, which he frequented while traveling. The village was situated at an important colonial crossroads, with routes leading to the Rappahannock, the tidewater and to the Potomac farther north.

Additionally, Washington also encountered the house and plantation that gave the town its name. Bowling Green, later called Old Mansion, is situated on the southern end of the town on Main Street and can be seen from the road on the right about 750 feet back (it is privately owned). A wide brick structure with end chimneys and a 1791 frame extension in rear, the house was originally constructed in the early 1740s (although dubious claims for a late seventeenth-century date of construction can be found in many sources). Notably, the house had a racetrack around it, in addition to a tree-lined bowling lawn in front, which can still be seen today from South Main Street. It was the longtime estate of the Hoomes family, who originally owned seventeen thousand acres in the area. Washington may have been entertained at the house during the Yorktown campaign of the Revolution, but he surely visited on occasion while serving in the House of Burgesses.

Farther south of Bowling Green on the west side of modern Route 2, Washington called on occasion to visit Newmarket, a sprawling plantation

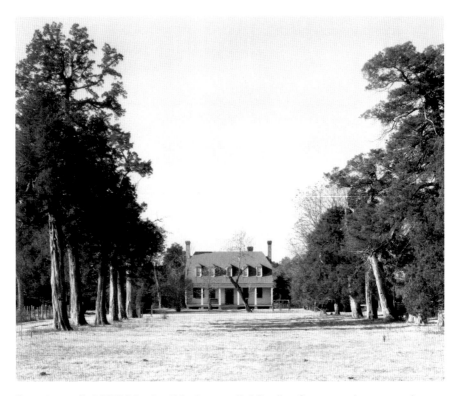

Sometimes called "Old Mansion," the house called Bowling Green gave its name to the nearby town in Caroline County. A racecourse once circled the house, around the trees. *Library of Congress.*

three miles from town. This estate was owned by the English-educated John Baylor III, a planter and a well-known breeder of thoroughbred horses along the eastern bank of the Mattaponi River. In fact, while a student he became so enamored with horses he named his Virginia estate after the popular English racecourse near Cambridge. Eventually he turned to importing expensive English horses as well, and Washington sent many of his mares to Newmarket for breeding with Baylor's prize studs—including Fearnought, for whom he paid over £2,000 in 1764. His racetrack is still partially visible on the grounds today, though Baylor largely gave up betting on horses by the 1750s. He served in the House of Burgesses from 1756 to 1765 and knew Washington quite well from serving under him in the French and Indian War at Winchester in 1755 and 1756. Baylor died deeply in debt at Newmarket in 1772. Baylor's son George was an aide-de-camp to Washington and later the commander of the Third Continental Light Dragoons during the Revolutionary War. He suffered a bayonet wound during the war

An eighteenth-century outbuilding at Newmarket, the Baylor plantation south of Bowling Green. It was known for its superb horses and racetrack. *Author photo.*

Green Falls plantation, located in Caroline County along an old roadway from Fredericksburg to Williamsburg, still stands in a bucolic setting. *Author photo.*

and eventually died from it in 1784 while seeking recovery in Barbados. Another Baylor descendant, Judge R.E.B Baylor, helped establish Baylor University in Waco, Texas, in 1845. Today, the plantation is a working farm, just south of the intersection of Route 721 and Route 2. Baylor's original 1730s house is no longer standing, but at least one eighteenth-century outbuilding remains, and a monument to Baylor family members and their role in Virginia history is on this property.

Washington typically traveled southeast from the Newmarket area on what is now Sparta Road (Route 721), which was a major path to the lower section of King and Queen and King William Counties. At the modern hamlet of Dejarnette, he is known to have stayed to the left toward Sparta, but he might have made a turn to the right on occasion, on what is now the Mattaponi Trail (Route 627). On this road he would have passed Green Falls, also known as Johnston's Tavern in the mid-eighteenth century, at the corner of today's Routes 623 and 627. The property was originally a 2,700-acre land grant made to Richard Johnston near the original Caroline County courthouse at Kidds Fork, about half a mile south of the Green Falls, at Kidds Fork Road (Route 654). This white frame house dates from the mid-1700s, although the front porch is a later addition and claims have been made that the house itself is from 1710. It is a two-story dwelling with wings of one story on either side and huge chimneys of Flemish bond brickwork, set on a low hill near the crossroads. It is one of the oldest standing structures in Caroline County and is near an eighteenth-century meat house on this privately owned property. The home and outbuildings can be easily seen from the roadway and are set in an agricultural area of several hundred acres.

Records indicate that from Newmarket, Washington rode southeast generally on Route 721 (Newtown Road), although some modern side roads actually cover the original trace. On many trips to Williamsburg, the future president made stops at Hubbard's Ordinary in Caroline County, at today's village of Sparta, about seven miles east of the Baylors' Newmarket. Owner Benjamin Hubbard (who resided at Aylett) was a Quaker merchant and innkeeper since the 1750s, having moved to Virginia from Pennsylvania, and Washington had visited the tavern since at least February 1759. Washington's expense accounts show that he dined at this inn many times in the 1760s and 1770s and apparently stayed there one night with Martha and her children on the way to Mount Vernon after their wedding. Although a small village remains at Sparta, the tavern there has long since disappeared.

After crossing from Caroline into King and Queen at Beverley Run (still on modern Route 721) he passed Newtown, an important crossroads village

The eighteenth-century road to Todd's Bridge on the Mattaponi River in King and Queen County, traveled by Washington on his "Burgess Route." *Author photo.*

on the King's Highway even in Washington's day. Continuing, Washington headed for the well-known crossing of the Mattaponi River at Todd's Bridge, which no longer exists. This bridge was north of Aylett and present-day

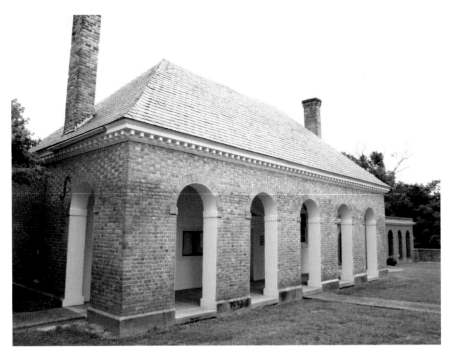

King William Court House, perhaps the oldest court building in the United States still in use today. *Author photo.*

US Route 360 and linked King and Queen and King William Counties. Its approximate site can be found at the west end of Route 628 (Todd's Bridge Road), off of Newtown Road (Route 721) at Biscoe. Although drivers cannot access the bridge site on the river, the narrow road does go near it, and a sense of the eighteenth-century plantation countryside and road can be experienced in this area. Here Washington refreshed himself at Todd's Ordinary, probably situated on the north side of the river, along with many tobacco warehouses and wharves for shipping crops.

Once across the Mattaponi, Washington rode southeast through the flat tobacco plantations of King William County (on modern River Road, Route 600) in order to reach one of the ferry crossings of the Pamunkey River, about thirty miles away. Along this route and State Route 30, he came to King William Court House, where today visitors can find the original colonial court building. This quaint one-room structure with its distinctive brick arcade façade was built in 1725 and may be the oldest courthouse of English foundation in continuous use in the United States. A low enclosure wall surrounding the courthouse and green was added in the 1800s.

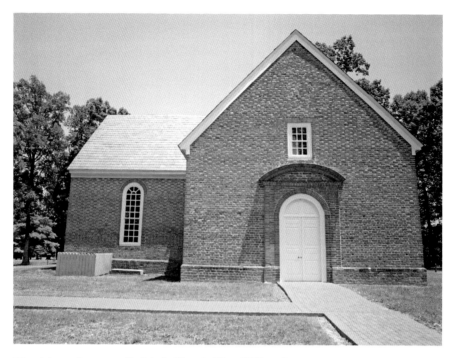

The eighteenth-century St. John's Church, King William County, situated on the "Burgess Route" near West Point, Virginia. This ecclesiastical structure has been painstakingly restored. *Author photo.*

As Washington rode south along the sandy road from King William Court House, he passed the beautifully simple ecclesiastical structure called St. John's Church, which has been restored to its eighteenth-century condition and is readily accessible to the public off Route 30, ten miles west of West Point. Built in 1734 from funds collected through a tobacco tax, the brick church was originally Anglican, and Carter Braxton, a signer of the Declaration of Independence, was a parishioner. He lived at nearby Chericoke plantation, on the Pamunkey River, eight miles south of King William Court House. The disestablishment of the Anglican church after the Revolutionary War and a destructive occupation by Union troops during the Civil War led to the building's deterioration, but starting with Robert E. Lee Jr. in 1877 and the St. John's Church Restoration Association in 1913, efforts to restore the church have been ongoing. The churchyard and surrounding land are open to visitors all year, and the renovated interior can be seen at times as well by contacting the association at www.oldstjohns.org.

ACROSS THE PAMUNKEY

Still headed south, Washington crossed the Pamunkey River at several ferries near West Point during his years as a burgess. Most of them were close together and operated under different names over the years. One was called Thomas Dansie's Ferry, which crossed to New Kent County from a wharf near Claiborne's plantation in King William County, in the marshy grounds northwest of West Point. Nearby is the Claiborne family's Sweet Hall plantation, including a one-and-a-half-story brick dwelling built in a T-shape. The house was constructed in the early eighteenth century and is considered to be an example of pre-Georgian architecture. Notably, the house's uppercruck, the curved timbers supporting both the walls and roof, is one of only three such structures to use this framing known in America and the only one in Virginia. The house can be viewed at a distance by turning south off of Route 30 seven miles from West Point onto Sweet Hall Road (Route 634). The property

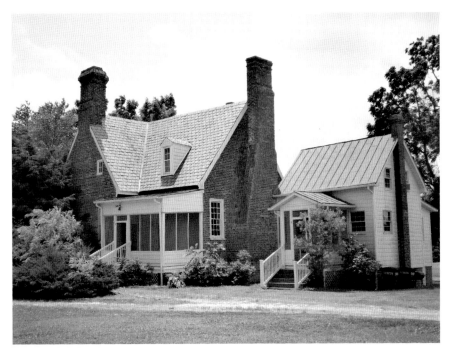

The early 1700s plantation house called Sweet Hall, at Claiborne's Ferry in King William County. The dwelling is a rare example of surviving pre-Georgian architecture in Virginia. *Author photo.*

is not open to public visitation, but some glimpses of the Pamunkey River can be had along Sweet Hall Road.

Also located close to this ferry landing is Windsor Shade, a one-and-a-half-story five-bay frame house on top of a brick basement built around 1745 by the Chamberlayne family. The massive double chimneys at each end are perhaps the structure's most impressive features. This private house (sometimes called Waterville) also served as a tavern and was patronized by George Washington from the 1750s to the siege of Yorktown in 1781. It is situated just west of the Sweet Hall house and the site of Claiborne's Ferry (also called Ruffin's Ferry), frequently used by Washington to cross into New Kent and back. Windsor Shade is only partially visible from the road beyond Sweet Hall, near Harrell Pond, in a stand of tall trees.

The southern landing for Claiborne's (Ruffin's) Ferry was at the end of Sweet Hall Ferry Crossing Road (Route 624) in New Kent County, eight miles from Eltham. One 1755 traveler who crossed at Claiborne's Ferry noted that the ferry had to make "a long slant" across the river to the other

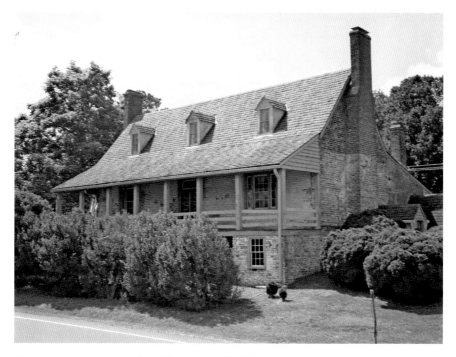

The colonial-era tavern at New Kent, where Washington and traveling companions dined in 1773. *Author photo.*

side "upon the account of large marshes" along the Pamunkey's many twists and turns, which can still be observed today.

Once in New Kent County across the river, Washington's journey to Williamsburg took him along what is now Route 30 through Barhamsville to modern US Route 60 and on to the old colonial capital. Washington visited New Kent Court House many times from the late 1750s to the 1780s. Here the small town is still home to a roadside eighteenth-century tavern, a one-and-a-half-story building with dormers and a high front porch. Washington recorded in 1773 that he "Dind at New Kent Court House" on his way to Westover on the James River. The tavern is directly across from the courthouse complex on Route 249, close to the road.

FERRIES AND FRIENDS

Occasionally, weather conditions, poor roads and flooded rivers forced Washington to take an alternate path to or from Williamsburg. In May 1763, for instance, he crossed the Potomac near Mount Vernon into Maryland, at times by the Clifton Neck ferry near today's American Horticultural Society, part of the River Farm. He then rode south in Charles County to Lower Cedar Point on the river (at today's Morgantown) where he crossed back into Virginia using Hooes Ferry, the landing of which on the lands of Colonel Rice Hooes is now within the Naval Surface Warfare Center south of the modern Potomac River Bridge (with no public access to the site). The Hooes family had operated a ferry at this spot since at least 1713.

Proceeding south once in Virginia, he crossed Machodoc Creek by Little Ferry (on modern Little Ferry Road, Route 613) downstream from where today's Windsor Drive (Route 218) crosses the creek. Washington then crossed the Rappahannock River into Essex County at Layton's Ferry, about twenty miles upriver from Tappahannock at a narrow span of less than half a mile. This ferry landing was just east of Leedstown in Westmoreland County, on Route 640, Layton Landing Road. Leedstown, now with few traces of the eighteenth century, was an important tobacco port and the closest town to the Washington farms on Popes and Bridges Creek. Here in February 1766, over one hundred prominent Northern Neck men assembled to approve a proposal written by Richard Henry Lee to protest the hated Stamp Act, enacted the year before by Parliament. Known now as the Leedstown or Westmoreland Resolves, the document

Layton Landing Road, leading to the Rappahannock River in Essex County. *Thomas A. Reinhart photo.*

was signed by Washington's brothers Samuel, John and Charles, who along with their cosigners were "roused by danger and alarmed at attempts, foreign and domestic, to reduce the people of this country to a state of abject and detestable slavery." The meeting was likely held at Bray's Church (built in 1678) in the town, but this structure is no longer standing.

The hamlet of Leedstown is located on Leedstown Road (Route 637) on the north side of the Rappahannock, about twelve miles south of the George Washington Birthplace and sixteen miles from Port Royal. The southern landing site for this ferry on the opposite bank is also on Layton Landing Road (Route 637, off of US Route 17) in northern Essex County fifteen miles from Tappahannock, lined with tall trees and high banks, retaining its eighteenth-century appearance. From there, Washington likely rode south on what is now Route 17 to Tappahannock into King William County on his way to Williamsburg.

In April 1763, on Washington's return route from Williamsburg, he stopped to visit his cousin Lawrence Washington, who was descended from the brother of George's great-grandfather John the Immigrant. His kinsman's plantation and his father's temporary early home, Chotank, was on a bluff overlooking the Potomac in what was then Stafford County at the mouth of Chotank Creek. George had visited the plantation here many times in the late 1740s during his teenage years and again in 1768 on a fishing excursion. His brother Samuel had also settled in this area by then, on a six-hundred-acre plantation. The site was near modern Owens in King George County, about twenty miles east of Falmouth. It is now part of the Chotank Creek Natural Area Preserve, which is privately owned and not open to the public, but hikers can get a feel for the area within the eastern part of Virginia's Caledon State Park on Route 218, adjacent to the Chotank preserve. In fact, Washington sometimes crossed the Potomac either to or from Nanjemoy, Maryland, to Boyd's Hole, an old Virginia ferry landing as early as 1705, a tobacco inspection station starting in 1742 and shipping point, now within the wooded park's boundaries. From the visitor center of the park, a two-mile improved trail leads to Boyd's Hole on the river, where long views of the wide Potomac can be enjoyed in both directions.

About ten miles south of Boyd's Hole and thirteen miles east of Fredericksburg, Washington dined on occasion at one of the Carter family plantations called Cleve, on the north side of the Rappahannock River about four miles southwest of today's courthouse town of King George. Much of his land was in a bend of the river called Nanzemun Neck. Here Charles Carter (not to be confused with the owner of Shirley, near

On the south bank of the Potomac River, Boyd's Hole was a well-used ferry landing used by Washington to cross from Maryland to Virginia. It is now located in Caledon State Park near Fredericksburg. *Richard C. Maass II photo.*

Richmond) was a fellow burgess of long service to the colony and a militia officer. Twice a widower, he had also courted Martha Dandridge Custis before she married Washington. Carter was a prominent supporter of

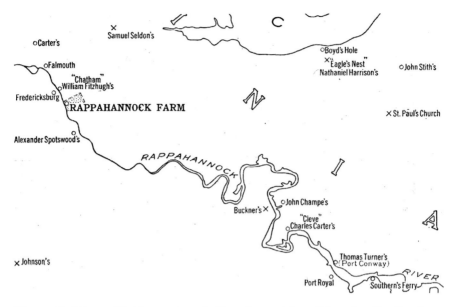

The world of George Washington along the Rappahannock from Falmouth to Port Royal. Note also Chatham, Cleve, and Boyd's Hole. George Washington Bicentennial, *Vol. 1*.

agricultural diversification and also engaged in winemaking, copper mining and distilling. At Cleve, Carter grew the first recorded European grape vines in Virginia by 1763 and was awarded a medal for these efforts by the London Society for the Encouragement of the Arts, Manufacture and Commerce. His home at Cleve reflected his wealth—it was a large brick dwelling near the river, known also for its collection of family portraits, but it was destroyed by fire in 1800. The site of the plantation can be viewed along Cleve Drive (Route 692) on the east bank of the river near the crossroads called Dogue. Additionally, a public boat launch and fishing pier on the river off nearby Port Conway Road (Route 607) give visitors an excellent view of the plantation's riverbanks.

Not far from Cleve, Washington had occasion to attend divine services at St. Paul's Church in King George County in 1768. This Anglican church (now Episcopal) is a two-story Flemish bond brick structure. High windows in two tiers on all sides distinguish this beautifully proportioned Greek cross structure, still nestled in a rural setting. It was constructed in the mid- to late 1760s, so perhaps Washington wanted to see the new church while he was nearby visiting his brother John. Much of the interior woodwork is not original, but the simple exterior is in fine condition. Part of the vestry house that stands nearby is also of the colonial period. St. Paul's is at the south

Cleve Plantation, owned by Washington's friend and planter Charles Carter, was located on the north bank of the Rappahannock River (*right side*) below the fall line. *Author photo.*

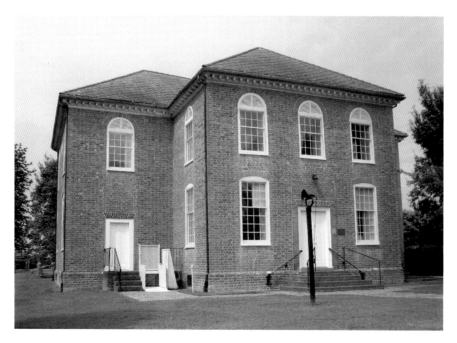

St. Paul's Church in King George County, attended by Washington in the 1760s. *Author photo.*

side of the intersection of St. Paul's Road (Route 632) and Dahlgren Road (Route 218), not far from Chotank Creek, and about seven miles from King George Court House. Information about visiting the church can be had at www.stpaulskgva.org.

On several trips to Williamsburg, Washington the burgess crossed the Rappahannock at Port Royal in Caroline County, about twenty miles upstream from Leedstown on the main road from the Potomac River to Bowling Green. Port Royal was an old tobacco shipping town settled in 1652, and it is situated at the modern crossroads of US Routes 17 and 33 in Caroline County. The wood frame tavern here was called Roy's—after the original proprietor's name—and still stands, despite having been built around 1750. Visitors can also see the remaining chimneys of the Dorothy Roy house from the eighteenth century; the 1770 Holloway house; the mid-eighteenth-century Peyton-Brockenbrough house; the 1755 Fox Tavern, where George Washington lodged on three occasions; and the St. Peter's Church Rectory, built in about 1745. More information can be found at www.historicportroyal. net, and the town's museum is located at 506 Main Street.

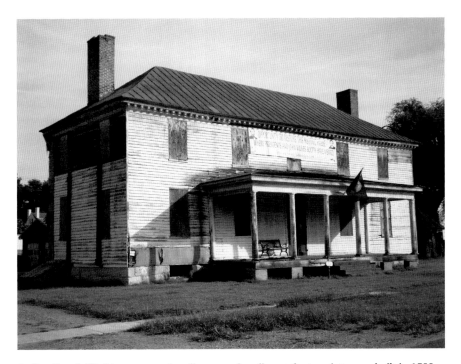

At Port Royal, Washington occasionally stopped to dine at the town's tavern, built in 1755. *Thomas A. Rinehart photo.*

While serving in Williamsburg as a legislator, Washington had many occasions to visit nearby homes and farms of friends and family. In the winter of 1764, for instance, Washington visited Rosegill, the plantation of Ralph Wormeley in Middlesex County. This large white frame house was originally built in 1740 overlooking the Rappahannock. It was enlarged in the early 1770s, which made the façade eighty-eight feet wide with eleven bays. The home was later modified greatly in the 1850s and 1940s. Several outbuildings from Washington's time do remain, however. The privately owned dwelling stands on the east side of the mouth of Urbanna Creek, across from the town of the same name north of Route 227, just two hundred yards from the river but far off the public road.

Nearer to Williamsburg was a Washington-related property on the Severn River in Gloucester County, called Warner Hall. Mildred Warner, who grew up here, was George Washington's grandmother. Additionally, Betty Washington—George's sister—married Fielding Lewis, whose parents lived at this plantation. Washington visited Warner Lewis there in 1768 at least once. Although the eighteenth-century mansion house no longer stands, visitors to the property—now a bed-and-breakfast—can see an original seventeenth-century dependency that was the plantation's schoolroom and tutor's quarters, and eighteenth-century brick stables, a dairy barn and a smokehouse. Patented in the early 1600s by Augustine Warner I, Nathaniel Bacon used this plantation briefly as his headquarters during the rebellion he led in 1676. Additionally, the family graveyard is nearby, maintained by the Association for the Preservation of Virginia Antiquities. The site, including the Inn at Warner Hall, is at 4750 Warner Hall Road (Route 629), east of White Marsh. The inn can be reached at www.warnerhall.com.

In 1764, records show that Washington paid a visit to Mann Page II, whose Gloucester County plantation, Rosewell, was situated on the York River and Carter's Creek. This massive three-story Flemish bond brick house on a raised basement was built over a period of several years starting before 1726 by Mann Page I and completed about 1737 by his son, Mann Page II. When completed, the home had thirty-five rooms inside. Shortly after Washington's 1764 visit, Mann Page II and his wife moved to a new home, Mannsfield, near Fredericksburg. His son John (who had served under Washington in the French and Indian War and was later governor of Virginia from 1802 to 1805) remained at Rosewell and became a close friend of Thomas Jefferson, who visited the home several times. Even in ruins—the house burned down in 1916—it is impressive, and has been called "the finest of all American houses" in its day by noted architectural historian Thomas

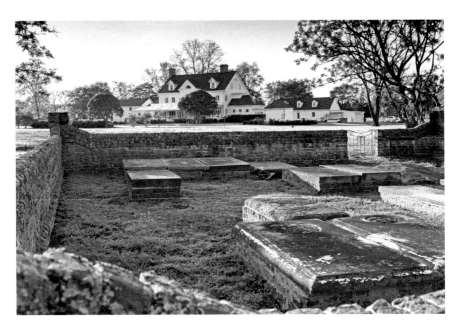

Warner Hall in Gloucester County, with the old graveyard of Washington's ancestors in the foreground. *Jumping Rocks Photography.*

T. Waterman, particularly due to its "superb brickwork." Moreover, the house also included two turrets on the roof, carved staircases and elaborate interior paneling. The site of Rosewell and surrounding acres is now in the care of the Rosewell Foundation and can be visited at 5113 Old Rosewell Lane, west of White Marsh, in Gloucester County. More information can be had by calling (804) 693-2585 or at www.rosewell.org.

Closer to the Custis lands and homes around West Point was another plantation Washington came to know on the Mattaponi River: Chelsea. The massive brick house was built around 1709 by Augustine Moore and has had quite a history. Located at the end of Chelsea Plantation Road about two miles north of Route 30 near West Point, the Moore home overlooks the Pamunkey River. This two-story Georgian house with a hip roof was built using striking Flemish bond brickwork with glazed headers, while inside several of the rooms are fully paneled in both walnut and pine and filled with family portraits. In the early colonial period, the house was the site where Virginia governor Alexander Spotswood and his "Knights of the Golden Horseshoe" left on their famous journey to the peaks of the Blue Ridge Mountains in 1716. Spotswood's daughter Anne Katherine later married Moore's son Bernard in 1742 (who was deeply in debt to Martha

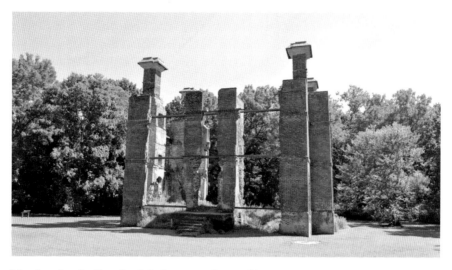

Now in ruins, the Page family's three-story Rosewell house on the York River in Gloucester County was once considered to be the finest home in Virginia. It burned in 1916. *Ginger Shaw photo.*

Built in the early 1700s on a bluff above the Mattaponi River near West Point, the mansion at Chelsea was visited by Washington, Jefferson and Lafayette, and it is still open for tours today. *Author photo.*

Washington's daughter Frances by the early 1770s, through her inheritance from her father). Bernard Moore lived at Chelsea from the 1760s until his death in 1775—without settling his accounts with Patsy Washington before her death in 1773.

George Washington visited and dined here on his way from Fredericksburg to Williamsburg, and Thomas Jefferson attended the wedding of Bernard's daughter Betsy and John Walker (of Albemarle County) here in the 1760s. Later, in August 1781, part of the army commanded by the Marquis de Lafayette camped here prior to the siege of Yorktown, and Bernard's son served on the Frenchman's staff. The estate belonged to the Moore family until the 1870s and is now once again owned by a Moore descendant. The impressive house, graveyard and grounds with sweeping views of the winding river are open for tours, about which visitors can contact the site at (804) 843-2386 or through the plantation's website www.virginia.org/listings/HistoricSites/ChelseaPlantation.

On the banks of the Pamunkey River is still another fine old home and grounds with a Washington connection, this time from Martha's family. Elsing Green began as a plantation on the Pamunkey River in the late 1600s, owned by the West family. Through the marriage of Unity West to William Dandridge, the estate came to Martha Washington's forebears in 1719. The main house was built around 1720 in the Queen Anne style, in a *U* shape with two stories of brick laid in Flemish bond. Nearby is the original brick Jacobean period lodge from about 1690, and at the river was the site of Williams' Ferry, often used by travelers such as George Washington. By the time Washington was a burgess, the property had been sold to the wealthy Carter Braxton. The main house and grounds, located at 1048 Elsing Green Lane, King William (off Route 632), may be viewed by appointment by calling the Lafferty Foundation at (804) 769-3416.

JAMES RIVER VISITS

During his legislative service in Williamsburg, Washington also traveled along the James River (on what is now Route 5) on the ancient River Road and paid calls at several well-known plantations, all of which can be visited today.

In November 1773, Washington went to Westover with Burwell Bassett and Jacky Custis, where they dined. Westover on the James River is considered to be the finest example of colonial Georgian architecture in the United

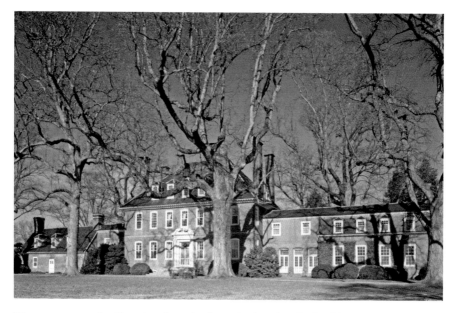

The most spectacular Georgian plantation home in America, the Byrd family's Westover, is located on the James River between Richmond and Williamsburg. *Library of Congress.*

States and "can have no peer as a picture of its style," writes an architectural historian. Completed in about 1750, it is a massive brick three-story home within yards of the river and known for its interior and exterior details, including the entrances, moldings, brickwork, plaster ceilings and three elaborate eighteenth-century English wrought-iron gates. The plantation had been in the Byrd family since 1688, and the library there eventually included four thousand volumes in several languages (which Federal troops destroyed during the Civil War).

Washington was acquainted with the owner of Westover, Colonel William Byrd III, who was residing there in 1773 with his second wife, Mary Willing Byrd, from their service as officers in the French and Indian War. Byrd was also a member of the royal governor's council from 1756 to 1775. As the most recent editors of Washington's papers conclude, the wealthy Byrd "had no head for managing his own affairs. He eventually dissipated his inherited fortune by indulging his passions for thoroughbred horse racing, gambling for high stakes, personal luxuries, and fine houses." He accumulated huge debts at the gaming table by his thirties and eventually killed himself in 1777. His wife's loyalties during the Revolutionary War were questioned by Virginia Patriots but she was not banished from the property. A quarter mile inland from the house is Westover Church, dating from the 1730s. This small, well-restored building was

used as a stable by Union troops in 1862, but by 1867, it was being used for worship again. Restoration began in the late 1800s. Washington is said to have worshipped here while visiting the Byrds prior to the Revolutionary War.

The exterior of the house and its grounds can be seen for a small fee at 7000 Westover Road on the south side of Route 5, six miles west of Charles City Court House. The interior is not open to the public. More information can be had by calling (804) 829-2882.

Soon thereafter, Washington visited the Harrison family plantation, Berkeley, where there stood a fine brick Georgian home only two miles west of Westover. The house has two stories and was built in 1726. Its owner was Benjamin Harrison V, one of Virginia's signers of the Declaration of Independence and postwar governor of Virginia for three years. Harrison was married to Burwell Bassett's sister Elizabeth. Also home at the time of Washington's visit was the Harrisons' new baby, William Henry Harrison, who grew up to win the battle of Tippecanoe in 1811 and was (briefly) the ninth president of the United States. The restored home and landscaped grounds are accessible to the public off Route 5 at 12602 Harrison Landing Road. Visitors should call (804) 829-6018 or visit www.berkeleyplantation.com.

The Harrisons lived at Berkeley and were visited there by George Washington just before the Revolutionary War. Two U.S. presidents were born in this house. *Library of Congress.*

Washington visited Shirley plantation on the James River in late 1773, an impressive Carter family home started in the 1730s. *Randy Carter photo.*

The following day, William Byrd took Washington to visit Shirley, the plantation home of the Carter family on the riverbank five miles upstream (west) where the James River narrows at Bermuda Hundred. The Hill family established the plantation there in 1638, and construction of the present manor house was begun in the 1730s by John Carter, a member of the governor's council and secretary of the colony. The brick house—"tall, graceful, and welcoming," according to a modern writer—is known for its "flying" staircase utilizing concealed supports and its intact Queen Anne forecourt, as well as formal gardens and several original brick outbuildings. It has a mansard roof and no center hall—unusual for its day. At the time of Washington's visit, the property was owned by Charles Carter, whose daughter Ann Hill Carter later married Revolutionary War cavalryman and Virginia governor Henry "Light-Horse" Lee at Shirley in 1793. Their son was Robert E. Lee of American Civil War fame.

Guided tours of the house and grounds are conducted regularly at the site, reached by turning south off Route 5 onto Route 156 (Roxbury Road), then turning right onto Westbury Farm Road and proceeding two miles. For additional details see www.shirleyplantation.com or call (804) 829-5121.

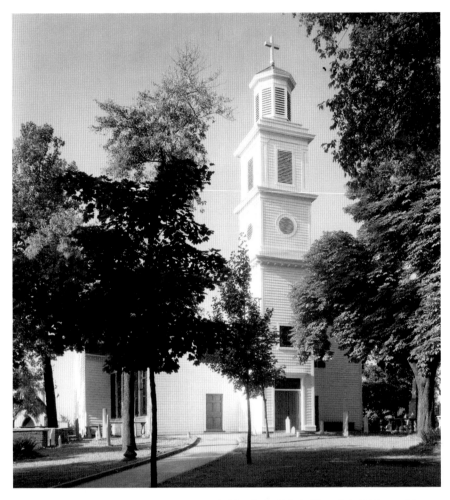

During a session of the House of Burgesses held at Saint John's Church in Richmond in 1775, Patrick Henry gave his famous "Liberty or Death" speech. *Library of Congress.*

Washington also spent some time in Richmond toward the end of his legislative career. In one instance, in March 1775, on his way to attend the Second Virginia Convention at Saint John's Church in Richmond to discuss the growing colonial political crisis with Great Britain (and where Patrick Henry demanded either "liberty or death"), he took a direct way south from Fredericksburg, as his diaries and expenses document. On that occasion, he rode to Bowling Green, where he dined at Roy's Ordinary, crossed the Mattaponi River at Burke's Bridge (on Burkes Bridge Rod, Route 654, near Wright's Fork) and proceeded southward to Hanover Court House, where he lodged for the night.

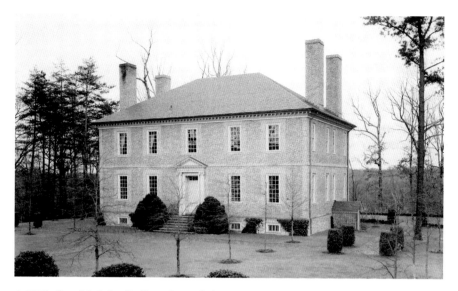

A 1750s Randolph family Georgian-style home on the James River. Lafayette used Wilton plantation as his headquarters in May 1781, and Washington visited here in 1775. *Library of Congress.*

During this stay in Richmond, Washington also visited Wilton, then on the James River below the city, a two-thousand-acre tobacco plantation and home of the influential Randolph family. The 1752 brick Georgian house, one "of subtle charms…solid and unpretentious" according to a modern author, was originally built by William Randolph III and his wife, Anne Carter Harrison (of Berkeley), on the north bank of the river on land called World's End. Although the exterior is relatively unadorned, every room is completely paneled, including the closets. In its original location, it served for a time as Lafayette's military headquarters in May 1781, and his Continental Army troops camped on the surrounding grounds. The Randolph heirs sold the house in 1859 to pay their numerous creditors, and for a time, the deteriorating home was used as a granary. It was relocated to Richmond's West End for restoration and to avoid industrial encroachment in the twentieth century. It is now open to the public and owned by the National Society of the Colonial Dames of America in the Commonwealth of Virginia, who rescued the house beginning in 1932 and moved it to its present location at 215 South Wilton Road in Richmond. More information about seeing this impressive brick Georgian manor house can be had at www.wiltonhousemuseum.org.

9

THE REVOLUTIONARY WAR

Triumph at Yorktown

I t is a matter of no little irony that General George Washington, commander of the Continental Army during America's War for Independence since 1775, won few military victories. His triumph at Trenton on December 26, 1776, was against a small garrison of only 1,000 Hessians in winter quarters, and Washington's subsequent victory at Princeton on January 3, 1777, was against a British detachment of just 1,200 men. Washington was soundly defeated at the battle of Long Island in the summer of 1776, and his army was pushed out of New York and across New Jersey by mid-December 1776, unable to impede the British advance. The following year, at Brandywine, Pennsylvania, he was again defeated in a battle. His overly complex plan of attack against the redcoats outside Philadelphia at Germantown in October 1777 failed to come together and led to his army's retreat to winter quarters. In June 1778, Washington attacked the enemy near Monmouth Courthouse, New Jersey, as they moved toward New York. The British stood and fought hard, then left the field the next day, leaving the Continentals with something less than a clear-cut victory. A period with no major battles involving Washington's troops followed the battle at Monmouth until well into 1781. Not until the summer and fall of that year was Washington able to coordinate the operations of his own army along New York's Hudson River with that of his French ally's troops and naval forces to fight a final battle against the enemy under Lieutenant General Charles, Lord Cornwallis far to the south.

Until autumn of 1781, none of Washington's battles were fought within his home "country" of Virginia. His three frontier military campaigns during

the French and Indian War—the humiliating surrender of Fort Necessity in 1754, General Braddock's disastrous defeat in 1775 and Forbes's successful campaign against Fort Duquesne in 1758—were all fought in Pennsylvania. His Revolutionary War operations from 1775 to the summer of 1781 described above ranged from Boston to New York and Philadelphia and New Jersey. It seems only fitting then that his greatest military victory and, arguably, the battle that finally broke Britain's will to continue the fight, was in Virginia, at the little river port called Yorktown.

MARCH TO YORKTOWN

A detailed account of the Yorktown campaign is beyond the focus of this book, but a general overview of Washington's successful operations in Virginia during 1781 follows. Additionally, the journey Washington made with his French army counterpart, General Donatien-Marie-Joseph de Vimeur, Vicomte de Rochambeau, from Mount Vernon to Yorktown immediately prior to the siege of the British position along the York River, is detailed here, as much of it can be followed by the modern tourist today. Known as the Washington-Rochambeau National Historic Trail, it has been one of the National Park Service's designated historic routes since 2009, based on the research and preservation efforts of the Washington-Rochambeau Revolutionary Route Association and the various states along the route.

In May 1781, Admiral Jacques-Melchior de Saint-Laurent, Comte de Barras, and Rochambeau arrived in Newport, Rhode Island, the headquarters of French army and naval forces in America. These two French officers were to coordinate efforts against the British in America with General Washington, who was to be the overall commander. Washington preferred an attack on British-held New York City, with Rochambeau's 5,300 troops and his own 6,650 Continentals. Rochambeau, however, was inclined toward a joint army and navy campaign against the British in the Chesapeake Bay. Admiral de Barras did not favor a Chesapeake expedition because of British naval superiority along the coast. In the end, all of these officers decided to pursue a campaign in Virginia against the forces under Cornwallis in the tidewater area of Virginia when they learned that another French naval force under Admiral François-Joseph Paul, Comte de Grasse had left France in early April 1781 and would be available to coordinate its operations with those in America. Once Washington finally abandoned the idea of attacking New York, he began moving his Continental troops southward

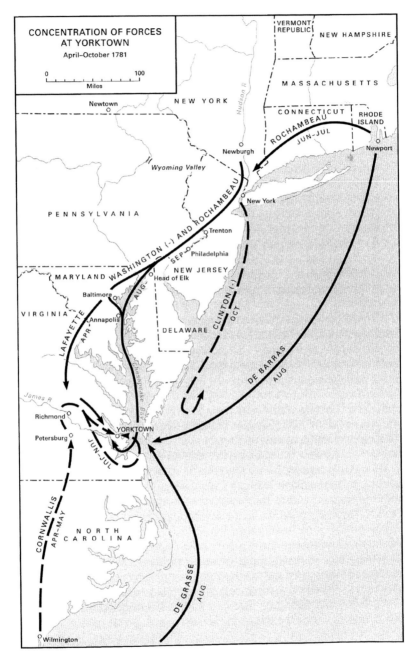

American and French forces concentrated in the Chesapeake Bay region prior to the 1781 Siege of Yorktown, where British forces surrendered to Washington. *U.S. Army Center of Military History image.*

on August 18. Thousands of French troops followed two days later, and de Barras set sail from Newport soon thereafter. Together, the force numbered approximately 6,300 men. American troops and Virginia militia regiments in eastern Virginia under the command of the young Marquis de Lafayette since April were ordered to keep an eye on Cornwallis so that he did not escape before Washington and the French forces could bottle up the enemy at Yorktown, where the enemy had begun to fortify in early August.

On August 30, de Grasse arrived at the mouth of Chesapeake Bay with twenty-eight ships and 3,250 men from Head of Elk, Maryland (at the northern end of the bay), who were landed at James Island, the site of the early English settlement at Jamestown, on September 2. Other troops had marched from Head of Elk to Baltimore and from there were to take ship to the Williamsburg area by September 22. Washington, Rochambeau and their staff officers, however, took an overland route from Head of Elk to Mount Vernon, the first time the American general had been home since 1775. Here they stayed from September 9 to 12, then continued south through the tidewater counties of Virginia to the Yorktown area, which they reached several days later. The French fleet secured the entrance to the bay by a victory over the British navy on September 5 in what came to be called "the battle of the Capes," and Washington and Rochambeau surrounded Yorktown with their armies and opened the siege of the British lines on September 28. After an abortive escape attempt from his lines, a beaten Cornwallis decided to surrender his post and troops, who laid down their arms in the open fields near Yorktown on October 19. Washington, with vital French assistance, finally won his great victory.

THE WASHINGTON-ROCHAMBEAU REVOLUTIONARY ROUTE

As noted above, Generals Washington and Rochambeau paid a three-day visit to Mount Vernon as they proceeded overland from Head of Elk in Maryland to Yorktown in September. Thanks to the research of historians (most notably Dr. Robert A. Selig) and the availability of invaluable period maps, their route through Virginia is now known with accuracy and detail and for the most part can be driven today. The Commonwealth of Virginia began to mark highways and backroads in the mid-twentieth century to promote tourism and heritage, but much of that route covered major roads that were often not the exact path

of Washington and Rochambeau in the eighteenth century. In recent years, the Washington-Rochambeau Revolutionary Route and the Park Service's Washington-Rochambeau National Historic Trail have been developed into excellent resources to use for accurately studying and following the trail today. For NPS information on the route in Virginia visit www.nps.gov as well as the private website www.w3r-us.org.

The two allied generals left Mount Vernon on September 12 and followed the route familiar to Washington toward Fredericksburg, known as the King's Highway. They traveled past Pohick Church, crossed the Occoquan at Colchester and went on to Fredericksburg by way of Dumfries, Peyton's Ordinary and Falmouth. Part of the route today goes through modern Quantico Marine Corps Base and is not accessible to the general public. However, travelers can see a well-preserved original section of the road in Prince William Forest Park, a National Park Service unit just north of the Marine Corps base. Located just off I-95 at exit 150-B, visitors can drive west on Joplin Road two-tenths of a mile to the park's entrance. The visitor center is half a mile farther, and beyond it is a car park and picnic area near the trailhead for the Crossing Trail. This easy wooded path leads walkers only a few hundred yards to the site of the road used by the two generals across Quantico Creek. For more information about the park, call (703) 221-4706 or visit www.nps.gov. There is an entrance fee, and the park is open all year.

After spending the night at a city tavern or at Kenmore, Washington and Rochambeau proceeded south from Fredericksburg as the former had done previously on his "Burgess Route" to Williamsburg before the Revolutionary War. They rode to Bowling Green in Caroline County and turned southeast by way of Sparta, Newtown and Todd's Bridge to King William Court House. From here, they went south to Ruffin's Ferry at Sweet Hall and crossed the Pamunkey River. Again, this was essentially his usual route taken to House of Burgesses sessions during the colonial years. Once across the river, the officers moved on what is now Stage Road in New Kent County to Routes 30 and US 60 (and at times nearby Route 603) by way of modern Barhamsville and Toano to Williamsburg. They stopped for a meal on their way in New Kent County at Frank's Tavern, located on modern Cook's Mill Road (Route 623) at Hill Farm Road (Route 625). The generals joined the army on September 14 and moved with the troops to Yorktown to begin the siege. Upon his arrival, the soldiers cheered with "inexpressible joy," according to a Pennsylvania officer in the American army.

It should be noted that several respected historians and Washington biographers, as well as the Virginia House of Delegates in 1940 and 1982,

This overgrown section of the Washington-Rochambeau Route is still preserved in Prince William Forest Park near Quantico and can be explored along a short hiking trail. *Author photo.*

have interpreted the Washington-Rochambeau route erroneously. These histories and legislative acts concluded that the two generals rode south from Bowling Green to Hanover Court House (not southeast to Todd's Bridge) and went along the southern bank of the Pamunkey River through Hanovertown and Newcastle to New Kent Court House. Evidence gleaned

from "Washington's Accounts of Expenses While Commander-in-Chief of the Continental Army 1775–1783" and his diary, especially ferry receipts, suggests that a route by way of Hanover Court House is incorrect, as are the various state and local road signs and historical markers indicating it (though he did occasionally take this route as a burgess). The wagon train, however, following about two weeks behind the generals, did in fact take the route by way of Hanover Court House to Williamsburg and is documented by period French army sources.

VICTORY

Washington was in overall command of the Continental troops at Yorktown in addition to the Virginia militia and the French regulars under Rochambeau, a force totaling about eighteen thousand men. At the port town and the point of land jutting into the York River opposite (north of) the town called Gloucester Point, British forces numbering around seven thousand dug field works and trenches to protect their positions and the port. Washington decided to lay siege to the enemy's fortifications and ordered his men to begin digging traditional siege lines of approach from which the allied artillery could blast the British lines into submission. On October 14, American and French troops captured two key British positions—Redoubts 9 and 10—in a bold attack co-commanded by Washington's former aide Alexander Hamilton. This successful assault allowed the allies to complete their siege lines close to the town, and soon led Lord Cornwallis to seek terms of surrender. British troops glumly marched out of their works on October 19 to lay down their arms and enter captivity as

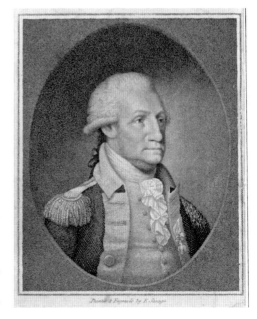

General Washington during the Revolutionary War. *Library of Congress.*

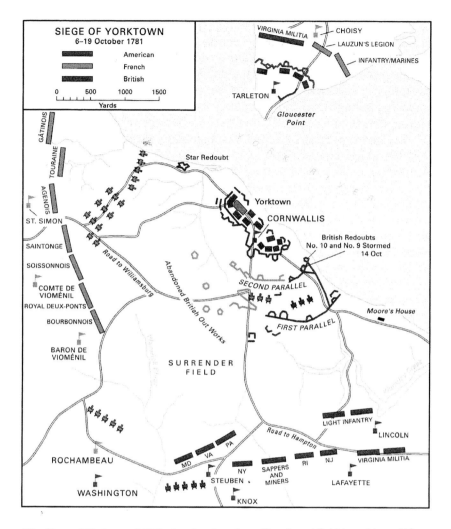

The Siege of Yorktown (1781), showing American, French and British positions. *U.S. Army Center of Military History image.*

the victorious American and French troops looked on. Washington had won the siege and, in effect, the war.

There are today numerous sites at Yorktown and Gloucester Point related to the operations at Yorktown, as well as the colonial port town itself. The riverside village, located at the eastern terminus of the National Park Service's Colonial Parkway, retains a strong colonial charm, thanks to the survival of a number of buildings and streets from the colonial and Revolutionary era. After parking in town or at the nearby National Park

Service Visitors Center at Yorktown Battlefield, many structures and sites are within an easy walk.

The town was established on the south bank of the York in 1691, and by 1697, Grace Anglican Church had been built there. The church, destroyed during the War of 1812, was rebuilt by 1848. Yorktown was a tobacco export center for local plantations and a convenient spot to cross the river to Gloucester County. One visitor to the town in the 1730s noted that "the Taverns are many here and much frequented." The qualities that made the town suitable for a port also made it attractive to the British in 1781, when they sought a place to fortify and use for shipping.

On Main Street, visitors today can see the Georgian home of Thomas Nelson Jr., a signer of the Declaration of Independence, a Continental congressman, a prominent militia general during the war and the state's governor in 1781. The fine two-story brick house at Main and Nelson Streets was erected by his grandfather "Scotch Tom" Nelson in about 1730 and is occasionally opened to the public for informal tours. It suffered some damage from bullets and cannon shots during the siege, which may be seen today.

Also in town is the Dudley Digges house, a white frame house built in 1760 on Main Street. Digges was a York County lawyer, a fellow burgess with Washington during the 1750s and 1760s and a colonel of militia. Digges also served on a House committee to oversee funds for the Virginia Regiment during the French and Indian War during Washington's command. He later became the state's lieutenant governor during the Revolutionary War. During British lieutenant colonel Banastre Tarleton's Charlottesville Raid in June 1781, Digges was captured by the enemy dragoons in Albemarle County but later paroled. Nearby is the town's prewar customs house for the payment by shippers of duties on goods imported to the colonies. This imposing brick structure of two stories was constructed on a raised basement on Main Street near the river. The Swan Tavern on Main Street is also a period structure, built about 1722 by the Nelson family. While walking around the town, hikers can see much of the British fieldworks from 1781 (modified by Confederate troops in 1862 during the Civil War), where they defended the town and port.

Much of the actual battlefield, army camps, siege works and roadways can be visited within the National Park Service's Yorktown Battlefield, part of Colonial National Historical Park. The visitor center is at the end of Colonial Parkway and includes exhibits, demonstrations, cannon firings and a museum related to the town and the 1781 siege. Redoubts 9 and 10 and

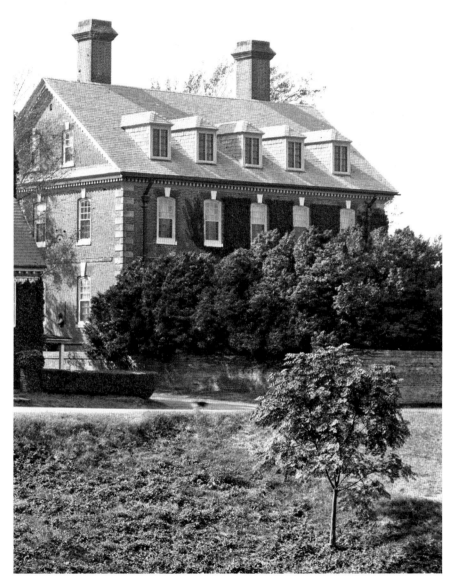

The elegant Thomas Nelson house in Yorktown. Nelson served briefly as Virginia's governor in 1781. *Library of Congress.*

the Surrender Field are part of the battleground tour, as are the French lines, the American Artillery Park and General Washington's headquarters. Also nearby is the Augustine Moore House, to the east of town, where British

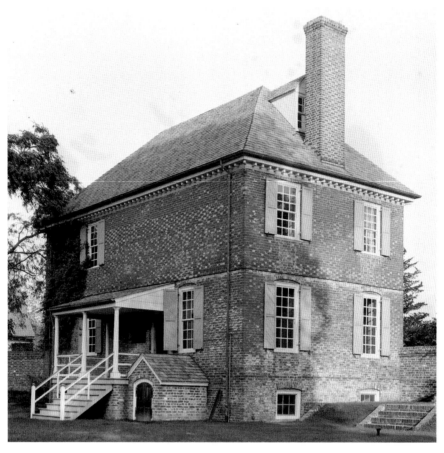

The colonial customs house in Yorktown, a remnant of British commercial regulations in America. *Library of Congress.*

and allied representatives met on October 18 to work out the details of Cornwallis's capitulation. The house was built in the mid-eighteenth century, and Moore occupied the home with his wife beginning in 1768. He was at one time clerk of the York County court before the war. The National Park Service restored the Moore House in the 1930s. Yorktown Battlefield includes an auto tour, numerous hiking trails and outside interpretive signs and is open all year. More information can be obtained at www.nps.gov or by calling (757) 898-2410.

In addition to the National Park Service unit at Yorktown, the events there of 1781 can also be experienced at the Commonwealth of Virginia's Yorktown Victory Center, located near the Fusilier's Redoubt

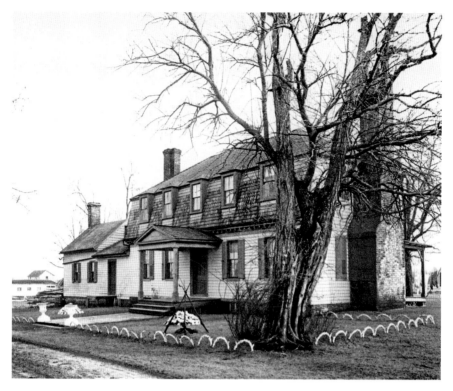

The Moore House on the Yorktown battlefield, where British and American officials negotiated the surrender of Cornwallis's army in October 1781. *Library of Congress.*

on the western edge of the battlefield and off of the Colonial Parkway. The newly renovated and expanded site includes a colonial farm, a Revolutionary War encampment, cannon firings, demonstrations and extensive museum and interpretive exhibits. Special events and lectures are held here throughout the year. Admission fees are charged, and the museum is open all year. More details can be had by calling (757) 253-4838 or going to www.historyisfun.org/visit.

George Washington's military career ended two years after the British surrender at Yorktown, although there was very little fighting during this period. This was his last occasion to don his country's uniform, save for a brief stint in 1794 during the Whiskey Rebellion in western Virginia and Pennsylvania, during which he saw only limited active service. He was "first in war, first in peace, and first in the hearts of his countrymen," as eulogized by fellow soldier Light-Horse Harry Lee, who was also a Virginian and neighbor of the great general.

Old Town Alexandria

Alexandria was "a small trading place in one of the finest situations imaginable," wrote a visitor to the port town in 1759. The official origins of the port town, however, go back to 1732, when the colony's legislature authorized the establishment of a public tobacco inspection warehouse north of Hunting Creek at West Point, on the Potomac River at what is now the east end of Oronoco Street. There, Hugh West had already built a warehouse by 1730, and by the mid-1740s, a tavern and ferry to Maryland were also at this site. In 1749, the colonial assembly passed an act for the creation of a town near the tobacco warehouses to be called Alexandria, after the Alexander family who owned the land where the town was to be established. Alexandria was often referred to as Belhaven, and the name in common usage for twenty years or more after Alexandria was its official name, although the first written use of Belhaven occurs only in 1749. While today the area called Belhaven (and often spelled Belle Haven) refers to a park and marina off the George Washington Memorial Parkway on the south side of Hunting Creek, in the eighteenth century, the two place names were synonymous. Also, by 1749, a young surveyor who lived several miles downstream with his older step-brother had been given the job of laying out the town plan and thus began a lifelong association with what we now call Alexandria.

Visitors to Old Town today can see numerous structures and sites associated with George Washington while walking the city's charming streets. Those buildings described as follows are only a sample of these. For an exhaustive

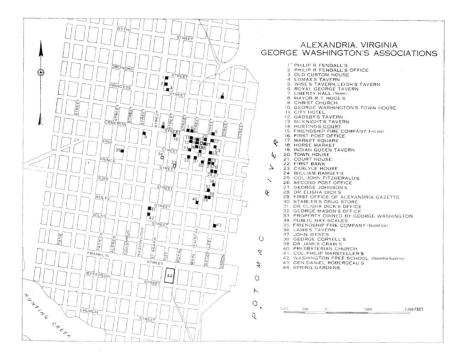

ALEXANDRIA, VIRGINIA
GEORGE WASHINGTON'S ASSOCIATIONS

1. PHILIP R. FENDALL'S
2. PHILIP R. FENDALL'S OFFICE
3. OLD CUSTOM HOUSE
4. LOMAX'S TAVERN
5. WISE'S TAVERN, LEIGH'S TAVERN
6. ROYAL GEORGE TAVERN
7. LIBERTY HALL (Theatre)
8. MAYOR R. T. HOOE'S
9. CHRIST CHURCH
10. GEORGE WASHINGTON'S TOWN HOUSE
11. CITY HOTEL
12. GADSBY'S TAVERN
13. McKNIGHT'S TAVERN
14. HUSTINGS COURT
15. FRIENDSHIP FIRE COMPANY (First site)
16. FIRST POST OFFICE
17. MARKET SQUARE
18. HORSE MARKET
19. INDIAN QUEEN TAVERN
20. TOWN HOUSE
21. COURT HOUSE
22. FIRST BANK
23. CARLYLE HOUSE
24. WILLIAM RAMSEY'S
25. COL. JOHN FITZGERALD'S
26. SECOND POST OFFICE
27. GEORGE JOHNSON'S
28. DR. ELISHA DICK'S
29. FIRST OFFICE OF ALEXANDRIA GAZETTE
30. STABLER'S DRUG STORE
31. DR. ELISHA DICK'S OFFICE
32. GEORGE MASON'S OFFICE
33. PROPERTY OWNED BY GEORGE WASHINGTON
34. PUBLIC HAY SCALES
35. FRIENDSHIP FIRE COMPANY (Second site)
36. LAMB'S TAVERN
37. JOHN WEST'S
38. GEORGE CORYELL'S
39. DR. JAMES CRAIK'S
40. PRESBYTERIAN CHURCH
41. COL. PHILIP MARSTELLER'S
42. WASHINGTON FREE SCHOOL (Alexandria Academy)
43. GEN. DANIEL ROBERDEAU'S
44. SPRING GARDENS

George Washington had numerous associations with Alexandria, many of which can still be seen today. George Washington Bicentennial, *Vol. 1.*

guide to all sites in and near Old Town linked to Washington, readers should consult the well-researched *Walking with Washington*, Robert L. Madison's 2003 book available at local booksellers and online.

CHURCHES

When the Washingtons were in residence at Mount Vernon, they attended religious services at Pohick Church. However, when business or pleasure took them to Alexandria, they typically attended what became known as Christ Church, located on what is now Columbus Street, one block north of King Street. This rectangular Georgian-style church was designed by James Wren, who was also the architect of both Pohick Church and Falls Church. Construction of Christ Church, part of Fairfax Parish, began in 1767 and was estimated to cost about £600.00. Washington's friend John Carlyle oversaw the completion of the building in 1773. The finished

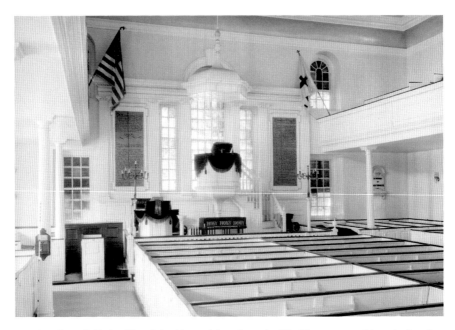

Interior view of Christ Church in Alexandria, where the Washingtons worshipped when in town. *Library of Congress.*

church was of brick laid in Flemish bond and included quoins of Aquia sandstone from Stafford County. The church's distinctive bell tower was added around 1818–20. Although the roof originally had juniper (cedar) shingles, these were later changed to more durable slate tiles. Much of the interior of the church is original, while some nineteenth-century modifications are evident. Inside, the church congregants sat in box pews, and today's visitors can see the one belonging to George Washington. He bought box pew No. 5 for his family for £36.10 and probably first attended the new church on June 13, 1773.

Also inside the church near the pulpit visitors can see Wren's original hand-lettered panels, which contain the Ten Commandments, the Apostles' Creed, the Lord's Prayer and the Golden Rule. The galleries were added after the Revolution to allow additional seating and are now accessed by a stairway in the bell tower. Washington's good friend Bryan Fairfax (of Towlston Grange and later Mount Eagle) served as rector there from 1790 to 1792. Not long afterward, Robert E. Lee began to attend the church as a child, and in July 1853, he was confirmed there. Christ Church offers tours to the public seven days a week, and more visitor information can be obtained at www.historicchristchurch.org.

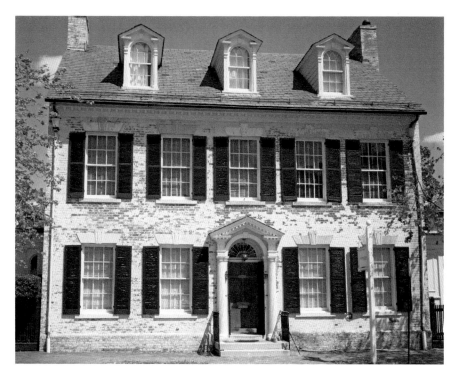

The rectory of Christ Church, built in 1785 and located on Princess Street. *Richard C. Maass II photo.*

Two blocks north of the church is the original rectory, located at 711 Princess Street. The white two-story, five-bay brick Georgian-style dwelling with dormer windows was built about 1785 for the Reverend David Griffith, the church's third rector. George Washington may have visited the clergyman here during one of his frequent visits to Alexandria. The structure is now privately owned and not part of the parish properties.

Another church associated with Washington is found at 323 South Fairfax Street, the Old Presbyterian Meeting House. The original building was erected in the late 1770s, but a fire in 1835 destroyed much of the structure, which was rebuilt in 1837. The church was the second house of worship built in Alexandria, after Christ Church. It is known that Washington attended services there for a "National Day of Solemn Humiliation, Fasting, and Prayer" issued by President John Adams in 1798, and the town's 1799 memorial services for Washington were held in this sanctuary.

The Tomb of an Unknown Soldier of the American Revolution is located in the burial ground adjoining the meetinghouse. These were the

remains of a soldier found buried nearby, still clothed in a Revolutionary War uniform and possibly from the small army commanded by the Marquis de Lafayette encamped by the town in April 1781. Also buried here are Washington's friend and fellow soldier John Carlyle and physician Dr. James Craik. Much more information about the church, its history and architecture can be found at www.opmh.org/history.

THE DOCTORS

Dr. Craik's residence was at 210 Duke Street, a three-story brick town house built in 1796 (now a private residence) around the corner from the Presbyterian church. The Scottish-born doctor trained in Edinburgh, served several years with Washington at Winchester during the French and Indian War, became surgeon general in the Revolutionary War and was one of George Washington's oldest friends, attending the former president during his final hours at Mount Vernon. He was also at Braddock's Defeat in 1755 and treated General Braddock's mortal wounds after the army's retreat. The doctor practiced

The Alexandria home of Dr. James Craik, longtime friend and physician to George Washington. *Eileen M. Maass photo.*

medicine in the front of the home while maintaining his private rooms on the upper floors.

Another of George Washington's physicians, Dr. Elisha Cullen Dick, owned several residences in Old Town, one of which was at 209 Prince

The Elisha Cullen Dick house on Prince Street in Alexandria. *Eileen M. Maass photo.*

Street, built by Captain John Harper in 1793. Dr. Dick cared for Washington along with Dr. Craik during Washington's fatal illness. He was also one of the founders of the Alexandria Library Company and a prominent fellow Mason with Washington in the local Masonic Lodge No. 22. Initially,

George and Martha Washington were regular customers of the Stabler-Leadbeater Apothocary on South Fairfax Street in Old Town Alexandria, just off King Street. *Library of Congress.*

he lived at 408 Duke Street, but in 1801, he went bankrupt and lost his home there. He later rented 211 Prince Street from Mary Harper from 1804 to 1820. From 1804 to 1805, he was the mayor of Alexandria, and the doctor became a Quaker in 1812. Dr. Dick was also part of a delegation of Quakers who rowed out in the Potomac River to the flagship of Admiral George Cockburn in 1814 to prevent the British naval forces from sacking Alexandria in the War of 1812. Dick also lived at 517 Prince Street from 1794 to 1796 in a small wooden dwelling set on a brick basement. Although Dick resigned from the Alexandria Quaker meeting in 1825 shortly before his death that year, he was buried in the Quaker Burying Ground at 717 Queen Street.

On South Fairfax Street, the Washingtons were customers of the Stabler-Leadbeater Apothecary Shop, at No. 107. This apothecary began in 1792 and was in business until 1933, run by a Quaker family. It is now a museum open to the public and owned by the City of Alexandria. As noted on its website, the museum contains "a vast collection of herbal botanicals, hand-blown glass, and medical equipment. It also has a spectacular collection of archival materials, including journals, letters and diaries, prescription and formula books, ledgers, orders and invoices. The names of famous customers appear in these documents, including Martha Washington, Nelly Custis, and Robert E. Lee." Details on tours and hours of operation can be had by calling (703) 746-3852.

TAVERNS AND INNS

Just to the north at 201 North Fairfax Street is what once was the Dalton-Herbert Tavern, now two private homes. Construction of the structure began in 1777 and was finished a few years later. It is a large three-story brick building on a corner lot at Cameron Street. George Washington dined there in September 1785, "at the New Tavern, kept by Mr. Lyle," he noted in his diary, referring to Henry Lyles, who had served in the Third Maryland Regiment during the Revolutionary War. In the early 1800s, the tavern was converted into two separate residences.

Another eating and drinking establishment in Alexandria associated with George Washington was William Duvall's tavern, now a private residence at 305 Cameron Street. There on December 31, 1783, General Washington was celebrated by townsmen shortly after he had returned his

Dating from 1777, the Dalton Herbert Tavern in Old Town was converted into two residences in the 1800s. *Author photo.*

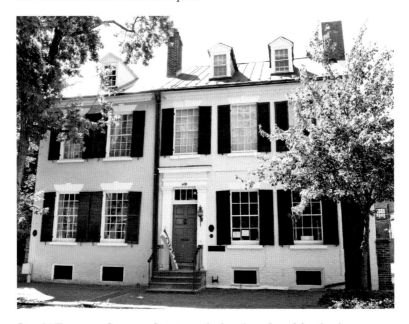

Duvals' Tavern on Cameron Street was the location of a celebration in Washington's honor shortly after he resigned his military commission in 1783. *Author photo.*

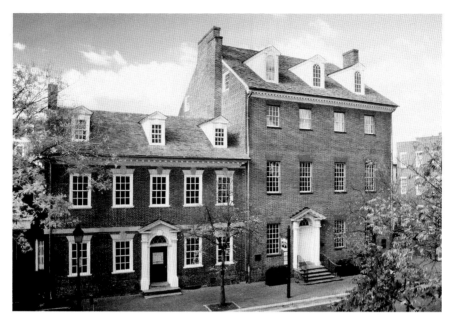

Gadsby's Tavern, which Washington frequented, is still in use as a museum and restaurant today. *Gadsby's Tavern Museum photo.*

commission as the Continental Army's commander-in-chief to Congress at Annapolis. This building later housed the Bank of Alexandria—the first bank established in Virginia—from 1793 to 1807; Washington was both a depositor and stockholder there.

More well known to today's visitors is Gadsby's Tavern, which still offers historic tours and fine dining. This establishment consists of a 1785 tavern and a 1792 hotel located at 138 North Royal Street, near the Carlyle House. They were leased by John Gadsby from 1796 to 1808. Washington was a frequent guest here and attended two Birthnight Balls here in his honor in 1798 and 1799. Records show that John Adams, Thomas Jefferson, James Madison, James Monroe and the Marquis de Lafayette also visited the tavern. In fact, President Thomas Jefferson's Inaugural Banquet was held there in 1801. Today there is a museum, gift shop and restaurant on the premises, and it is open all year. More information can be obtained by calling (703) 746-4242 or at www. alexandriava.gov/GadsbysTavern.

HOMES

A couple blocks west at 508 Cameron once stood George Washington's town house, erected in 1769 but later demolished in 1855. A replica of the home was constructed on its original foundation in 1960 based upon a contemporary drawing. Washington bought the lot in 1763 for ten pounds, ten shillings. He later added a stable and other outbuildings there and used the dwelling when in Alexandria on business and later for political meetings in the 1770s. He referred to it as "my own house" and left it to Martha unencumbered in his will. Martha's niece, Fanny Bassett Washington, lived here with her children from 1794 to 1795.

Just off North Washington Street is the imposing "Boyhood Home of Robert E. Lee," actually one of a few in Old Town that can claim that title. As noted above, Washington's friend William Fitzhugh moved his family from their Stafford County home, Chatham, to Alexandria in 1796, where they lived in a brick town house still standing at 607 Oronoco Street. Washington dined at the home and was an overnight guest in 1799. Here Fitzhugh's daughter Mary Lee married George Washington Parke Custis, the grandson of Martha Washington and son of Jacky and Eleanor Custis. Robert E. Lee would spend much of his childhood in this Old Town home as well, beginning in 1812. A state historical marker stands in front of this private, two-story house just west of Washington Street.

On the south side of town, at the southeast corner of Washington and Wolfe Streets, the three-story Alexandria Academy building still stands as a reminder of Washington's interest in education. "There is nothing which can better deserve your patronage than the promotion of science and literature," he wrote to Congress in 1790. Erected in 1785, the Alexandria Masonic Lodge laid the cornerstone for the brick building, and the school was incorporated the next year. In the 1780s, George Washington was a trustee of the academy, which operated as a free school and relied on local benefactors for its support. Washington wrote to the school's trustees in December 1785 that he intended at his death to donate £1,000 and have the interest from it "be applied in instituting a school…for the purpose of educating orphan children who have no other resource—or the children of such indigent parents as are unable to give it." He also asked that his gift be spent on "that kind of education which would be most extensively useful to people of the lower class of citizens, viz.—reading, writing & arithmetic, so as to fit them for mechanical purposes." A limited number of girls attended there as well. When Washington died, he left his Bank of Alexandria stock to the Alexandria Academy to endow it. Two of Washington's nephews, George

George Washington's town house was rebuilt on Cameron Street in the 1960s. The original structure was pulled down in the 1850s. *Author photo.*

Known today as the "Boyhood home of Robert E. Lee" on Oronoco Street, Martha Washington's grandson George Washington Parke Custis married Mary Lee in this stately house. *Author photo.*

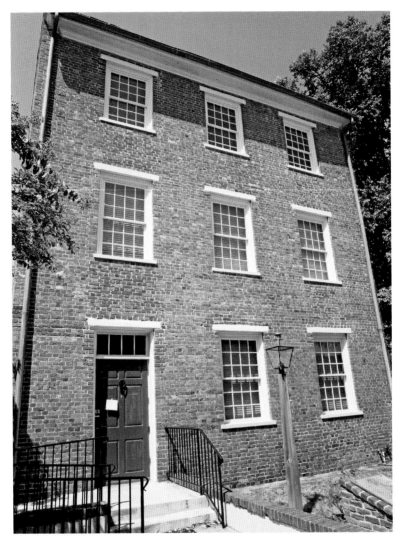

The Alexandria Academy on Wolfe Street was a public school Washington supported financially in his will, and it has been restored recently. *Author photo.*

Steptoe Washington and Lawrence Augustine Washington, attended the school and lived with Dr. Craik while enrolled. Later, a young Robert E. Lee was enrolled at the school in the early 1820s. The Historic Alexandria Foundation restored it in 1999, and visitors can walk all around it next to the Little Theatre of Alexandria.

More information about historic Alexandria can be easily obtained by visiting the restored Ramsay House, on the corner of King and Fairfax Streets in Old Town, which now houses the city's visitor center or by calling (703) 746-3301.

"Pursuits of Commerce and the Cultivation of the Soil"

When George Washington began farming at Mount Vernon after his half brother Lawrence's death, the estate was primarily a tobacco plantation. This "noxious weed," as King James I called it in the seventeenth century, was Virginia's cash crop, and the majority of colonial planters in the Chesapeake and Tidewater areas grew, harvested, cured, shipped and sold it to English merchants as their primary livelihood. For decades, along Little Hunting Creek and the Potomac River, the Washingtons were no exceptions to this system of agriculture, including Young George upon leasing—then owning—Mount Vernon as a young man.

It must be remembered that by their very location in rural areas often far removed from colonial ports and commercial centers, Virginia plantations were far more than just tobacco-producing farms. With slaves to feed and clothe, animals to husband, buildings to maintain and equipment to care for, life on estates like Mount Vernon was diverse and dynamic. Washington made many changes in the agricultural and commercial operations at his plantation until his death, and experimented often with new ideas and pursuits to make Mount Vernon more efficient and profitable.

FROM TOBACCO TO GRAIN

In 1617, just ten years after Englishmen founded Jamestown in Virginia, the Welshman William Vaughan penned several verses encapsulating tobacco's characteristics as a mixed blessing. "Hail thou inspiring plant!" he wrote, "Thou balm of life," also noting that to many it was the "Exhaustless fountain of Britannia's wealth." Yet in the next verse he also called tobacco "that outlandish weed" that "dulls the spirite" and "dims the sight."

No doubt many Virginia planters would agree with Vaughn's mixed assessment of this crop, especially by the mid-1700s, when Washington became a planter as well. Although this crop initially made many planters and merchants wealthy, by the 1750s, if not earlier, tobacco planting was not the road to wealth it was once thought to be. In the decades before the Revolutionary War, many planters had become deeply in debt to Scottish merchants who shipped their tobacco to Great Britain in exchange for credit, with which they purchased necessities and luxuries from commercial houses in cities such as London and Bristol. Like many other Virginians, Washington came to resent the poor quality of goods he received for his crop, the high costs and fees he had to pay to ship his tobacco and the dependency this created on British firms he no longer trusted.

Additionally, tobacco cultivation was fraught with problems beyond just the vagaries of weather. Tobacco depleted the soil of its nutrients, exhausting the land which then had to remain fallow for years or planted in wheat. It was also a labor-intensive crop that required the purchase of numerous slaves in the process. In the fields, slaves had to hoe the weeds, pick worms off the plants and prune leaves. Moreover, volatile markets and world events such as wars also made investments in tobacco cultivation risky, and often led to crippling debts.

Given the many problems with tobacco farming, Washington began to look for other crops to plant and money-making endeavors to explore on his farms. By the 1760s he began to grow wheat as his cash crop, as fewer acres at Mount Vernon were devoted to tobacco. A severe drought in 1762, which devastated that year's tobacco crop, also prodded Washington on the path to wheat farming. In Washington's lifetime as many as three thousand acres were being cultivated on his four working farms. In 1764, his fields produced about 250 bushels of wheat, but five years later his expanding wheat fields yielded over 6,000 bushels. He further diversified his farm economy by growing hops, hemp for rope making and flax for linen cloth. As a result of the linen production, Washington developed a small-scale

WASHINGTON AT MOUNT VERNON 1787

Washington spent much of his time improving his farms while in residence at Mount Vernon and switched from growing tobacco to grains by the 1760s. *Library of Congress.*

spinning and weaving operation at the plantation in the spinning house on the north lane near the mansion house, and his workers produced over thirteen hundred yards of linen in 1768.

By 1766 tobacco, once a staple there, was no longer being grown at Mount Vernon. "Once he committed to wheat," notes historian Edward Lengel, "there would be no turning back." Modern Washington biographer Harrison Clark also noted that "Washington was one of the first American farmers, and perhaps the first on a large-scale, to experiment with crop rotation and to plan his crops in accordance with future market demands."

Washington kept extensive records of his agricultural pursuits at the plantation, noting items such as crop yields, soil quality and the labor rates of his slaves. Growing wheat took less labor, so slaves were available now to do other tasks. He frequently inspected his farms and associated operations on horseback, keeping a watchful eye on farm managers, overseers and slaves. In his efforts to improve the land and production, he sought out new tools and methods, such as innovated plows, crop rotation and "the new husbandry" as it was called in England. He sought to "pursue a course of

The innovative sixteen-sided wheat-threshing barn designed by Washington has been reconstructed at Mount Vernon. *Library of Congress.*

husbandry which is altogether different and new to the grazing multitude, ever averse to novelty in matters of this sort, and much attached to their old customs," he wrote in 1786.

"I shall begrudge no reasonable expence that will contribute to the improvement and neatness of my Farms," Washington promised in 1793, and he was as good as his word. As an impressive example, in 1792 he designed and had built an innovative sixteen-sided wheat treading barn of two stories near his mill on Dogue Run Farm. On the upper level, reached

by way of an earthen ramp, horses moved around in a circle to step on threshed wheat and oats in order to separate the heads from the stalks. The heads would then fall down to the lower level through narrow gaps in the white oak floorboards, where they would be collected prior to milling nearby. This was a cleaner process as well, as most farmers of the time had their horses tread wheat outside, where the plants became muddy or wet. The original barn disappeared long ago but a replica has been erected recently at the colonial farm area of Mount Vernon, where it can be seen by visitors today.

As early as 1787, Washington had a dung repository constructed near the stables, just downhill from the mansion. This was to facilitate the use of fertilizer on his nearby gardens and fields using horse manure. Measuring about thirty feet by twelve feet, this open-sided, cobblestone-bottom structure was also used for discarding other household waste, and may have been in use as late as the 1820s. It has recently been reconstructed in its original location.

THE GRISTMILL ON DOGUE RUN

Once wheat became the main crop at Mount Vernon, a modern mill was of course required. A small gristmill dating from the 1730s was already operating at Mount Vernon when George Washington began farming the lands of his plantation. Work at the mill—including its oversight—was usually performed by slaves. In the early 1770s, Washington built a larger watermill on Dogue Run for grinding Mount Vernon's expanding wheat production, including the export of flour to foreign markets and other American colonies. Records show that Washington's flour was sold in Norfolk, Lisbon and the West Indies. Moreover, corn was ground at the new mill to provide meal to feed Mount Vernon's hundreds of slaves.

The new mill was a two-and-one-half story structure with an internal waterwheel sixteen feet in diameter, and was situated on Dogue Run west of the mansion house. The two millstones were of the highest quality, imported from France, in order to mill superfine flour, and were expensive to obtain. In 1791, Washington improved his milling operations by installing innovated technology, the newly patented Evans system, which drastically reduced the need for the slave's manual labor and improved production. Neighboring farmers also milled their wheat, oats and rye there, and paid Washington a percentage of their finished flour.

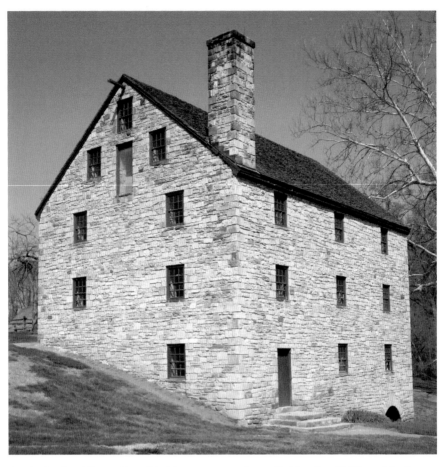

On the banks of Dogue Run, Washington operated a profitable gristmill. The original stone building was razed in 1852; in the 1930s, a reconstruction was built at the original site. *Richard C. Maass II photo.*

The original mill was destroyed about 1850 due to its deteriorating condition. In 1932, as part of an effort to mark Washington's 200th birthday in Virginia, the state bought about six acres at the site and rebuilt the mill and a miller's house the following year. Since 1997 it has been owned by the Mount Vernon Ladies Association, open to visitors from April through October, and is located at 5514 Mount Vernon Memorial Highway, about five hundred yards south of US Route 1, and less than three miles from Mount Vernon's main gate.

WASHINGTON'S DISTILLERY

Not all of the grains harvested at Mount Vernon were used for meal. Much of the rye was turned into whiskey at the distillery, located just steps from the mill and Dogue Run, a source for water much in demand in the distilling process.

Washington became involved with making liquor on his estate at the suggestion of his Scottish-born farm manager, James Anderson, who had previous experience making whiskey in Scotland prior to arriving in America. Although he began cautiously, the operation soon proved to be a profitable success once it began in 1797. Grain from his own farms along with that purchased locally were used in the process. The whiskey produced along Dogue Run was primarily made from rye, with smaller amounts of corn and malted barley. The product was put into barrels for shipment after it was finished, and was not aged or bottled. Additionally, small quantities of vinegar and brandy were also made there. The distillery building was 75 feet by 30 feet and housed five copper stills. By 1799, the distillery produced about 11,000 gallons of whiskey valued at $7,674 and was the largest such operation in America.

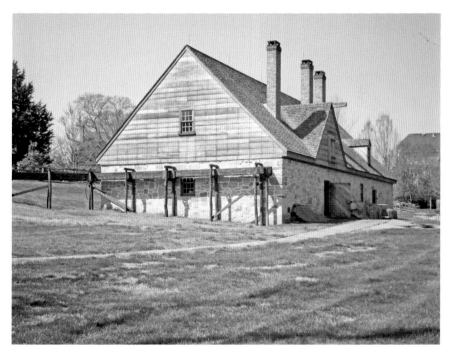

The whiskey distillery George Washington built next to his mill in the 1790s quickly became the highest-producing distillery in the United States by the time of his death. *Author photo.*

A full-scale replica of Washington's distillery was built on the original site in 2007 after archaeological investigations beginning in 1997. Open to the public from April to October, the whiskey produced at the distillery is available for sale at the Mount Vernon gift shop in limited quantities, and samples can be purchased at the Mount Vernon Inn. See www. mountvernon.org/the-estate-gardens/distillery-gristmill for more details.

LAND SPECULATION

From his early days as a surveyor, Washington always had his eye on more land as an investment. These lands were usually not to farm, but to purchase, divide and sell to settlers. Often he pursued these investments as a member of a land company or enterprise. While some of his land acquisitions were successful, others provided few if any returns.

One of the land ventures Washington joined was the Mississippi Company. Once the French left most of its former possessions in North America by 1763 after their defeat in the French and Indian War, Virginians sought to obtain huge land grants (totaling over two million acres) along the lower Ohio and Mississippi Rivers and encourage settlement there. The company wished for British authorities to build two forts along the rivers as well. Primarily a project of the Lee brothers of Westmoreland County, Washington joined a number of prominent men in this "adventure,' as he termed it. Other investors included Francis Lightfoot Lee and Richard Henry Lee; Charles, Samuel and John Augustine Washington; William Fitzhugh; and Adam Stephen, a former Virginia Regiment officer who had served with George. Organized in Stafford County in June 1763, Washington attended the first meeting on his way home from Williamsburg, and he attended many others.

The company's members usually met at the former site of Stafford Court House (until 1718), which was then located on the north side of the mouth of Potomac Creek on the Potomac River, at a now-lost town called Marlborough. This town was first surveyed for lots in 1691, but it struggled to thrive commercially, suffered a fire in 1718 and was abandoned before the Revolution. George Mason's guardian John Mercer tried unsuccessfully to revive the town's fortunes in the 1730s and 1740s and became heavily indebted in the process. The area can be visited today by following Route 621 (Marlborough Point Road) to its eastern end, about six miles from the modern crossroads town of Brooke. Glimpses of the river can be seen near the point,

The remnants of a lane leading to a landing can still be seen at Marlborough Point in Stafford County, where Potomac Creek meets the Potomac River. Nothing now remains of the mid-eighteenth-century town planned there. *Author photo.*

but all of the land once planned as a town is now privately held. No trace of the courthouse remains, nor of the wharf, tavern, water mill, glass factory, windmill, brewery, tobacco warehouses or racetrack that were once part of the town. A historical marker stands at the intersection of Indian Point Road and Menne Road. In the end, the company's repeated requests for grants on the western rivers were never made by the British crown.

Within Virginia, Washington spent decades before and after the Revolutionary War trying to make riches from a swamp. Its northern

edge only a dozen miles or so southwest of Norfolk, the Great Dismal Swamp was a huge morass of around two thousand square miles that straddled Virginia's southeast border with North Carolina. Oddly, the tree-choked swamp was actually higher in elevation than its surroundings, and drained its freshwater to surrounding streams to the east. Given its proximity to tidewater shipping ports, the land was seen by rival Virginia and Carolina investment companies as potentially valuable—if its dark, rich soil could be drained. The large swath of marshlands had long been a place of refuge for displaced Indians, runaway slaves and lower-class whites who did not want to be found. Some ex-slaves set up long-term settlements within the swamp, and were called maroons. "It is certain many Slaves Shelter themselves in this Obscure Part of the World," wrote William Byrd II of Westover in 1728. Decades later another observer recorded that "runaway negroes have resided in these places for twelve, twenty, or thirty years and upwards, subsisting themselves in the swamp upon corn, hogs, and fowls."

In the autumn of 1763, George Washington joined a group of investors to seek land grants in the Dismal Swamp, through which they planned to have slaves dig a canal to link the Chesapeake Bay to Albemarle Sound in North Carolina. These men included his brother-in-law Fielding

An early twentieth-century image of the Great Dismal Swamp in Virginia. Washington's investment there was largely unsuccessful. *Library of Congress.*

204

Lewis and Dr. Thomas Walker of Albemarle County (who was also a member of the Mississippi Company). The land grant was approved by the colonial council soon after the petition was made in November, and Washington began to make regular exploratory expeditions to the swamplands. The Dismal Swamp Land Company, as it was called, found progress slow going, and for many years the only profits came from slaves making cedar shingles. The Revolutionary War interrupted the attempts to drain the swamp, and eventually the effort was given up entirely. Some canals were dug in sections of the swamp in the early 1800s, but by 1814 the company had dissolved. Washington had sold his four thousand acres there by 1795 to his neighbor Henry Lee Jr. (of Revolutionary War fame), but he was unable to make payments on the shares, so the property came back to Washington's estate ownership in 1809. Washington made little if any profit from the venture in the bog.

A historical marker on the west side of the swamp points visitors to the "Washington Ditch," a four-and-a-half-mile canal dug by slaves in the 1760s to Lake Drummond in the center of the swamp. It is located on Washington Ditch Road, just east of White Marsh Road (Route 642), several miles south of Suffolk. Today, visitors to southeastern Virginia can experience this large spread of swampland at the Great Dismal Swamp National Wildlife Refuge, created in 1974 and now managed by the U.S. Fish and Wildlife Service. Consisting of 112,000 acres, the headquarters of the refuge and many of its trail heads are located in Suffolk. Call (757) 986-3705 or visit www.fws.gov/ refuge/Great_Dismal_Swamp for more details.

THE POTOMAC COMPANY

For almost all of his adult life, George Washington sought to link the Ohio Country west of the Appalachian Mountains with the Potomac River Valley in terms of commerce. He hoped that if people of the new settlements in the west could move their produce inexpensively to markets in Virginia, his home state—and in particular, his hometown of Alexandria—would benefit financially from this trade. He sought to "make a smooth way for the produce of that Country to pass to our Markets." Moreover, this commercial connection would tie the people across the mountains to the United States, and not the British or Spanish along the Mississippi and the Gulf Coast, where American settlers might

Great Falls on the Potomac River, now within Great Falls National Park. *Library of Congress.*

be tempted to trade their goods with foreign powers. In order to achieve these ends, Washington and other Virginians long sought to facilitate commerce from the Potomac to the headwaters of the Ohio River. His French and Indian War service and surveying career first alerted him to the geography and opportunities for these endeavors.

Washington became involved with the Potomac Company after the Revolution, in order to make it easier to ship goods on that river, especially in navigating waterfalls. Started in 1785, this group of investors sought to use locks, canals and better roads to avoid obstructions such as Great Falls on the Potomac River on Fairfax County's northwestern border, and river obstructions at Harpers Ferry farther upstream. Other interested parties from Maryland also joined these efforts, and Washington served as the company's first president for several years.

Evidence of these grand commercial plans can be explored today at Great Falls National Park, located off Georgetown Pike (Route 193) several miles west of Exit 44 of the Washington, D.C. beltway in Fairfax County. At this site are the remnants of an extensive system of canals and locks used by cargo boats to avoid the rocky falls and rapids on the river. Slaves and hired hands took seventeen years to complete the dangerous work, which was often beset by financial problems. Also at Great Falls was the town of Matildaville, which began as a home for the workers and the company's headquarters for a time. Eventually the Potomac Company declined and was purchased by the Chesapeake and Ohio Canal Company in 1828. Little is left of the town within the park, but remains of the canals and locks are easily seen along several trails, as

are the dramatic falls. For more information about Great Falls National Park, see www.nps.gov/grfa/index.htm.

WASHINGTON'S COLLEGE

Washington was not only interested in increasing his fortune, even when given the chance. In 1749, a Presbyterian minister named Robert Alexander began a small grammar school in the Shenandoah Valley to prepare men to enter college and the seminary. Situated in Augusta County, the school is believed to have been located just south of today's town of Greeneville at Larkin Spring, off Old Providence Road. Later, but prior to 1773, the school was called Augusta Academy and had moved to a location called Mount Pleasant northeast of today's Fairfield in Rockbridge County, along modern Ridge Road (Route 613), .3 miles north of Sterrett Road (Route 710). Many of the school's students went on to seminary at Princeton University (then called the College of New Jersey), and the school even had a scientific laboratory, but nothing remains of the structure today.

In 1776, school rector William Graham, a Pennsylvanian of Scotch-Irish descent, relocated the academy south a few miles to Timber Ridge, near the colonial-era Presbyterian Church described earlier. Given the onset of the Revolutionary War, the school's name was changed to Liberty Hall Academy, but the war led to decreased enrollment and a scarcity of funds. After briefly suspending its instruction, the school next moved to a hilltop site just west of Lexington and was housed in a modest frame building. In 1782, the school was incorporated by the state and could now confer degrees as a higher academic institution. After fire leveled the building and its successor, a three-story stone building was erected in 1793, along with several outbuildings. Here students studied Latin, Greek, mathematics, surveying, philosophy and sciences. With this ambitious academic program, the school experienced financial difficulties, no doubt exacerbated by its remote location in Virginia's backcountry. Enter George Washington.

As a token of its esteem, the Virginia legislature awarded one hundred shares of stock to Washington in 1785 in a newly formed canal building concern, the James River Company. The recently retired general accepted the stock, only on the condition that he would be permitted to

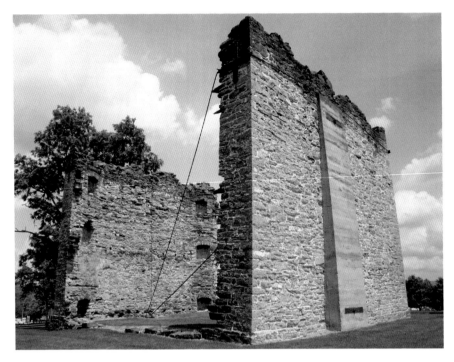

The ruins of Liberty Hall Academy, precursor to Washington and Lee University, in Lexington. George Washington donated shares of canal company stock to support the struggling institution in 1796. *Author photo.*

choose a suitable recipient to which the stock would be donated. "I do not want to show disrespect to the Assembly or to appear ostentatiously disinterested by refusing this gift," he worried. Of note, he chose to endow an educational institution. His own lack of a formal higher education made him recognize the benefit such study was to others in the new nation. "Nothing can give me more pleasure, than to patronize the essays of genius, and a laudable cultivation of the arts and sciences," he wrote back in 1778. Liberty Hall's trustees sent an appeal to Washington to be considered for the gift, as did other schools in the state. In 1796, Washington picked Liberty Hall to receive the valuable shares, worth $20,000, and in the following year the trustees changed the name of the school to Washington Academy in his honor. Not only did the donation ensure the financial stability of the institution, Washington's recognition greatly advanced the prestige of the school. Although fire destroyed the three-story limestone academy in 1803, the ruins of this structure, including its two side walls, can be explored today near the university's

athletic practice fields off West Nelson Street (US 60) by turning north onto West Denny Circle.

After the Civil War, former Confederate general Robert E. Lee served as the college's president from 1865 until his death in 1870. Not only is Lee entombed in the family crypt beneath the school's chapel, several members of the Custis family are as well, as Lee married into that clan (to Mary Anna Randolph Custis in 1831). The college is now known as Washington and Lee University, one of America's top liberal arts institutions. Washington's philanthropic legacy endures to this day.

CONCLUSION

George Washington's associations with Virginia are extensive and lasted all his life. The land of his ancestors for three previous generations, he was born and died on the banks of the Potomac, and is buried in his native state. He fought in his first war and won his second one there as well. His magnificent home, Mount Vernon, was his favorite place to be, along with the spouse to whom he was devoted—also a Virginian. Although he was the commander of American forces during the Revolutionary War and the first United States president, he preferred being at home in Virginia to the seat of power. "All see, and most admire, the glare which hovers round the external trappings of elevated office," he wrote to a Boston correspondent in 1790, but "to me there is nothing in it, beyond the luster which may be reflected from its connection with a power of promoting human felicity." Many of his letters written during the war years and his presidency contain expressions of his desire to retire to his farms, and withdraw from the world to Virginia. "I will move gently down the stream of life," he planned in 1784, "until I sleep with my fathers."

This book has attempted to show readers some of the numerous places in Washington's Virginia landscape that can still be found today. Some are easy to find, such as Mount Vernon, Williamsburg and Yorktown. Some are hidden in plain sight, such as Towlston Grange, his "burgess route" and the taverns of Old Town Alexandria. Still more are "lost," places known to Washington but now long since gone, such as the frontier

French and Indian forts and Marlborough. Not all Washington-related sites could be included in this work, but hopefully those described above will entice readers to explore George Washington's Virginia.

Bibliography

Achenbach, Joel. *The Grand Idea: George Washington's Potomac and the Race to the West.* New York: Simon and Schuster, 2004.

Anderson, Fred. *Crucible of War: The Seven Years' War and the Fate of Empire in British North America, 1754–1766.* New York: Alfred A. Knopf, 2000.

Baker, Norman L. *Braddock's Road: Mapping the British Expedition from Alexandria to the Monongahela.* Charleston, SC: The History Press, 2013.

———. *French and Indian War Sites in Frederick County, Virginia.* Winchester, VA: Winchester-Frederick County Historical Society, 2000.

Brownell, Charles E. *The Making of Virginia Architecture.* Richmond: Virginia Museum of Fine Arts, 1992.

Brumwell, Stephen. *Gentleman Warrior.* London, UK: Quercus, 2012.

Chase, Philander D, et. al. *The Papers of George Washington.* Charlottesville: University Press of Virginia, 1985.

Dalzell, Robert F., and Lee B. Dalzell. *George Washington's Mount Vernon: At Home in Revolutionary America.* New York: Oxford University Press, 1999.

Felder, Paula. *Fielding Lewis and the Washington Family: A Chronicle of 18th Century Fredericksburg.* Fredericksburg, VA: American History Company, 1998.

———. *George Washington's Fredericksburg.* Fredericksburg, VA: American History Company, 1998.

Flemer, Carl F. Jr. *Birthplace of the Nation: A Story Worth Telling.* Oak Grove, VA: Carl F. Flemer Jr., 2008.

Flexner, James T. *George Washington: The Forge of Experience, 1732–1775.* Boston: Little, Brown, 1965.

Freeman, Douglas S. *George Washington: A Biography*. 4 vols. New York: Scribner, 1948–54.

Fusonie, Alan, and Donna Jean. *George Washington: Pioneer Farmer*. Mount Vernon, VA: Mount Vernon Ladies Association, 1998.

George Washington Bicentennial Commission. *History of the George Washington Bicentennial Celebration*. 5 vols. Washington, D.C.: 1932.

Greene, Jerome. *The Guns of Independence: The Siege of Yorktown, 1781*. New York: Savas Beatie, 2005.

Hatch, Charles E. Jr. *First Entrepreneur: How George Washington Built His—and the Nation's—Prosperity*. Boston: DeCapo Press, 2016.

———. *Popes Creek Plantation: Birthplace of George Washington*. Washington's Birthplace, VA: George Washington Birthplace National Memorial Association, 1979.

Lengel, Edward. *General George Washington: A Military Life*. New York: Random House, 2005.

Levy, Philip. *Where the Cherry Tree Grew: The Story of Ferry Farm, George Washington's Boyhood Home*. New York: St. Martin's Press, 2013.

Maass, John R. *The Road to Yorktown: Jefferson, Lafayette and the British Invasion of Virginia*. Charleston, SC: The History Press, 2015.

Madison, Robert L. *Walking with Washington*. Baltimore, MD: Gateway Press, 2003.

Mount Vernon Ladies Association. *George Washington's Mount Vernon Official Guidebook*. Mount Vernon, VA: Mount Vernon Ladies Association, 2nd ed., 2013.

Preston, David L. *Braddock's Defeat: The Battle of the Monongahela and the Road to Revolution*. New York: Oxford University Press, 2015.

Royster, Charles. *The Fabulous History of the Dismal Swamp Company: A Story of George Washington's Times*. New York: Alfred A. Knopf, 1999.

Selig, Robert. *March to Victory: Washington, Rochambeau, and the Yorktown Campaign of 1781*. Washington, D.C.: U.S. Army Center of Military History, 2005.

Waterman, Thomas T. *The Mansions of Virginia, 1706–1776*. Chapel Hill: University of North Carolina Press, 1946.

Wayland, John. *The Washingtons and Their Homes*. Berryville: Virginia Book Company, 1973.

Wolf, Thomas A. *Historic Sites in Virginia's Northern Neck and Essex County: A Guide*. Warsaw: Preservation Virginia, 2011.

Index

A

Abingdon plantation 119
Accokeek 38, 42, 43, 105
Alexandria 15, 16, 48, 51, 61, 69, 70,
 71, 72, 98, 107, 109, 110, 118,
 119, 121, 142, 143, 144, 182,
 183, 185, 187, 189, 192, 194,
 205, 211
Alexandria Academy 192
Aquia Church 36, 142, 143, 184
Ash Grove 51, 52
Augusta County 78, 85, 207
Augusta Stone Church 78

B

Ball, Joseph 28
Bath County 86, 87
Baylor, John, III 146, 148
Bel Air plantation 57
Belvoir plantation 45, 48, 49, 50, 51,
 55, 57, 63, 70, 101, 113, 115,
 118, 126
Berkeley plantation 166
Blackburn, Richard 114, 115
Blenheim 24, 26

Bowling Green 145
Boyd's Hole 156
Braddock, Gen. Edward 69, 70, 71,
 72, 73, 74, 75, 76, 78, 94, 95,
 171, 186
Bridges Creek 19, 21, 22, 24, 26, 154
Bruton Parish Church 138
Buchanan, Col. John 81
Bullskin Run 61, 62, 73
Burgess Route 140, 174
Bushfield 32, 33, 34

C

Carlyle House 69, 70, 183, 186, 191
Caroline County 41, 42, 145, 148,
 160, 174
Cedar Lawn 63
Charles Town, WV 61, 62, 63, 72
Chatham 144, 145, 192
Chelsea plantation 162, 164
Cherry Point 29
Chesapeake Bay 173
Chestnut Grove plantation 125
Chotank Creek 21, 62, 156, 160
Christ Church, Alexandria 51, 143,
 183, 184, 185

Christ Church, Winchester 55
Claiborne's plantation and ferry 131, 153
Cleve plantation 156, 158
Colchester 57, 109, 112, 140, 174
Coleman's Ordinary 72
Colvin's Fort 88
Craik, Dr. James 186, 187, 194
Custis, Jacky 118, 131, 164

D

Dalton-Herbert Tavern 189
Dick, Elisha Cullen 186, 187
Dinwiddie, Robert 67, 68, 70, 74, 75, 87, 93, 123, 134, 136
Dismal Swamp 16, 204, 205
Distillery, at Mount Vernon 201
Dogue Creek 23, 104
Dumfries 57, 59, 114, 142, 174
Duvall's Tavern 189

E

Elsing Green 164
Eltham plantation 129, 131, 133, 153
Enoch's Fort 92, 93
Epping Forest 28, 29

F

Fairfax, Bryan 51, 103, 121, 184
Fairfax, Col. William 45, 47, 48, 50, 51, 57, 63, 69, 70, 101, 110
Fairfax, George William 49
Fairfax, Sarah "Sally" 49
Falls Church 110, 183
Falmouth 43, 142, 144, 156, 174
Fauquier County 43, 57, 58
Ferry Farm 23, 35, 37, 38, 41, 42, 43, 99, 144
Fort Ashby 94, 95
Fort Breckenridge 84
Fort Dickinson 87
Fort Dinwiddie 85
Fort Edwards 91, 92, 93

Fort Lewis 86, 87
Fort Loudoun 76
Fort Mayo 84
Fort Pearsall 95
Fort Trial 84
Fort William 82
Fort Young 84
Frederick County 60, 61, 75, 76, 89, 134
Fredericksburg 14, 15, 22, 23, 29, 35, 37, 38, 40, 42, 61, 62, 63, 112, 114, 140, 142, 144, 145, 156, 161, 164, 168, 174
French and Indian War 15, 41, 42, 61, 62, 66, 75, 76, 80, 89, 96, 101, 123, 134, 146, 161, 165, 171, 178, 186, 202, 206

G

Gadsby's Tavern 191
George Washington Birthplace National Monument 25
Glebe House 34
Graham, William 207
Great Falls 206
Green Falls 148
Greenway Court 48, 52, 55
gristmill, at Mount Vernon 16, 118, 199, 202
Gum Spring 106
Gunston Hall 115, 117

H

Halifax County 76, 83, 84
Hamilton, Alexander 176
Hanover Court House 168, 175
Happy Retreat 63
Harewood 62, 63
Hayfield plantation 101
Hollin Hall plantation 118
House of Burgesses 14, 19, 21, 35, 42, 68, 76, 113, 123, 130, 131, 134, 135, 145, 146, 174
Hupp House 89

J

Jefferson, Thomas 62, 65, 116, 121, 135, 137, 144, 161, 164, 191

K

Kenmore 38, 39, 40, 62, 118, 174
King and Queen County 131, 148, 150
King George County 26, 62, 156, 158
King William County 125, 128, 131, 133, 150, 152, 156

L

Lafayette, Marquis de 15, 40, 164, 169, 173, 186, 191
Lancaster County 21, 29
Layton's Ferry 154
Lear, Tobias 121
Leedstown 154, 156, 160
Lee, Henry "Light-Horse" 167, 181
Leesylvania 142
Lewis, Betty Washington 22, 38, 39, 62, 118, 161
Lewis, Fielding 38, 42, 62, 118, 161, 205
Liberty Hall Academy 207
Little Hunting Creek 19, 21, 22, 23, 35, 37, 44, 48, 99, 105, 107, 108, 118, 195
Looney's Ferry 80, 82
Lord Fairfax 45, 48, 51, 52, 55, 57, 61, 63, 113, 121

M

Marlborough 115, 202, 212
Mary Washington House 40
Mason, George IV 93, 110, 112, 113, 115, 118, 135, 140, 202
Matildaville 206
Mattaponi River 131, 133, 146, 148, 149, 150, 162, 168
Mattox Creek 18, 19, 21, 25
McCarty, Daniel 113, 118
Mercer Apothecary Shop 41
Mississippi Company 202, 205

Moore House 179
Mount Air 113
Mount Eagle 121, 184
Mount Vernon 14, 15, 16, 17, 18, 19, 33, 37, 38, 44, 45, 48, 51, 55, 61, 71, 97, 98, 100, 101, 102, 103, 104, 105, 106, 107, 108, 109, 112, 113, 115, 118, 119, 121, 122, 125, 126, 127, 128, 134, 140, 143, 148, 154, 171, 173, 174, 183, 186, 195, 196, 197, 199, 200, 201, 202, 211

N

Natural Bridge 80
New Kent County 125, 126, 127, 128, 131, 152, 153, 154, 174
Newmarket 145, 148
Newtown 148, 174
Nomini Church 32, 34
Northern Neck 17, 27, 28, 29, 30, 32, 34, 45, 47, 48, 54, 99, 123, 154

O

Occoquon 110
Ohio Company of Virginia 66
Old Presbyterian Meeting House 185

P

Painter's Run 96
Pamunkey River 123, 125, 127, 128, 130, 131, 133, 150, 151, 152, 153, 154, 162, 164, 174, 175
Pearis's Fort 89
Peyton's Ordinary 142, 143, 144, 174
Pohick Church 109, 112, 174, 183
Popes Creek 17, 22, 23, 25, 26, 37, 99
Poplar Grove 123, 125, 127
Port Royal 156, 160
Potomac River 14, 15, 16, 17, 29, 30, 51, 57, 62, 73, 76, 94, 95, 98, 99, 105, 106, 114, 117, 118, 142, 154, 160, 182, 189, 195, 202, 205, 206

Prince William County 57, 58, 101, 113, 140, 142
Prince William Forest Park 174

R

Raleigh Tavern 135
Ramsay House 194
Rappahannock River 23, 28, 31, 35, 38, 42, 43, 99, 144, 154, 156
Richmond 110, 118, 129, 157, 168, 169
Rippon Lodge 113
Rising Sun Tavern 41
River Farm 105, 107, 118, 121, 122, 154
Rockbridge County 77, 78, 80, 207
Rockledge House 140
Rosegill 161
Rosewell 161
Round Hill Church 26

S

Shenandoah Valley 14, 15, 46, 47, 48, 56, 59, 62, 72, 73, 76, 78, 80, 88, 96, 134, 207
Shirley plantation 167
slavery 106, 116, 156
Stabler-Leadbeater Apocothary 189
Stafford County 21, 29, 35, 38, 115, 142, 156, 184, 192, 202
Steele's Fort 77
St. George's Church 42
St. John's Church (King William) 151
St. Mary's Whitechapel 31
St. Paul's Church 158
St. Peter's Church 128, 131
Sweet Hall plantation 152

T

Timber Ridge Church 78
tobacco 196
Todd's Bridge 149
Towlston Grange 51, 52, 121, 184, 211

V

Vause's Fort 82
Vestals Gap Road 72

W

Wakefield 23, 24, 25
Warner Hall 21, 39, 161
Warreneye Church 129
Washington and Lee University 209
Washington, Augustine 23, 26, 27, 29, 30, 32, 35, 38, 42, 62, 63, 106, 194, 202
Washington, Bushrod 32, 33, 106, 114
Washington, Charles 63
Washington, Jane 21
Washington, John 18, 19, 21, 25, 33, 99
Washington, John Augustine 22, 30, 32, 33, 62, 106, 202
Washington, Lawrence 19
Washington, Lawrence (brother) 44
Washington, Lund 101
Washington, Martha 15, 16, 42, 51, 103, 104, 106, 109, 118, 119, 121, 123, 125, 126, 127, 128, 129, 130, 131, 133, 138, 148, 157, 162, 164, 189, 192
Washington, Mary Ball 15, 17, 27, 29, 34, 35, 38, 40, 41
Washington-Rochambeau Revolutionary Route 174
Washington, Samuel 62, 63
Watt's Ordinary 59
Weems, Parson Mason 38
Westmoreland County 15, 17, 18, 21, 25, 29, 30, 32, 34, 62, 99, 113, 154, 202
Westover plantation 154, 164, 165, 166, 204
West's Ordinary 61
whiskey 201
White House plantation 51, 98, 125, 126, 127, 128

Williamsburg 14, 68, 114, 123, 125,
 126, 134, 135, 136, 137, 138,
 140, 142, 145, 148, 154, 156,
 160, 161, 164, 173, 174, 176,
 202, 211
Wilton plantation 169
Winchester 51, 52, 55, 60, 61, 68, 75,
 76, 77, 84, 87, 88, 89, 91, 92,
 94, 95, 96, 125, 146, 186
Windsor Shade plantation 153
Woodlawn plantation 118
Wythe House 137

Y

Yeocomico Church 29, 30
Yorktown 15, 16, 42, 120, 138, 140,
 145, 153, 164, 170, 171, 173,
 174, 176, 177, 178, 180, 181,
 211

ABOUT THE AUTHOR

J ohn R. Maass received a bachelor's degree in history from Washington and Lee University, a master's degree in U.S. history from the University of North Carolina–Greensboro and a PhD in early American history from the Ohio State University. He is a historian at the U.S. Army Center of Military History in Washington, D.C. His publications include *North Carolina and the French and Indian War: The Spreading Flames of War* (The History Press, 2013), *Defending a New Nation, 1783–1811* (U.S. Army, 2013), *The Petersburg and Appomattox Campaigns, 1864–1865* (U.S. Army, 2015) and *The Road to Yorktown: Jefferson, Lafayette and the British Invasion of Virginia* (The History Press, 2015). He was an officer in the U.S. Army Reserves and has contributed scholarly articles to the *Journal of Military History*, *Virginia Cavalcade*, *Army History*, the *Journal of Backcountry Studies* and the *North Carolina Historical Review*. He lives with his family in the Mount Vernon area of Fairfax County, Virginia.